Maternal Geographies

Mothering In and Out of Place

edited by Jennifer L. Johnson & Krista Johnston

T0289501

DEMETER

Maternal Geographies
Mothering In and Out of Place
Edited by Jennifer L. Johnson and Krista Johnston

Demeter Press
140 Holland Street West
P. O. Box 13022
Bradford, ON L3Z 2Y5
Tel: (905) 775-9089
Email: info@demeterpress.org
Website: www.demeterpress.org

Demeter Press logo based on the sculpture "Demeter" by Maria-Luise Bodirsky www.keramik-atelier.bodirsky.de

Printed and Bound in Canada

Front cover image: Maternity Leaves: *Nine Paces* © Lizzie Philps, 2014 (lizziephilps.com)
Front cover artwork: Michelle Pirovich
Typesetting: Michelle Pirovich

Library and Archives Canada Cataloguing in Publication
Title: Maternal geographies : mothering in and out of place
Edited by Jennifer L. Johnson and Krista Johnston.
Names: Johnson, Jennifer L. (Jennifer Lesley), 1976- editor. |
Johnston, Krista, 1977- editor.
Description: Includes bibliographical references.
Identifiers: Canadiana 20190083948 | ISBN 9781772582000 (softcover)
Subjects: LCSH: Motherhood—Social aspects. | LCSH: Mothers—Social conditions. | LCSH: Feminist geography.
Classification: LCC HQ759 .M38 2019 | DDC 306.874/3—dc23

MIX
Paper from
responsible sources
FSC
www.fsc.org FSC® C004071

We acknowledge and wish to express our gratitude to the numerous people who have read and commented on the chapters in this collection. We are especially grateful to the anonymous peer reviewers who provided detailed critiques with helpful suggestions for improvements. The omissions remain our own. Thank you also to Caitlin McAuliffe and Kana Tagawa for research assistance and to the Laurentian University Research Fund.

Contents

Chapter 1

Maternal Geographies: Mothering In and Out of Place

Jennifer L. Johnson and Krista Johnston

The purpose of this collection is to attend to the spatial practices of mothering. Our aim is to explore how ideas about motherhood, and mothers themselves, are produced through the spaces they occupy and how these spaces are animated through the act of caring for children. We enter this conversation at the intersection of feminist geography and critical motherhood studies—two fields that continue to attract many voices into a critical interdisciplinary dialogue about motherhood. In what follows, we build on these conversations and invite the reader to think about how motherhood produces and is produced through space and place. We present our thinking about what we refer to as maternal geographies and introduce the reader to geographies of mothers, motherhood, and mothering as explored by the contributors to this collection.

This collection brings together critical studies of motherhood across the fields of feminist geography, women's and gender studies, sexuality studies, sociology, anthropology, fine arts, poetry, and film; the contributions of these interdisciplinary scholars reference the geographical contexts of Aotearoa/New Zealand, Argentina, Australia, Brazil, Canada, the Eastern Caribbean, Great Britain, Japan and Samoa, and the United States. Our aim is to bring the reader into conversation with feminist research on mothering that accounts for the production of motherhood as a spatial practice embedded in, and

productive of, spatial relations of power (Hardy and Wiedmer). There are several important areas where research on motherhood and space already thrive—such as in studies of unpaid motherwork (Johnstone and Todd; Dillaway and Pare), transnational migration (Hondagneu-Sotelo and Avila; Raghuram; Parreñas; Horton; Tyldum), pregnancy (Longhurst and Johnston), breastfeeding (Boyer, "Of Care and Commodities"; Groleau et al.), hospital birth spaces (Fannin; Hardy and Wiedmer), and the ways in which affect overlays geographies of motherhood as an institution and mothering as a socially constructed practice (Robinson). In the literature on gender and paid work, there is also a specialist focus on how mothers interact with spaces of paid work (Dillaway and Paré; Hardy and Wiedmer). Despite these important contributions, we have observed that the robust literatures in feminist geography and motherhood studies appear to have developed separately from one another, even though many of the central problems handled through critical studies of motherhood are inherently spatial ones and the very scholars who animate these fields may straddle both worlds in their personal and professional lives (Kate Boyer's recent book *Spaces and Politics of Motherhood* stands as a notable exception to this trend of bifurcation). We approach this collection as an opportunity to draw upon the extensive transnational network of scholars associated with critical motherhood studies and those in feminist geography. In doing so, we anticipate that the chapters in this collection demonstrate not only how mothers are produced and regulated as subjects in relation to space and place but also how practices of mothering produce a range of unique spatial relationships.

The theoretical orientations and genealogies referenced in this collection have in common a drive to disentangle motherhood from biological essentialism. Is a mother always a woman? Is every woman potentially a mother? How does one's location in places such as the home and other sites of care work force the identification of mother and woman together? These questions cannot be ignored in an era when there seems no end to the use of sexism, class, and racism as a way of extracting free and devalued labour from poor, working class, and women of colour in the Global North and Global South. Sexism, as a complex and intersecting form of oppression, is still used as a way of punishing and limiting both human expression and the ability to build community. Disentangling acts of caring from the heteronormative

white feminine subject has proven to be a difficult task. The idea of a nurturing and giving adult (or youth) who cares for others is not one we want to degrade because these are qualities too easily cast aside precisely because they have been historically associated with women. But when imposed, the identity of "mother" carries a lot of baggage with it. Indeed, as a number of contributors to this collection investigate, the figure of the mother continues to be a powerful tool for advancing many projects. For instance, attacks on mothering practices, particularly those which may encode resilience and continuity, have been hallmarks of colonialism, imperialism, and the transnational networks of inequality that continue to striate the world. Narrow conceptualizations of a singular "mother" as white, cisgender, able bodied, heterosexual, and middle class continue to circulate, which validate the dominant power relations that perpetuate interlocking forms of oppression. Yet in the contributions to this collection, we see the possibility of diagnosing and rejecting such dominant represent-ations and of delinking mothering practices from binary ideas about gender rooted in biological essentialism and heteronormativity. Although motherhood is deeply connected to embodied relationships between parent and caregiver, these relationships may exceed and extend normative ideas about how families (and mothers) are made and what kinds of insurgent relationships and communities may be imagined through the opening up of ideas about motherhood beyond simplistic ideas about the normative body. There is much to be learned from queer and transgender parenting practices, from those who parent grandchildren and extended family, who parent and mother children other than our own or in tandem with multiple adults, who care and nurture adults instead of children, and who transgress religious and cultural norms associated with maternal womanliness. As a number of scholars have demonstrated here and in other sources, mothering is also a crucial aspect of antiracist and anticolonial constructions of family and community (hooks; Hill Collins; Lavell-Harvard and Anderson; Lavell-Harvard and Corbiere Lavell).

We define maternal geographies as those creative pathways most often travelled by people who think of themselves as mothers and who, in the act of caring for others, demonstrate awareness of how their paid and unpaid work happens in space. In our attention to the spatialization of mothering, "[t]he underlying premise is that space is

never a homogenous, neutral and a-priori entity that precedes subjects but emerges as the outcome of an ongoing production process which involves actors and material components" (Baydar and Ivegen 699). We do not see these pathways or spaces of motherhood as inherently oppressive (Marotta) but as necessarily filled with information about the social relations of power through which they are constituted. Mothering in specific sites—such as grocery stores, airports, public washrooms, law courts, daycares, prisons, emergency rooms, homes, playgrounds, online spaces, and in visual cultures of all descriptions—are all subject to material and discursive constructions of motherhood with their own histories. The pathways that mothers create as they navigate these spaces can invite scrutiny, can be acts of rebellion, and can also be creative and sustaining acts that draw communities together.

In this collection, readers will find that maternal geographies include the mappings of individualized subjects called "mothers" as well as the imposition or elevation of institutions of motherhood in particular places. Contributors also discuss in some detail the location of everyday work associated with mothering and how to go about researching these topics. Maternal geographies are necessarily intersectional (Valentine) if only because the range of activism mothers have undertaken frequently challenges colonial, capitalist, and imperialist institutions. Intersectionality, as a concept, is embraced by many critical race and feminist geographers as an inherently spatial concept (Mollett and Faria) and so is readily taken up by many who want to understand how racialized and sexualized historical oppressions inform research about mothering and motherhood. By extension, maternal geographies are relational (Dixon and Jones) in that mothers usually act in tandem with at least one other subject such as a child. Maternal geographies are transformative through the direct activism of mothers to reclaim spaces denied to them (McKittrick) as evidenced in the deliberate intergenerational sharing of their strategies for changing cityscapes and landscape with family and new activists (Isoke). In this volume, contributors trace the maternal figure through time and place and think about the spatial relations of motherhood at multiple scales, including the home, the workplace, the family, the body, the nation, the community, the playground, the research site, and the academy.

Many pathways that knit together a maternal geography are completely unremarkable except to the people who experience them. It

is a longstanding idea that one day a city, a region, or an individual home space could be reorganized by people who mother and that these accomplishments could also be more widely recognized (Rendell). Feminist architects and urban planners have certainly attempted the planning of entire cities from the perspectives of marginalized subjects, but it is important to understand that mothers frequently transform very small and unassuming spaces into pragmatically meaningful sites with no external recognition at all. For example, a nook can become a place in which to shelter one's dependents from the elements, and even the space between the body of someone who mothers and that of a child gains significance based on an imposed or assumed responsibility of care (Rendell). Lizzie Philps, the artist and contributor whose work *Nine Paces* appears on the cover of this book, invites us to consider the image of a baby left in a stroller inside an empty garage in an urban laneway. Although the mother-photographer was, in fact, close by, just nine paces away, this image suggests that just a few feet of space can mean "the difference between 'ahh, look—a mother taking a photo of her baby' and 'what the hell is she doing?'" (Philps). The composition of this photograph incites a range of potential concerns and further questions about the relationship between the child, the implied figure of the mother, the viewer, and the connections among them through space and place. How does one's spatial proximity to children test the definition of who mothers and who can be named a mother? And, in reference to Philps' explanation in her chapter in this collection, how is this proximity to children as definitive of motherhood stitched into and written onto various landscapes. What do we learn about the tenuous connections between mothers and children when they are placed in one locale versus another? It may be that these relationships are sustained by personal effort as much as by tradition, culture, and the expectations of others. Returning to the cover image, we are also prompted to ask: are there mothers who would prefer to move more than nine paces away in the hopes that someone else will take over? And in a Western capitalist economy, how does the stroller actually stand in for presence of the mother as a culturally specific thing that symbolizes care? Who would like to be able to mother but for any number of reasons is prevented from closing the distance between themselves and a baby?

Motherhood is frequently mobilized through essentialist ideas

about who is a good or natural parent when it serves institutions other than mothers, which renders the spaces mothers occupy invisible if they do not serve the purpose of another. We understand and agree with scholars of motherhood who argue that being a mother is at once a subject position and an institution requiring construction, and in order to see the components of these constructions, mothers need to be visible. What spaces do mothers occupy with their children or because of their children? In our own lives, we note that mothering is largely associated with a constrained set of spaces: the home (and perhaps especially the kitchen), the playground, the community centre, and the primary school. These spatializations are concurrently shaped by geographical contexts, class, and ability, as well as through racial-ization and dominant expectations about gender and sexuality. In short, expectations of what it means to mother, and particularly to be a good mother, are mapped onto multiple scales simultaneously, but there is a tendency to focus on spaces of domesticity precisely because these spaces have often been hidden from view or over-scrutinized.

Feminist scholars have long problematized the ready associations between femininity, mothering, and domesticity. They note that these relations are frequently mapped onto the symbolic and physical construct of the home. The study of home within feminist geography and related fields has expanded through the field of population geography as well as in studies of the impacts of migration (Contreras and Griffith; Underhill-Sem; Liamputtong; Gedalof; Bonizzoni; Gilmartin and Migge; Moorhouse and Cunningham; Dragojlovic); historical studies of the production of home in colonial and imperial sites (McClintock; Kenny; Mills); qualitative research that cuts across axes of gender, class, racial, and sexual identity (Nast; Sigad and Eisikovits; Marquardt and Schreiber; Gorman-Murray; Dominguez and Watkins; Skelton); and rich introspective interdisciplinary humanities studies of identity and the relationship to place (Dillaway and Paré; Aitken; Gatrell). As illustrated by this robust body of literature, feminist geographers have been particularly concerned with the ways that ideas about home construct gendered spaces and, likewise, with how ideas about gender, specifically about gendered roles, including mothering, are mapped onto the physical spaces associated with home (Domosh; Massey; McDowell et al.). As Mona Domosh suggests, "the home is rich territory indeed for understanding

the social and the spatial" (281). Mothering is bound up with conceptions of home, whether or not the practices of mothering take place exclusively within the space of the household.

Much feminist literature has focused on powerful conceptions of home that have served to limit women's social and physical mobility (Friedan; Oakley; Firestone), but critical race feminists have also argued that in contexts of racism and white supremacy, the home may provide an important refuge, a site for survival, and a place for the valuing of culture and family life (hooks; Hill Collins; Isoke). Indeed, the home is not a homogenous space, nor does it exist in isolation from complex societal relations, including racism, colonialism, and white supremacy. The question of how mothers do the hard work of producing and reproducing what hooks terms "homeplaces" in locales that may be hostile, unwelcoming, or dismissive of their existence is often silenced and devalued as the stuff of mundane everyday life. The chapters in this collection address this gap, demonstrating the creativity at play in the making of home, and showcasing different ways of making spaces for mothering.

The collection is organized into three main sections. Part I examines the creative spatial practices mothers undertake when limits are imposed on where and how mothering happens. The contributors explore how acts of mothering make spaces for children in meaningful and culturally specific sites of parenting. Part II turns to themes of paid work, pregnancy, and what happens when mothers produce knowledge about mothering through research and cultural production. The chapters collectively take note of when mothers are out of place and document their strategies for navigating their dislocation. Part III details various attempts to regulate mothering, including through discourse, policy, and visual culture. Each of the chapters in this section also documents strategies employed to negotiate, subvert, and, at times, reject these attempts at keeping mothers in place. Combined, the chapters in this collection illustrate the importance of motherhood and mothering as spatial practices engaged with systems and structures of power and with the potential to subvert narrow, normative roles and expectations and to imagine motherhood in multiple spaces and places.

Part I. A Woman's Place: Making Maternal Spaces

The site of the home has received intense scrutiny from feminist geographers and scholars of motherhood alike, and it is to this space that we turn our attention in the first part of this book. Orna Blumen, Tovi Fenster, and Chen Misgav draw out the connections between body, home, and domesticity, noting that "bodies are intimate homes" (6), and in this section, scholars engage particularly with the concept of home and the various forms of caring and provisioning work associated with this space. All of the chapters in this section draw on the embodied experience of home in relationship to making space for children.

In Chapter 2, Minako Kuramitsu turns readers' attention to the construction of Japanese homeplaces for migrant mothers from Samoa. Kuramitsu demonstrates that Samoan mothers raising families in Japan reform the space of the home through the essential support of extended family in Samoa as well as through culturally specific ideas about the interconnectedness of domestic spaces to other parts of one's village or community. The home in this sense is both a creative assertion of identity within the bounded semi-private space of the household and also a site for community building and the maintenance of crucial transnational connections. In Chapter 3, Wanda Campbell responds to Alex Colville's painting *May* with an ekphrastic poem exploring the spaces and places of motherhood and evoking a sense of the expansiveness of motherhood across time and place. Campbell raises questions about how the work of mothering is imagined when it is layered onto colonial and industrial landscape, and how Colville's muse, a mother, provides new interpretations of his oeuvre.

Mothers' production of spaces that are nurturing of children is also evident in Chapter 4, in which Laurel O'Gorman draws from ethnographic research with single mothers living in urban and rural sites and examines how mothering is shaped by (and, in turn, how it shapes) children's spaces of play. Bound up with ideas about safety, about appropriate spaces for play, and about expectations of mothers and motherhood, this chapter illustrates the specific constraints and challenges for single mothers, where racialization and class intersect directly with spatialized mothering practices. Chapter 5, by Karen Falconer Al-Hindi, explores the strategies and discourses of "biomed moms" (mothers who engage in biomedical practices) with children

who have autism. In it, she argues that mothering practices "create, use, and hold open new physical, metaphorical, and virtual spaces for their children, themselves, and others, sustaining a rhizomatic community that supports families pursuing biomedical intervention and recovery." In Chapter 6, Elizabeth Philps further considers the construction of appropriate spaces for mothering and, in particular, the mother who is out of place—that is, not within the physical confines of the home. Employing the spatial metaphor and technology of the global positioning system (GPS), the author details her practice of finding herself in a landscape on which motherhood has been mapped in narrow and constrained ways.

Part II. In and Out of Place: Pregnancy, Mothering, Research, and the Workplace

Motherhood studies begins from the premise that the labour, expectations, and material realities of parenting are deeply gendered as well as enmeshed in existing social, political, and economic relations. The second part of the collection focuses on maternal geographies of work and the creative or conflictual spaces that are opened up when mothers simultaneously claim their identities in paid work, in unpaid care (Dillaway and Paré) and as researchers. The contributors explore what happens when the work of reproduction is layered onto knowledge production— centring the embodied experience of the researcher and cultural producer.

Chapter 7, by Tracy Gregory and Jennifer L. Johnson, examines the relationship between motherhood and employment in the strip trades. In this ethnography, mothers use space to manage their identities in rural and northern Ontario communities. Their chapter challenges the presumed division between sexualized labour and maternity. In Chapter 8, Jules Arita Koostachin engages with the contributions of her documentary film *PLACEnta*, which focuses on Cree tradition, place, and the transfer of traditional knowledge regarding the handling of placentas after birth. In Chapter 9, Danielle Drozdzewski and Natascha Klocker investigate structural and discursive aspects of the regulation of motherhood with a focus on the pregnant body in Australian workplaces using data from a nationwide survey on parenting and work. In Chapter 10, Shana Calixte examines the effect

JENNIFER L. JOHNSON AND KRISTA JOHNSTON

of pregnancy on research relationships and teases apart relations of class, racialization, and sexuality in research field sites. Relating her experiences as a pregnant researcher, she points to the complex ways in which bodies are read and positioned at the research site. Chapter 11 by Emma Sharp similarly examines the experience of the pregnant researcher and presents an autoethnography of her experiences doing participatory research on foodwork, in which care figures prominently in research relationships.

Part III. Spatial Practices and the Regulation of Motherhood

The chapters in the third and final section of this book examine how mothers, motherhood, and mothering are persistent sites for scrutiny and regulation. Containments of femininity are often spatial, as women – particularly women of colour and Indigenous women – are considered out of place in public sites, especially when it comes to enjoying the full range of access to public resources and spaces that others enjoy (Boyer; Domosh; Gill; Mawani; Razack). As Massey notes, "spatial control, whether enforced through power of convention or symbolism, or through the straightforward threat of violence, can be a fundamental element in the constitution of gender in its (highly varied) forms" (180). Just as feminist scholars have long interrogated the question of a woman's place, the chapters in this section examine the policies, discourses, and practices through which women are constructed as out of place or, relatedly, as out of order. As Domosh notes, this has a great deal to do with ideas about home as well. She writes "when we move out of the house and on to the streets, our identities are constantly being monitored, judged, constituted, negotiated and represented" (Domosh 280). The chapters address the construction, regulation, and containment of mothering through social assistance programs implemented at different levels of government, workplace policies, discourse, cultural representation, political mobilization, and legal change.

In Chapter 12, Carolyn Fraker investigates assumptions about mothering and the mothering practices of poor women of colour; she argues that although the Opportunity New York City (ONYC) policy was designed as a less punitive measure, it, nevertheless, perpetuates

stereotypes about mothering practices while regulating and shaping them. The theme of regulation is taken in a different direction by Nadia Der-Ohannesian in Chapter 13, which examines representations of motherhood in recent Argentine cinema, particularly in relation to narratives of heterosexuality and representations of the nation. In Chapter 14, Natalie Reis Itaboraí examines the Bolsa Familia Program (BFP)—a national poverty alleviation program implemented by the Brazilian government to address child poverty rates by providing supports to mothers. As Itaborai notes, while the BFP provides crucial financial support, it fails to address the wraparound support needed for families living in poverty. In other words, the program serves to perpetuate assumptions about mothering and poverty rather than to make substantive structural interventions. Written by Laurence Simard-Gagnon, Chapter 15 examines the production of francophone spaces in predominantly anglophone Kingston, Ontario, as mothers in this linguistic minority seek to create affinities with one another and through these affinities to transform play and social spaces. She argues that the moment of identification as a mother is synonymous with a reaffirmation of one's identity as a francophone when one becomes a minority. In her analysis, finding and creating spaces for francophone mothering is central to trying to be 'at home' in a predominantly anglophone milieu. Chapter 16 by Catherine Nash, Andrew Gorman-Murray, and Kath Browne tracks resistance to same-sex marriage in Great Britain, Canada, and Australia with a focus on the discourses of "motherless children" deployed by heteroactivists in these nationalized sites. Their research demonstrates the problematic ways in which mothering is mobilized through heterosexuality as well as through nationalist narratives. Combined, the chapters in this section present a rich overview of the many ways in which states, policies, activists, and cultural producers engage with powerful ideas about motherhood that seek to use mothers for their own purposes. The chapters provide glimpses of the strategies employed by mothers to negotiate and, at times, subvert these expectations.

Readers will find a number of omissions in this collection. We acknowledge the absence of these bodies, spaces, and important debates to remind ourselves of what and who is missing, as much as to incite the reader to seek out scholarship on these topics. The voices of very young mothers and grandparents who mother are absent. Given

that communities who are experiencing colonialism and militarized warfare globally often have very young populations, this is an oversight that means we will have missed the voices of many Black, Indigenous, and racialized young mothers and grandparents. Although a number of authors discuss the process of migration, the experiences of refugees or those living with precarious immigration status are missing. Discussions around the desexualization of motherhood as well as the acceptability of mothers' sexuality only under the terms of heteronormativity—which has been widely discussed as a paradox of mothering (Montemurro and Siefken)—are underrepresented here. Moreover, discussions of how technologies—such as fetal imaging and the rapidly evolving field of reproductive technologies—have expanded the number of participants whose own geographies intersect with the maternal are largely absent. The management of bodies through digital epidermalization has important implications for mothering, family reunification, and the filtering of bodies out of national territories (Browne), and it deserves the attention of critical motherhood scholars. Disability in relation to motherhood is a theme we anticipated being able to include but have not explicitly addressed. This absence is unfortunate given how the fields of architecture, design, and urban planning have been pressed to include a wider notion of accessibility in the organization of planned public places, such as bathrooms, public transportation, and other services. Combined with the inclusion of disability in the human rights codes or similar legislation in many countries globally, the concerns of parents or guardians with disabilities, or those caring for children with disabilities, have not necessarily been included in how new architects and planners are educated (Keddy). There is room for all of these topics in critical studies of motherhood, and we would have liked to have done more here.

Mothering is a spatial practice because it makes zones of conflict visible. The moral, material and discursive geographies laid out for mothers can be restrictive and punishing (Hardy and Wiedmer; Marotta; Robinson). These impositions are evident in ongoing colonialist projects in cities that confine the bodies of Black and Indigenous people to spaces of death and dying. Mothering can also produce alternative geographies of hope that refuse the dualisms imposed by patriarchies and whiteness (Isoke; McKittrick). People who mother can and do modify locales and environments through direct

action and through the occupation of spaces that are normally off limits to them. The work of the scholars in this collection demonstrates that mothers, mothering, and motherhood can be transformative of space and place and can create locales and environments that would not exist except for acts of mothering. In thinking about mothering in and out of place, these chapters make place for new maternal geographies.

Works Cited

Aitken, Stuart C. "Mothers, Communities and the Scale of Difference." *Social and Cultural Geography*, vol. 1, no. 1, 2000, pp. 65-82.

Baydar, Gülsüm and Berfin Ivegen. "Territories, Identities and Thresholds: The Saturday Mothers Phenomenon in Istanbul." *Signs*, vol. 31, no. 3, 2006, 689-716.

Blumen, Orna, et al. "The Body within Home and Domesticity: Gendered Diversity." *Studies in Culture, Policy and Identities*, vol. 11, no. 1, 2013, pp. 6-19.

Bonizzoni, Paola. "Here or There? Shifting Meanings and Practices in Mother-Child Relationships across Time and Space." *International Migration*, vol. 53, no. 6, 2012, pp. 166-182.

Boyer, Kate. "Of Care and Commodities: Breast Milk and the New Politics of Mobile Biosubstances." *Progress in Human Geography*, vol. 34, no. 1, 2010, pp. 5-20.

Boyer, Kate. *Spaces and Politics of Motherhood*. Rowman and Littlefied, 2018.

Browne, Simone. "Digital Epidermalization: Race, Identity, Biometrics." *Critical Sociology,* vol. 36, no. 1, 2010, pp. 131-150.

Contreras, Ricardo, and David Griffith. "Managing Migration, Managing Motherhood: The Moral Economy of Gendered Migration." *International Migration*, vol. 50, no. 4, 2012, pp. 51-66.

Dillaway, Heather, and Elizabeth Paré. "Locating Mothers: How Cultural Debates About Stay-at-Home Versus Working Mothers Define Women and Home." *Journal of Family Issues*, vol. 29, no. 4, 2008, pp. 437-464.

Dixon, Deborah P., and John Paul Jones. "Feminist Geographies of Difference, Relation, and Construction." *Approaches to Human Geography*, edited by Stuart Aitken and Gill Valentine, Sage Publications, 2006, pp. 42-56.

Dominguez, Silvia, and Celeste Watkins. "Creating Networks for Survival and Mobility: Social Capital Among African-American and Latin-American Low-Income Mothers." *Social Problems*, vol. 50, no. 1, 2003, pp. 111-135.

Domosh, Mona. "Geography and Gender: Home, Again?" *Progress in Human Geography*, vol. 22, no. 2, 1998, pp. 276-282.

Dragojlovic, Ana. "'Playing Family': Unruly Relationality and Transnational Motherhood." *Gender, Place and Culture*, vol. 23, no. 2, 2015, pp. 243-256.

Fannin, Maria. "Domesticating Birth in the Hospital: 'Family-Centered' Birth and the Emergence of 'Homelike' Birthing Rooms." *Antipode: A Radical Journal of Geography*, vol. 35, no. 3, 2003, pp. 513-535.

Firestone, Shulamith. *The Dialectic of Sex: The Case of Feminist Revolution*. William Morrow, 1970.

Friedan, Betty. *The Feminine Mystique*. Norton, 1970.

Gatrell, Caroline J. "Maternal Body Work: How Women Managers and Professionals Negotiate Pregnancy and New Motherhood at Work." *Human Relations*, vol. 66, no. 5, 2013, pp. 621-644.

Gedalof, Irene. "Birth, Belonging and Migrant Mothers: Narratives of Reproduction in Feminist Migration Studies." *Feminist Review*, vol. 93, no. 1, 2009, pp. 81-100.

Gill, Sheila Dawn. "The Unspeakability of Racism: Mapping Law's Complicity in Manitoba's Racialized Spaces." *Race, Space, and the Law: Unmapping a White Settler Society*, Between the Lines, 2002, pp. 157-184.

Gilmartin, Mary, and Bettina Migge. "Migrant Mothers and the Geographies of Belonging." *Gender, Place and Culture*, vol. 23, no. 2, 2015, pp. 147-161.

Gorman-Murray, Andrew. "Reconfiguring Domestic Values: Meaning of Home for Gay Men and Lesbians." *Housing, Theory and Society*, vol. 24, no. 3, 2007, pp. 229-246.

Groleau, Danielle, et al. "Power to Negotiate Spatial Barriers to Breastfeeding in a Western Context: When Motherhood Meets Poverty." *Health and Place*, vol. 24, 2013, pp. 250-259.

Hardy, Sarah, and Caroline Wiedmer, editors. *Motherhood and Space: Configurations of the Maternal through Politics, Home, and the Body.* Palgrave, 2005.

Hill Collins, Patricia. *Black Feminist Thought: Knowledge, Consciousness, and the Politics of Empowerment.* 2nd edition. Routledge, 2000.

Hondagneu-Sotelo, Pierrette, and Ernestine Avila. "'I'm Here, but I'm There': The Meanings of Latina Transnational Motherhood." *Gender and Society,* vol. 11, no. 5, 1997, pp. 548-571.

hooks, bell. "Homeplace: A Site of Resistance." *Yearning: Race, Gender, and Cultural Politics,* Between the Lines, 1990, pp. 41-49.

Horton, Sarah. "A Mother's Heart is Weighted Down with Stones: A Phenomenological Approach to the Experience of Transnational Motherhood." *Culture, Medicine, and Psychiatry,* vol. 33, no. 1, 2008, pp. 21-40.

Isoke, Zenzele. "The Politics of Homemaking: Black Feminist Transformations of a Cityscape." *Transforming Anthropology: Journal of the Association of Black Anthropologists,* vol. 19, no. 2, 2011, pp. 117-130.

Johnstone, Micael-Lee, and Sarah Todd. "Servicescapes: The Role that Place Plays in Stay-at-Home Mothers' Lives." *Journal of Consumer Behaviour,* vol. 11, no. 6, 2012, pp. 443-453.

Liamputtong, Pranee. "Life as Mothers in a New Land: The Experience of Motherhood among Thai Women in Australia." *Health Care for Women International,* vol. 24, no. 7, 2003, pp. 650-668.

Keddy, Karen. "'Safety Is Just a Thing Men Take for Granted.' Teaching a Spatial Vocabulary of Equality to Architecture Students." *Atlantis,* vol. 37, no. 1, 2015, pp. 39-53.

Kenny, Judith T. "Climate, Race, and Imperial Authority: The Symbolic Landscape of the British Hill Station in India." *Annals of the Association of American Geographers,* vol. 85, 1995, pp. 694-714.

Lavell-Harvard, D. Memee, and Kim Anderson, editors. *Mothers of the Nations: Indigenous Mothering as Global Resistance, Reclaiming and Recovery.* Demeter Press, 2015.

Lavell-Harvard, Memee, and Jeanette Corbiere Lavell, editors. *'Until Our Hearts Are On the Ground': Aboriginal Mothering, Oppression, Resistance and Rebirth.* Demeter Press, 2006.

Longhurst, Robyn, and Lynda Johnston. "Embodying Place and Emplacing Bodies: Pregnant Women and Women Body Builders." *Feminist Thought in Aotearoa/New Zealand*, edited by Rosemary DuPleiss and Lynne Alice, Oxford University Press, 1998, pp. 156-163.

McKittrick, Katherine. "On Plantations, Prisons, and a Black Sense of Place." *Social & Cultural Geography*, vol. 12, no. 8, 2011, pp. 947-963.

Marquardt, Nadine, and Verena Schreiber. "Mothering Urban Space, Governing Migrant Women: The Construction of Intersectional Positions in Area-Based Interventions in Berlin." *Urban Geography*, vol. 36, no. 1, 2014, pp. 44-63.

Marotta, Marsha. "MotherSpace: Disciplining through the Material and Discursive." *Motherhood and Space: Configurations of the Maternal through Politics, Home, and the Body*. Palgrave, 2005, pp. 15-34.

Massey, Doreen. *Space, Place, and Gender*. University of Minnesota Press, 1994.

Mawani, Renisa. "In Between and Out of Place: Mixed-Race Identity, Liquor, and the Law in British Columbia, 1850-1913." *Race, Space, and the Law: Unmapping a White Settler Society*, Between the Lines, 2002, pp. 47-70.

McClintock, Anne. *Imperial Leather: Race, Gender and Sexuality in the Colonial Conquest*. Routledge, 1995.

McDowell, Linda, et al. "Women's Paid Work and Moral Economies of Care." *Social and Cultural Geography*, vol. 6, no. 2, 2005, pp. 219-235.

Mills, Sara. "Gender and Colonial Space." *Gender, Place and Culture: A Journal of Feminist Geography*, vol. 3, 1996, pp. 125-148.

Mollett, Sharlene, and Faria Caroline. "The Spatialities of Intersectional Thinking: Fashioning Feminist Geographic Futures." *Gender, Place and Culture: A Journal of Feminist Geography*, vol. 25, no. 4, 2018, pp. 565-577.

Montemurro, Beth, and Jenna Marie Siefken. "MILFS and Matrons: Images and Realities of Mothers' Sexuality." *Sexuality & Culture*, vol. 16, no. 4, 2012, pp. 366–388.

Moorhouse, Lesley and Peter Cunningham. "'We Are Purified by Fire': The Complexification of Motherhood in the Context of Migration." *Journal of Intercultural Studies*, vol. 33, no. 5, 2012, pp. 493-508.

Nast, Heidi J. "Mapping the 'Unconscious': Racism and the Oedipal Family." *Annals of the Association of American Geographers*, vol. 90, no. 2, 2000, pp. 215-255.

Oakley, Ann. *The Sociology of Housework*. Martin Robertson, 1974.

Parreñas, Rhacel Salazar. *Servants of Globalization: Migration and Domestic Work*. Second edition. Stanford University Press, 2015.

Philps, Lizzie. *Maternity Leaves: Nine Paces* © Lizzie Philps, 2014, http://lizziephilps.com. Accessed 16 Mar. 2019.

Raghuram, Parvati. "Crossing Borders: Gender and Migration." *Mapping Women, Making Politics: Feminist Perspectives on Political Geography*, edited by Lynn A. Staeheli, et al., Routledge, 2004, pp. 185-198.

Razack, Sherene. "When Place Becomes Race." *Race, Space, and the Law: Unmapping a White Settler Society*, Between the Lines, 2002, pp. 1-20.

Razack, Sherene. "Gendered Racial Violence and Spatialized Justice: The Murder of Pamela George." *Race, Space, and the Law: Unmapping a White Settler Society*, Between the Lines, 2002, pp. 121-156.

Robinson, Catherine. "Maternal Geographies." *Emotion, Space, and Society*, vol. 26, Special Issue, 2018, pp. 31-32.

Rendell, Jane. "Critical Spatial Practices: Setting Out a Feminist Approach to Some Modes and What Matters in Architecture." *Feminist Practices: Interdisciplinary Approaches to Women in Architecture*, edited by Lori A. Brown, Ashgate, 2011, pp. 17-55.

Sigad, Laura I., and Rivka A. Eisikovits. "Migration, Motherhood, Marriage: Cross-Cultural Adaptation of North American Immigrant Mothers in Israel." *International Migration*, vol. 47, no. 1, 2009, pp. 63-99.

Skelton, Ian. "Residential Mobility of Aboriginal Single Mothers in Winnipeg: An Exploratory Study of Chronic Moving." *Journal of Housing and the Built Environment*, vol. 17, no. 2, 2002, pp. 127-144.

Tyldum, Guri. "Motherhood, Agency and Sacrifice in Narratives on Female Migration for Care Work." *Sociology*, vol. 49, no. 1, 2014, pp. 56-71.

Underhill-Sem, Yvonne. "Maternities in 'Out-of-the-Way' Places: Epistemological Possibilities for Retheorising Population Geography." *International Journal of Population Geography*, vol. 7, no. 6, 2001, pp. 447-460.

Valentine, Gill. "Theorizing and Researching Intersectionality: A Challenge for Feminist Geography." *The Professional Geographer*, vol. 59, no. 1, 2008, pp. 10-21.

Part I

A Woman's Place:
Making Maternal Spaces

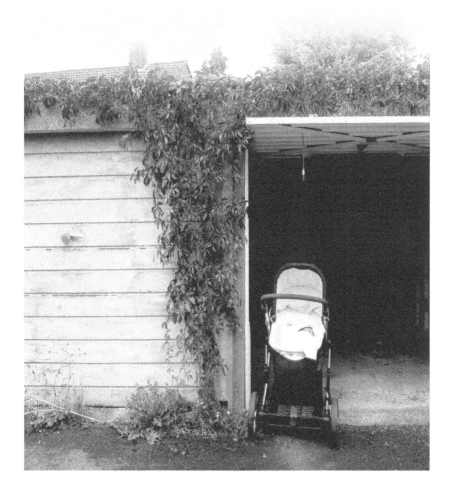

Chapter 2

Constructing Home Through Mothering: A Case Study of Early Samoan Wives in Japan

Minako Kuramitsu

Feminist geographers, initially from a predominantly white feminist perspective, critically identified that the notion of "home" in human geography was developed based on men's experiences and was, thus, romanticized, despite its potential for being oppressive from a woman's standpoint. Later, feminist work gradually expanded on the notion of home to show that it is not necessarily oppressive but historically and geographically diverse. Indeed, multiple lived experiences of home exist (Blunt and Dowling 14-19).

According to Takeshi Hamano, binational couples see home not only as a space where one derives emotional comfort from family but also as a space where cultures and values are brought together, negotiated, and reconstituted (55). In this chapter, I explore how binational couples experience home while raising children. In my own experience, negotiation is never ending. I am Japanese, born and raised in Japan, whereas my partner is Samoan, born and raised in the South Pacific island-nation of Samoa, where I have conducted research for over ten years. In our parenting experience, baths were a recurring issue, as I wanted our children to take baths—especially in winter to prevent colds—yet he hardly minded if our children took only showers. I was vexed to find that I questioned my approach to childrearing, whereas my

partner was confident in his own. At one point, I met several Samoan women married to Japanese partners at Samoan community gatherings and became interested in learning how they coped with Japanese society while raising children. Thus, I began to listen to their experiences relating to life in Japan.

"Early Samoan wives," a term I have adopted in my research of Samoan wives in Japan, refers to Samoan women who married Japanese men in the 1980s, when international marriage was not prevalent in Japan,[1] and have lived in Japan since. In Japan, Samoans are a distinct minority among foreign nationals. At the end of 2015, Japan's Ministry of Justice officially recorded 2,232,289 foreign nationals, of whom only sixty-seven (thirty-five men and thirty-two women) were Samoan. Of the sixty-seven, eleven were a spouse or child of a Japanese national, six were long-term residents, and twenty-four were permanent residents (National Statistics Centre).[2]

Through my research and community involvement, I have identified twelve early Samoan wives, nine of whom still reside in Japan as of 2016. In 2013, I collected the life stories of three women—Peta, Sina, and Emi (all pseudonyms)—through semi-structured interviews. At the time of our interviews, each woman was in her fifties. All three women met their husbands in Samoa, where the Japanese men were working as international volunteers for two or more years. Each interviewee came to Japan in her early twenties, between May 1982 and January 1985. At the time of their arrival, the wives knew very little about Japan or Japanese lifestyles and were unable to speak, read, or write the Japanese language. The husbands were salaried employees in Japan, and each household raised two children (for more, see Kuramitsu). In late 2016, I interviewed Peta and Sina on mothering in Japan but could not include Emi as she was away. These English-language interviews were audio recorded with participants' permission and were supplemented with casual conversation with Peta's husband, sister-in-law, and daughter-in law.

In this chapter, I explore how Peta and Sina constructed home at the household level through their mothering in Japan. First, I identify the differences between Japan and Samoa in terms of home and mothering to make the contexts of my study clear. Second, based on Peta's and Sina's stories, I illustrate their mothering practices in Japan. Finally, I discuss the ways that these women construct home through their mothering practices in Japan.

Home and Mothering in Japan and Samoa

The reality and symbolic meaning of home and practices of mothering in the household differ by place and time (McDowell 71-95). Both in Japan and Samoa, the notion of home has historically changed along with the role of women.

Feminist research reveals that the notion of a normative home in contemporary Japan has been constructed gradually since the Meiji Restoration in 1868. Yuko Nishikawa and Shizuko Ogawa respectively argue that the emergence of a Japanese modern family and ideals prescribed for women were intimately related to the process of establishing a modern nation-state. Their work illustrates that the place for Japan's modern family is "*katei*" (home), whereas the ideal Japanese woman is contained in the notion of "*ryosaikenbo*" (literally good wife and wise mother). Importantly, the meanings underlying *katei* and *ryosaikenbo* have shifted over time, yet they, nevertheless, strongly influence notions of home and mothering in contemporary Japan.

The first term, *katei*, was once used as a translation of the English word "home." According to Nishikawa, the Japanese *katei* was initially created so that second or third sons could form their own legitimated homes in the cities, whereas the "*ie*," their original household, was headed by eldest sons or other relatives with authority over family matters under Meiji civil law (17). In the process of establishing the modern nation-state, *katei* became a very important place for nurturing and educating children as bearers of the nation's future. At the same time, mothers came to carry primary responsibility for childrearing. According to Ogawa, *ryosaikenbo*, the second term, immediately accommodated for the modern era's gendered division of labour with men at work and women at home, where Japanese mothers were expected to supplement public education by shaping the next generation (234).

Through the Second World War, *katei* came to be the basic unit for the nation-state, as the notion of *ie* gradually declined (Nishikawa 22). Today, *katei* is an ideologically defined space with distinctive features. For one, a *katei* is formed from family members; it is not viewed as a collective of individuals but as a group bounded by love and affection. Additionally, a *katei* cannot be handed down from one generation to the next; each couple—understood to be a husband and wife—must construct their own. Lastly, a *katei* must include a husband, wife, and

children, such that the *katei* no longer exists if any is missing (Nishikawa 43).

Following the advent of *katei* and *ryosaikenbo*, the powers of ownership and decision making relating to physical spaces in the house were gradually transferred from men as the heads of *ie* to women serving as wives and mothers in the *katei*. During Japan's period of high economic growth, when husbands rarely returned home due to work, wives took responsibility for everything related to the home. Most Japanese households came under the jurisdiction of wives around the 1980s (Nishikawa 44-57). Especially in cities where physical land was limited, families preferred to add rooms for children over the father's study, as fathers were not often home. Spaces in Japan's small homes were used almost exclusively by mothers and children on a daily basis (Takahashi 149-50).

Relative to Japan, contemporary Samoa has no apparent normative notions of home or an ideal woman—generally due to the continuation of its distinctive traditions and customs rooted in the stratified chiefly system. The Samoan language has no words precisely corresponding to the English term "home." In the Samoan-English dictionary, "home" is translated as "'*āiga*" (Milner 383), a complicated term that principally signifies kinship groups consisting of several extended families, the core unit of the chiefly system. '*Āiga* is also translated to the English word "family." Each '*āiga* is founded in a specific village and shares customary land for housing and cultivation, among other things (Yamamoto and Yamamoto 33-35). In this regard, Sailiemanu Lilomaiava-Doktor points out that "home/place is closely related to *i'inei*, which means local, here, or home" and explains that each Samoan's *i'inei* remains fixed "for it is defined socially as the place where one's lineage originates" (7). In this sense, home for Samoans is the village where their natal family originates.

Lilomaiava-Doktor argues that Samoan culture values group unity more than individualism (12), such that Samoans' daily lives are shaped largely by age and gender. In Samoan society, the status of the wife, and possibly the mother, are relatively new—dating back to the nineteenth century when missionaries from England introduced these roles along with monogamy based on Victorian ideals (Schoeffel 6-10). Unlike in Japan, however, a modern gendered division of labour did not firmly take root. According to Peggy Fairbairn-Dunlop, Samoan

families generally observe a gendered division of labour, yet "tasks are not allocated strictly by rank or gender" in order to prioritize "what is best for family" (162). Childcare is typically shared by all members of the extended family. In general, "older family members must care for and socialize their younger siblings" (Fairbairn-Dunlop 80). Samoan mothers make use of many hands to care for their children, which allows them to share the burdens of childrearing, not only the physical and emotional burdens but also economical ones. The Samoan economy is comprised of subsistence agriculture and fishing as well as a cash economy relying heavily on remittances from overseas and international aid. Many Samoan families have close relatives staying in New Zealand, Australia, or the United States, and such families, thereby, receive financial and material support. Although their economic circumstances vary by time and place, family members with money generally cover the cost of education for their close relatives.

The physical layout of Samoan housing reflects collectivity and could be characterized as expressing openness. Traditionally, each Samoan house has physically consisted of several "*fales*" (houses without walls) on customary land (see photograph 1). Residential land includes one

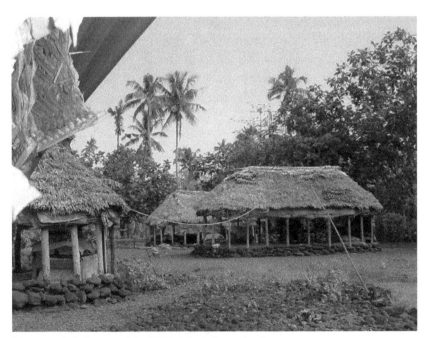

Photograph 1. Samoan *fale*, 2000 (photo by author)

fale tali mālō (house for guests), two or three *fale nofo* (living house), one
umu kuka (kitchen), and one *falevao* (toilet). The *fale tali mālō* is a place
to welcome guests and is located in the front of all *fales*. One *fale nofo* is
for couples and their children. Many Samoan houses have gradually
adopted a so-called Western style with walls and a corrugated iron
roof, yet some *fale tali mālō* remain open and guests are welcome any
time. In urban areas, the living room in a Western style house serves
as the *fale tali mālō*, and each room serves as a *fale nofo*.

Place and Mothering for Early Samoan Wives in Japan

In late 2016, Sina was living with her husband, who works at a Japanese
security company, and her twenty-six-year-old and twenty-three-year-
old daughters; her elder daughter worked at a clothing company, and
the younger one aspired to be a singer in Tokyo. I have never been to
their house, but my Samoan partner says it is a small two-story abode
with a living room connected to the kitchen, a bath and Western toilet
on the first floor, and two bedrooms for the parents and children on the
second floor. Initially, the family began their new life in a housing
development apartment (*danchi*) on the outskirts of Tokyo, and they
moved twice more before settling at their current place. Since coming
to Japan, Sina and her husband have always lived near his mother.
Even now, there are two different houses on the same property: one for
them and one for Sina's mother-in-law.

Peta was living with her husband in a small town in central Japan.
Her two children are married to Japanese citizens and live near her
house. Her thirty-year-old son has established his own shop selling
handicrafts from Samoa, and her twenty-seven-year-old daughter is a
nurse. Each child has one child of their own, giving Peta two
grandchildren. Peta's husband is an architect at an architectural design
office. My interviews with Peta were always conducted in her house,
which is two stories high and was designed by her husband. When
Peta came to Japan, her husband sought a job in Tokyo because he
thought that she, as a foreigner, would feel more comfortable in a big
city. However, they ultimately started life in his hometown where his
elder sister and brother lived, so that Peta could receive assistance from
his family. They lived in a small apartment for seven years, before
moving to their current house. Peta's husband wanted to move to a

house so they could welcome guests from Samoa. He also built part of their house in a Samoan way by crafting an open ceiling space over the living room, which directly connects the entrance door with the living room, and by installing louvre windows. Much like Sina's house, the living room is located by the kitchen, bath, and Western toilet on the first floor, with three bedrooms for the parents and children upstairs. Their son and his family temporarily stayed in the house, too.

In Peta's house, the living room serves as a *fale tali mālō*, where family members congregate and guests are welcomed. The living room is typically decorated with many large family photos; Peta also includes a twenty-first birthday key sent over by her family in Samoa.[3] Coincidentally, because Sina and Peta are both Catholic,[4] they also have small altars (Photograph 2). Peta's husband noted that the altar was her only request for the house. Such a small altar is normally present in Catholic houses in Samoa, as are photos and birthday keys in living rooms, but such fixtures are not at all common in Japan.

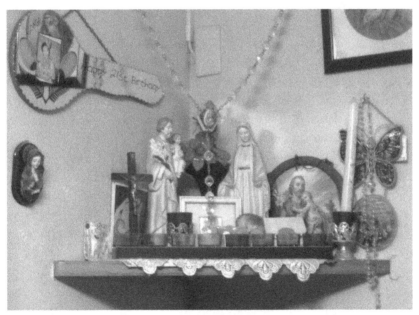

Photograph 2. Decorations in the living room, 2013 (photo by author)

Peta's daughter-in-law commented, "this house makes one feel as if one were in Samoa." This observation derives partly from the house's unique layout, but it also refers to Peta's actions as a mother. Both Sina and Peta demonstrate confidence in their mothering and take initiative in raising their children; both are tough negotiators, as they tenaciously advance their opinions in the house.

Although their husbands have been busy working, Sina and Peta do not manage all household duties alone. Owing to their proximity to their in-laws, both women have had essential support. Peta mentioned that her sister- and brother-in-law often visit her and her children to help as needed,[5] whereas Sina stated that she learned "everything" from her mother-in-law.

In cross-cultural marriages, mothers try to impart knowledge of their own culture—such as language, food, and religion—to their children based on a sense of social and cultural norms (Satake and Daanoy 135; Takeda 201; Liamputtong and Naksook 660-662). Because Sina wanted her daughters to know where she came from and be proud of their heritage, she took them to Samoa twice yearly until they entered kindergarten. Through their experiences in Samoa, Sina's daughters learned to cook Samoan food, wear "*'ie lavalava*" (wrap-around skirts), and speak in the Samoan language. Peta also returned to Samoa with her husband and two children every three years; they stayed with her family for a month while the children attended the local school.

However, apart from these trips, Sina and Peta did not often try to teach the Samoan language and culture to their children. Instead, their mothering in Japan concentrated on instilling two significant elements of Samoan heritage. First, both women raised their children as Christians. Sina practiced what her parents taught her—to "put God in the centre of your life." She, in turn, taught her daughters how to read the Bible and pray in Samoan. Peta took her children to Sunday school weekly and taught them to pray in English before meals. Moreover, she currently teaches English prayers to her grandchildren. Both women and my own Samoan partner tell me that rituals related to Christianity are important to Samoans because of their upbringing in Samoa. Second, both women were concerned with appropriate behaviour for children as defined in Samoa. Sina thought that her husband spoiled their daughters:

For example, for Samoan people, "children are children." Even you grow older, you are still the child of that parents whom you have to respect. There is our curfew that you come to the house. If you could not come till the time, you have to let us know. But in here, even though the father knows that they are not coming, he said: "Oh, it is okay". What do you mean "Okay"? Not okay for a Samoan mother.... He thinks, "They are already adults!" But for me, even though they are adults, they are still children, so that they still need our guidance.[6]

Sina insists that her daughters tell her where they are going, as long as they live in the same house. For her, no matter how old they are, children must obey their parents. Peta explained the same idea using a different example. She said that in Samoa, children are not allowed to disturb their parents' conversations; when parents are talking, children must wait until the conversation is over. Peta taught her children these manners, which they would have otherwise normally acquired in daily life in Samoa.

Constructing Home

The homes that Peta and Sina each constructed through their mothering in Japan have three commonalities. First, the houses are organized spatially, as if they were inhabited by an extended family, with features drawn from the women's Samoan childhoods and culture. On the surface, both families appear to live as nuclear family units, yet mothering has been practically and emotionally supported by family members in Japan and overseas. For one, Peta and Sina received assistance from their in-laws as they lived nearby. Although they were far from their own families, they sustained emotional support. For instance, on her first Christmas in Japan, Peta fought with her husband over the phone and left home with her son because she was angry that her husband had to work. She was so disappointed and upset that she ended up calling her brother in Hawaii. Her brother called her husband to say he would come to Japan to bring her back to Samoa. This prompted her husband and sister-in-law to apologize again and again to remedy the problem. Peta and Sina also shared multiple disputes with their husbands concerning bills for international calls. The support

provided by their extended family in Japan and Samoa benefits both women and is a feature more commonly associated with mothering practices in Samoa.

Second, Peta and Sina construct home as a place offering acceptance, comfort, and solidarity while remaining open to visitors and newcomers. Therein, Christianity may be one indispensable element. Not only did both women raise their children as Christians, which is uncommon in Japan, but they were also proud that their husbands and children have become Christian. Sina noted that her family went to church every Sunday. Indeed, her husband and two daughters always came to support a special service for the Pacific people in her church. Through the church, Peta has met other foreigners. Religious holidays have also become times to practice hospitality and homemaking. During Christmas 2016, Peta had a large get-together at her house with her sister-in-law, all her children, their spouses and children, her children's friends, and foreigners from her church. To open up one's home is an expression of Samoan hospitality. Peta told me that she could not understand why Japanese mothers were upset by sudden visits without advance notice, although they had invited her. She told me the following is the case in Samoa: "You could visit even if the house was messy. We don't care. We love people who visit."

Third, for Peta and Sina, motherhood was a key foundation for their homes in Japan. Sina remarked that she never seriously considered divorce once she had a child. Peta's sister-in-law repeatedly said that Peta experienced difficulty adjusting to life in Japan, but she ventured that Peta's children had enabled her to hang on. Without mothering or their children, Peta and Sina might have given up constructing a home in Japan. Moreover, although they both took the initiative in disciplining, neither forced their children to adopt Samoan ways. They saw mothering as involving a positive compromise between Samoa and Japan. Sina, for instance, explained the following:

> You need to compromise both cultures in the languages and disciplines. Otherwise, they [the daughters] will [become] confuse[d], you know ... if I wanted to discuss something very good for the family and the girls, I spoke to them in Japanese because, you know, they are Japanese anyway. They are living here and raised here, right?

Without insisting on Samoan ways, Sina chose the best middle ground for her children in Japan. The homes that Peta and Sina constructed were not for themselves or their culture alone; they were for their children and their children's comfort.

Concluding Remarks

This chapter has explored how two early Samoan wives construct home through mothering practices in Japan. At first glance, they seemed to construct *katei*, a normative Japanese home, as their narratives were full of memories of how their husbands were always at work. Looking closely, however, their experiences reveal negotiation between themselves and their husbands, or Japanese society itself, which is seen in the support they receive from extended family members and in how they discipline their children. Thus, their current homes capture their positive compromises between Samoan and Japanese mothering. Women, and especially those marrying in different countries and into different cultures, may not choose where they live because of unfamiliarity with the areas. Through mothering, however, they may still construct their homes in their own way.

Acknowledgment

I would like to express my appreciation for the early Samoan wives and their families in Japan who so kindly granted me interviews and shared their precious life stories. I also thank my Samoan partner who provided valuable advice on this project. *Fa'afetai tele lava.*

Endnotes

1. International marriages have increased dramatically in Japan since the mid-1980s. Between 1965, when data collection began, and 2013, the number of international marriages increased fivefold (Kuramitsu 14).

2. The number of Samoan wives in Japan is unclear because some Samoan wives have become naturalized citizens, and no statistical data on Samoans by both visa status and gender exist.

3. This is a common wall decoration in Samoan homes in the contemporary era, marking the coming-of-age birthday at twenty-one years of age.

4. In Samoa, there are several denominations. The largest is a localized protestant church called the Congregational Christian Church of Samoa, deriving from the London Missionary Society, while Catholics are the third largest group.

5. Peta's sister-in-law stressed the great efforts that Peta made to survive in Japan. She also mentioned that she was glad Peta had stayed because Peta always loved to be close to her, unlike typical Japanese wives.

6. The narratives used in this chapter retain each informant's original comments verbatim, with some syntactical corrections.

Works Cited

Blunt, Alison, and Robyn Dowling. *Home*. Routledge, 2006.

Fairbairn-Dunlop, Peggy. *E AU LE INAILAU A TAMAITAI: Women, Education and Development Western Samoa*. Macquarie University, PhD dissertation. 1991.

Hamano, Takeshi. "Making a 'Home' in Australian Suburbia: Case Studies of Japanese Female Marriage Migrants Living in Western Sydney." *Journal of Australian Studies*, vol. 26, 2013, pp.47-67.

Kuramitsu, Minako. "Samoan Pioneer Wives and 'Home': From the Experiences of Living in Japan More than 20 Years." *Geographical Review of Japan Series B*, vol. 89, no. 1, 2017, pp. 14-25.

Liamputtong, Pranee, and Charin Naksook. "Life as Mothers in a New Land: The Experience of Motherhood among Thai Women in Australia." *Health Care for Women International*, vol. 24, 2003, pp. 650-668.

Lilomaiava-Doktor, Sa'iliemanu. "Beyond 'Migration': Samoan Population Movement (Malaga) and the Geography of Social Space (Vā)." *The Contemporary Pacific*, vol. 21, no.1, 2009, pp. 1-32.

McDowell, Linda. *Gender, Identity and Place: Understanding Feminist Geography*. University of Minnesota Press, 1999.

Milner, George Bertram. *Samoan Dictionary*. Polynesian Press, 1966.

National Statistics Centre. "Tokeihyoichiran GL08020103." Tokeihyoichiran Seifutokei no sogomadoguchi." *E-stat*, www.e-stat. go.jp/SGl/estat/List.do?lid=000001150236. Accessed 11 July 2017.

Nishikawa, Yuko. *Kindaikokka to Kazokumodelu*. Yoshikawakobunkan, 2000.

Ogawa, Shizuko. *Ryosaikenbo to Iu Kihan*. Keisoushobo, 1991.

Schoeffel, Penelope. "The Origin and Development of Women's Associations in Western Samoa, 1830-1977." *Journal of Pacific Studies*, vol. 3, 1977, pp. 1-21.

Satake, Masaki, and Mary Angeline Da-anoy. *Filipina-Japanese Intermarriages: Migration, Settlement, and Multicultural Coexistence*. Mekon, 2006.

Takeda, Satoko. *Mura no Kokusai Kekkon Saiko*. Mekon, 2011.

Takahashi, Hitoshi. "Sumai no Kyoikuteki henseigensetsu no henyo." *Ikuji gensetsu no shakaigaku*, edited by Mutsuko Tendo, Sekaishisosha, 2016, pp.134-158.

Yamamoto, Matori, and Yasushi Yamamoto. *Girei toshiteno Keizai*. Kobundo, 1996.

Chapter 3

May: **Mothering in Space and Place, Painting, and Poem**

Wanda Campbell

A ssuming the role of a mother may lead to seeing "mothering" everywhere in life, in literature, and in art. A poem that responds to a specific work of art is called *ekphrasis* (Greek for "telling in full"), defined by James Heffernan as "the verbal representation of visual representation" (3), which "speaks not only *about* works of art but also *to* and *for* them" (7). The ekphrastic poet is akin to the experimental geographer, whose task it is to alert us to what is directly in front of us "in a manner that deploys aesthetics, ambiguity, poetry, and a dash of empiricism" by creating a conversation between painting and poem (Nato Thompson qtd. in Eliza Scott 52). What follows is a discussion of the painting *May* by Alex Colville and the poem I wrote in response to it, and how together they enhance our perception of motherhood.

Painting

May is one of twelve small square paintings (20 x 20cm) that Canadian artist Alex Colville (1920-2013) produced for a portfolio titled *The Book of Hours: The Labours of the Months* (1979)—a contemporary take on the medieval tradition of illuminated calendars such as *Très Riches Heures du Duc de Berry* (c.1412). My choice to interpret this painting through the lens of maternal geographies was influenced not only by Colville's use

of the word "labours" for the collection and "may" for the painting (a title reminiscent of the childhood game "Mother May I?") but also by the evocative relationship in the painting between the reclining female figure and her surroundings. In 1973, Colville moved to Wolfville in the Annapolis Valley of Nova Scotia, the agricultural setting behind these seasonal images, which Colville describes as "activities in environments" (2). The model Colville most frequently used for the female figures in his pictures was his wife Rhoda (Wright) Colville, his muse and the mother of his four children (Burnett 200). *May* features a woman wearing a pink top and brown skirt lying on top of a stack of logs held in place by sapling poles. Colville's paintings often include a manufactured object juxtaposed with a natural setting, and one assumes the logs are on a logging truck though the truck is not visible. Her bare feet dangling over the edge lead the eye down to a glimpse of a hillside with a patch of lighter green, perhaps indicating the clear cut where these logs were harvested. The load of felled logs dominating the painting looks much higher than the hill behind it, as if the woman could easily reach out and touch the clouds, but this is only an illusion of perspective, since human activity is never bigger than the environment shaping it. According to Colville, this work, like the others in the series, is organized on a geometric system, specifically the "circle-in-the-square" (2). Like Leonardo Da Vinci's *Vitruvian Man* (c. 1490), which contains both circle and square, Colville's paintings reveal his deep interest in proportion and the microcosmic relationship between the human body and the natural world. Michael Dear distinguishes between creativity *in* place, which refers "to the role that a particular location or time-space conjunction, has in facilitating the creative process," and creativity of place, which refers "to the ways in which space itself is an artifact in the creative practice.... The simplest creative acts are fraught with geographies that instruct the spectator how to see, but also hide things from us" (9). Colville's image is both in and of a specific place, and it both reveals and conceals what the woman is doing there.

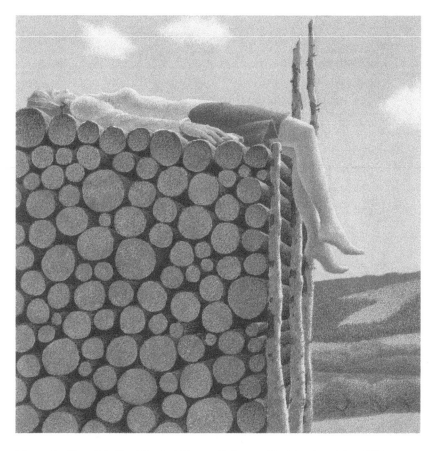

Figure 1: Alex Colville *A Book of Hours – Labours of the Months* – May 1974
Copyright A.C. Fine Art Inc. Image used with permission.

Poem

May (Alex Colville, 1979)

Dreaming of big and little hands she's held,
the mother lies exhausted on top of
all of the months and minutes she has felled
in over fifty years of life and love.

Maybe if she knew before she started
about all the labour that lay ahead
she might not tackle terrain uncharted
or feel the pea beneath her wooden bed.

She has lost count of rings including those
of tree and telephone, siren and sigh.
She sees the golden one she wears and knows
every ring puts her closer to the sky.

Each load of moments waiting to be milled
becomes lumber others will use to build.

My sonnet is an ekphrastic response to Colville's *May*, in which I assume the place is the Annapolis Valley surrounding his wife's home town of Wolfville where they lived until Colville's death in 2013 and where I myself raised three children and still live. I also imagine that the woman is a mother resting after long "labours" of bearing and rearing children. Because Colville's favourite model was his wife, whose children were all born in the 1940s, I interpreted *May* as an image of the aftermath of active motherhood. In the opening quatrain, I associate the challenging, one could say Herculean, labours of the mother not just with a single seasonal cycle but with a labour of years, more akin to forestry than farming—because trees, like children, take years to come to maturity.

I found the unusual low-angle perspective and Colville's use of space within the square canvas reminiscent of Edmund Dulac's 1909 illustration for "The Real Princess" or "The Princess and the Pea." Two female figures—Dulac's atop a stack of mattresses and Colville's atop a stack of logs—are both engaged in proving their worth. Motherhood is a long and unpredictable journey that one might not have attempted

if one had known the labours of love required. Although each row of logs puts the mother closer to the sky and the completion of her task, she can still feel the ache of her chosen role.

The third quatrain focuses on rings—the tree rings highlighted by the stacked circles of the cross-section of felled logs, the gold ring that traditionally marks the beginning of a new family unit, and the many auditory rings a mother must navigate in the raising of her children through time. A mother who has spent years pruning and tending must then hand on her offspring to others who will remake them just as trees are remade by the hands of others after they are felled or uprooted from their native soil. A mother invests in children in a certain geographical space until—infused like wine with the terroir that shaped them—they leave to make their way in the wider world. Colville believed that "the capacity to respond to actual life experience may be heightened by the contemplation of art" (Colville 1), and participating in dynamic conversations between art and audience with our own voices expands our understanding of how mothers are presented and represented through time and space.

Works Cited

Burnett, David. *Colville.* Art Gallery of Ontario, 1983.

Colville, Alex. *May* in *The Book of Hours: Labours of the Months.* Mira Godard Gallery, 1979.

Dear, Michael. "Creativity and Place." *GeoHumanities: Art, History, Text at the Edge of Place,* edited by Michael Dear, et al., Routledge, 2011, pp. 9-18.

Dulac, Edmund. *The Real Princess* in *Stories from Hans Andersen.* Hodder & Stoughton, 1911.

Heffernan, James. *Museum of Words: The Poetics of Ekphrasis from Homer to Ashbery.* University of Chicago Press, 2004.

Scott, Emily Eliza. "Undisciplined Geography: Notes from the Field of Contemporary Art." *GeoHumanities: Art, History, Text at the Edge of Place,* edited by Michael Dear, et al., Routledge, 2011, pp. 50-60.

Chapter 4

Mothering, Geography, and Spaces of Play

Laurel O'Gorman

After graduating from university, my first job was doing public health research designed to help combat childhood obesity. I went into this work quite enthusiastically; after six years of studying, I finally had a real grown up job. However, throughout the research, I kept seeing instances in which mothers were being blamed for their children's bodies, and I began to distrust the data linking fat bodies to an array of health conditions. After doing extensive research on the subject, I realized there was an entire body of academic literature that found substantial evidence that fatness has many complex causes, that bodies are meant to come in all sorts of shapes and sizes, and that the links between fatness and health are much more complicated than the public health discourses suggest (Gard and Wright; Boero; McPhail; Flegal et al.).

Canadian government documents on childhood obesity often focus on specific groups—such as Indigenous children (Greenwood and de Leeuw), rural populations (McPhail et al.; Statistics Canada), and families with low socioeconomic status (Brunner et al.; Clarke et al.; Sobal and Stunkard). When fatness is seen as a social problem and when particular groups are deemed to be more at risk, these groups are constructed as a "problem population" (McPhail). The research and policies implemented to prevent and combat childhood obesity end up replicating these ways of understanding the issue by reinforcing these discourses. For instance, they reinforce mother-blame by focusing on the mother's role in providing specific types of food, limiting screen

time, and enforcing daily exercise (Bell et al.). In my doctoral research, I wanted to investigate the ways that these dominant understandings affected mothering work for low-income single mothers in Northeastern Ontario, Canada.

To better understand how single mothers experienced mothering work in the context of childhood obesity discourses, I did interviews and neighbourhood tours with twenty low-income single mothers who resided in Northeastern Ontario. I recruited participants through social media and by putting up posters in grocery stores, community centres, and food banks throughout the region.

When I began this research, I was expecting the focus to be on food and foodwork. While I had questions about play and physical activity—such as "tell me about the spaces where your children play"—there were far more questions about meal planning, grocery shopping, and cooking than there was on children's play activities. Similarly, for the second part of the data collection, which involved going out into the neighbourhood with participants, I asked them to take me where they usually go to get food. Participants were not interested in going to grocery stores. The first two participants to bring me to a grocery store asked something along the lines of "do we have to go inside?" I spent a lot of time thinking about why this was; I questioned whether they were concerned about being judged by me or by the other people in the store. This may have been part of it, but when I asked the next participant about her reluctance to go to the grocery store, her response was that she hated being there and preferred to avoid it.

The participants who were reluctant to go to a grocery store were more than happy to take slightly different trips. They brought me to the neighbourhood park, past arenas, and community centres. They showed me which playgrounds their children liked, which they did not like, and explained some of the reasons why. They talked about areas that they felt were safe for their children and areas that were not. As a result, a lot of the focus of my research shifted from food to the spaces where children play. In these public spaces, mothers must negotiate the areas that are considered adequate for play and the ability of children to play free from safety risks (Valentine and McKendrick). Because mothers are primarily responsible for the reproductive labour involved in raising children, they are ultimately considered to be responsible for negotiating the spaces where children play (Mitchinson).

In this chapter, I will discuss some of my findings on how low-income single mothers negotiated the spaces where their children played—including how understandings about health and obesity, social norms, and perceptions of risk and safety regulate and organize the places where children play. For low-income single mothers, this negotiation is affected not only by geography—particularly whether the area is rural, urban, or something in between—but also by racism and other forms of discrimination in public play spaces.

Northeastern Ontario has a few cities, many small towns, and a lot of sparsely populated rural areas. Of the twenty participants I interviewed, eleven lived in cities of fifty thousand or more (three of whom previously lived in rural areas), three lived in smaller towns (between five thousand and forty-nine thousand people), and six lived in rural areas or towns with fewer than five thousand people. Ontario government research describes rurality as a barrier to accessing healthy foods and leisure activities, especially when families have limited financial resources (Healthy Kids Panel). However, academic literature on rurality has also emphasized some of the strengths of living in rural areas when it comes to health-maintenance behaviours. For instance, it may be easier to grow fresh food in rural areas than in urban areas, and it is perceived as safer for children to play outside (Beagan et al.; McPhail). It was important for me to demonstrate some of these strengths in my research as well as to describe some of the barriers for rural participants.

Play and Children's Health

All my participants talked about unstructured play. There were few barriers to play—the main one being perceptions of safety. Electronics as a competing interest was also mentioned as a barrier to play, and the presence of friends and playmates in the area was seen as a facilitator to play. When I asked what it means to be healthy, physical activity came up in every interview. It was often the first thing said, or it came second, after food. For instance, Laura said: "The term healthy child would probably mean a child that gets exercise on a daily basis." Sara said, "I don't want to say exercise but play." Laura was clearly noting the health benefits of physical activity but also acknowledging that physical activity can be fun: "He [her son] probably didn't realize he

was getting exercise because it's fun. And it wasn't a chore. He wasn't doing it because 'I have to do this' or 'I'll be healthier if I do this.' That takes the fun out of it" (Laura).

Several participants discussed a shift from unstructured play that they experienced as children to the pressure today for more participation in organized recreational activities. The idea that many children do not just play outside like "we" used to was a common theme in my interviews. As Chantal noted, "we were raised by the streetlights … whether it was at the park or with our friends in the yard. Doesn't matter, we were outside playing. We weren't sitting in front of TVs."

Others discussed wishing their children could experience this type of freedom but felt as though the culture had shifted, particularly in urban areas: "I gave him my phone once to play Pokémon Go and he was gone for an hour. And I got nervous. How do you not be a helicopter parent? I remember being gone for hours and hours and hours. Literally. Being gone forever, playing around, making clay pots in the woods, climbing trees. There is so much anxiety around parenting now" (Amanda). It is important to note that memories of one's childhood can be influenced by recall bias and by the blending of memories and retelling of memories and common childhood narratives over time (Göttlich). Still, mothers felt that they needed to be more involved in deciding where and when their children could play than their mothers were when they were young.

For almost all participants, having friends that live nearby for the children to play with facilitated outside play. Lyne, who lives in a rural neighbourhood where there are a lot of children who are the same age as her two boys, said, "They are playing with their friends … and it's intense, and they do it for a long time, like they're out there more than they're in the house in nice weather." For Lyne, living in an area filled with young children playing together was a benefit of living in her neighbourhood; it helped make up for some of the drawbacks, such as having to drive for forty-five minutes to get to the sports complex and to the grocery store. When there were other children playing outside in the neighbourhood, children were far more likely to play outside.

Perceptions of Safety and Fear for Youth

Although most participants had some access to safe spaces for their children to play outside—such as neighbourhood parks, school grounds, or a backyard—many also discussed safety concerns with respect to unstructured outside play. For many of the participants in urban centres, safety concerns centred around "stranger danger" and crime. For many rural participants, safety concerns had to do with the physical environment, such as a highway, train, or body of water. This chapter refers to mothers' perceptions of safety and danger with respect to children's play, not of actual risk.

In his book on children's participation in sports, Michael Messner suggests that cultural fears surrounding childhood are typically either fear of youth or fear for youth. Fear of youth is the idea that young people, especially teenagers, are destructive or dangerous. Fear for youth is the idea that children are inherently more vulnerable than adults, especially to strangers. Both of these fears came through in my interviews but, as previously noted, in different ways for rural than urban areas.

Participants in urban centres with populations of between 50,000 and 160,000 described such safety concerns as strangers, drug use, and violent crime:

We had an incident yesterday with a boy who was like ten [years old] flipping a knife out at some girls. (Vanessa)

We lived in a horrible neighbourhood. Horrible. Like crime every other day. Sometimes, I wouldn't even let them play in our own yard because there was just so much stuff going on. (Stacy)

The kids couldn't play there at all ... lots of drug paraphernalia on the ground, needles, everything. (Sylvia)

One described having a yard that was not safe for her children to play in, although she did not know that when she moved in. Sylvia said, "I can't allow the kids to play in the yard because the last people who were here decided to put carpet down through the whole entire yard and under the carpet was scrap metal and they bolted it into the ground so we're finding pieces of steel, rusty beams sticking up out of the ground and everything." Not all urban participants described this

type of fear, but it was a common theme throughout urban interviews.

Participants in small towns and rural areas were more likely to describe the environment as dangerous and people around them as protective factors. Lyne described how her children must cross a busy highway to get to the area where they like to play: "In order for the kids to get to a park quickly, they need to be on the highway and we don't have a crosswalk. Our community centre is across the highway... our corner store was across the highway up there. The launching dock where the kids go swimming, some of them go fishing, is across the highway." Natalie said that her children could not ride bikes to get around the neighbourhood because their town was built into a large hill: "We have bicycles and they tried to ride, but the hills here, they can't ride a bike.... They fall and give up. I wish they'd learn how to ride a bike because they'd have more freedom, but with the hills and stuff, they won't do it." Sara lived next to train tracks, and everything was on the other side of the tracks. She recounted times that she was forty minutes late waiting for the train to pass, and she worried about her kids being trapped on the other side of the tracks when they are coming home from the park: "Sometimes in the morning we are waiting an extra forty minutes, because the bus is stuck on the other side of the train."

Whereas many of the more urban participants described a fear of strangers (though not all of them did), many participants in small towns (under approximately five thousand people) and in very rural areas described other people in the community as protective factors, who made them feel safer about their children being outside:

> And other people, like the guy two houses down, he doesn't have little kids, but he's sent my kids home because he isn't happy with their footwear while they're riding their bikes or something like that...It is fabulous, everybody is kind of looking out for one another. (Lyne)

> It's a really nice area. There are lots of kids around and we know our neighbours... yesterday, my neighbour came over with tickets [to the circus] and she said let's go. (Natalie)

Perceptions of Safety and Fear of Youth

Several participants discussed how spaces for children's play were used by teenagers. Although one parent said that the teenagers were always accepting of their children in the shared space and even helped her son learn to ride a skateboard at the skate park, others experienced teenagers as a barrier to play. Paula said, "[This park] doesn't look like teenagers are hanging out there at night smashing bottles and stuff. The other park down by the water tower is a little bit more like that. You can see more older kids hanging out there and stuff, so I try not to take them there that much."

Kayla brought me to a park near her house where teenagers like to hang out. She did not find it safe for young children to play there because of the condition the park was in; there was broken glass throughout the park, including on the slide. The park was covered in graffiti. It had a skate park area that had several large holes on the paved ramps. These holes would be very difficult to avoid on a skateboard, bicycle, or scooter, which made it too dangerous to use. She suggested that there may be less broken glass if there were more things for teens to do in the area, but the nicer facilities are on the other side of town. There was an old trailer next to the park covered in spray paint, which she said was going to become a youth drop-in centre at some point but was not sure when. It was clear that safety—including the physical environment, perceptions of crime levels in the area, and whether the people around them were considered potentially dangerous for or protective of their children—all factored into which spaces mothers allowed their children to play in and whether adult supervision was required.

When I asked Kimberly, who had moved from a small First Nations community to one of the larger cities in the north, if she found the area safe, she challenged my ideas about safety in a really interesting way. She discussed how, in the small community, her children were outside playing and walking from her house to her parents' house or to one of her friends' house, or just playing in the woods:

Some people may think letting them venture in the woods would be unsafe with bears and whatnot ... My son has a couple of pellet guns, so he will take cans from the recycle bin, he'll pack ... his lunch box with snacks and he'll go to the bush.... Now if he said

he was going to the mall with a couple buddies, I'd be worried. I don't know what it is; other people would be like ok, go hang out at the mall. I'm more concerned about what's going to happen there or who's going to say something or whatever it might be. Whereas in the bush, I know it's him and the bush, and I know he's ok out there.

This story exposes how ideas around safety, including which activities are considered to be safe and which are not, are culturally constructed and vary in different families, cultures, and communities. She mentioned that racism in her current community influences the decisions she makes with respect to mothering her children in many ways. When he is at the mall or in other public spaces, she was worried that her son may be judged negatively by people around him, including peers, mall employees, and even the police.

Intersections of Race and Class

Natalie, a Black woman from a small, predominantly Caucasian, town described issues with play, safety, and racialization:

My oldest son said to me this year, "I don't want you to come because people are going to make fun of me because you're brown, so stay outside." So now I don't go to the school on behalf of my son.... As they're getting older, the racism is getting worse and worse and worse. You can't come to my birthday party because my mom doesn't like your colour. So that's another huge issue in this community. (Natalie)

She mentioned other difficulties that she faces as one of the only people of colour in her town, such as being followed around at stores and being refused service at a restaurant. She was also concerned that her sons might get in a lot of trouble for things that their white friends might get away with as they get older. She tried to negotiate watching them more closely because of the racism they are exposed to with trying not to be too visible to her children's friends.

When there were other children playing outside in the neighbourhood, children were far more likely to play outside. In both urban and rural areas, participants commented that children in lower income

neighbourhoods seem to be more likely to play outside than those in wealthier neighbourhoods:

> I don't know if all low-income neighbourhoods are like this because this is the first one I've ever lived in, but the kids know how to play. They are outside from sun up to sun down and beyond sometimes, which I don't necessarily agree with. But it's a huge community thing ... the kids play area is unfortunately the middle of the street, but it's also nice to see at the same time. (Vanessa)

Like several other participants, she had mixed feelings about children playing outside. She said that it is nice to see the kids playing outside, while, at the same time, noting that she doesn't always approve of when or how the kids are playing. Lyne noted the difference between how children play in her (rural, low-income) neighbourhood compared to her ex-husband's (urban, high-income) neighbourhood: "Their dad and stepmom live in a very rich neighbourhood. And kids just don't seem to be encouraged to go play outside. I have been booting my children out since they were very young, mainly because I needed a break from them. I need to clean my house, you're in my way, please go play outside."

The ways that children play outside was affected by feelings of judgment. Participants described not letting their kids play in certain areas because they do not want neighbours to judge them. For example, Claire talked about taking all four of her children to play outside in her small community: "We play on the street, and they do their bikes and stuff, but I have to be out there and watching because of cars. And it's not really that enjoyable for me. I always feel like people are staring at me" (Claire). In neighbourhoods where there are always children playing outside, it may be less conspicuous for mothers to just let their children go play on their own.

Perceptions of safety have also affected the ways that children can play in certain communities due to policies. For instance, some cities have banned road hockey due to safety concerns. Two of my participants discussed rules governing play that were implemented by their housing co-ops, with one saying: "We recently received a letter stating that children are not allowed to scooter in the parking lot, play sports with balls, or pretty much do anything.... And I personally am not

following these rules because I find them ridiculous" (Rachelle). These participants described getting letters from the housing's board of directors about things like leaving children's toys outside, kids playing too roughly, or playing with balls outside. They both described this as not having a lot of impact on how their children play because they ignore the policies in a lot of ways. However, one of the letters I was shown said that if they do not change the behaviour, the potential consequences they may face include eviction, so kids playing outdoors in the wrong ways could lead to serious consequences for the family.

Conclusion

In this chapter, I have described some of the ways that mothers negotiated children's play spaces, including the locations where they play, when they play, and how they play. Far from being a simple practice of just letting children go outside to play, mothers actively negotiate which spaces children can use for play, at which times, and for which specific activities. I have also demonstrated some similarities and differences between rural and urban mothers in Northeastern Ontario, including whether people around them are seen as a threat or a protective factor. These spatialized practices are so taken for granted that they are not explicitly thought about but are still made based on many assumptions about children's safety, understandings of health, normative judgments, the built and natural environments, and various other considerations.

Endnotes
1. I would like to thank Dr. Jennifer Johnson, Dr. Diana Coholic, and Dr. Susan James for all their assistance.
2. All names are pseudonyms.

Works Cited
Beagan, Brenda, et al. "'It's Just Easier for Me to Do It': Rationalizing the Family Division of Foodwork." *Sociology*, vol. 42, no. 4, 2008, pp. 653-671.

Bell, Kirsten, et al. "Medicine, Morality and Mothering: Public Health Discourses on Foetal Alcohol Exposure, Smoking around Children and Childhood Overnutrition." *Critical Public Health*, vol. 19, no. 2, 2009, pp. 155-710.

Boero, Natalie. "All the News That's Fat to Print: The American 'Obesity Epidemic' and the Media." *Qualitative Sociology*, vol. 30, no. 1, 2007, pp. 41-60.

Brunner, E.J., et al. "Social Inequality in Coronary Risk: Central Obesity and the Metabolic Syndrome. Evidence from the Whitehall II Study." *Diabetologia*, vol. 40 no. 11, 1997, pp. 1341-1349.

Clarke, P. et al. "Social Disparities in BMI Trajectories across Adulthood by Gender, Race/Ethnicity and Lifetime Socio-Economic Position: 1986-2004." *International Journal of Epidemiology*, vol. 38, 2009, pp. 499-509.

Flegal, K. M., et al. "High Adiposity and High Body Mass Index-for-Age in US Children and Adolescents Overall and by Race-Ethnic Group." *American Journal of Clinical Nutrition*, vol. 91, no. 4, 2010, pp. 1020-1026.

Gard, Michael, and Jan Wright. *The Obesity Epidemic: Science, Morality and Ideology*. New York: Routledge, 2005.

Göttlich, Andreas. "'When I Was Young': The Idealization of the Interchangeability of Phases of Life." *Human Studies*, vol. 36, no. 2, 2013, pp. 217-233.

Greenwood, Margo Lianne, and Sarah Naomi de Leeuw. "Social Determinants of Health and the Future Well-Being of Aboriginal Children in Canada." *Paediatrics & Child Health*, vol. 17, no. 7, 2012, pp. 381-384.

Healthy Kids Panel. "No Time to Wait: Healthy Kids Strategy." *Ontario Ministry of Health and Long Term Care*, 2013, www.health. gov.on.ca/en/common/ministry/publications/reports/healthy_ kids/healthy_kids.pdf. Accessed 11 Oct 2018.

Lupton, Deborah. "The Pedagogy of Disgust: The Ethical, Moral and Political Implications of Using Disgust in Public Health Campaigns." *Critical Public Health*, vol. 25, no. 1, 2015, pp. 4-14.

McPhail, Deborah. "Resisting Biopedagogies of Obesity in a Problem Population: Understandings of Healthy Eating and Healthy Weight

in a Newfoundland and Labrador Community." *Critical Public Health,* vol. 23, no. 3, 2013, pp. 289-303.

McPhail, Deborah, et al. "The Rural and the Rotund? A Critical Interpretation of Food Deserts and Rural Adolescent Obesity in the Canadian Context." *Health & Place,* vol. 22, 2013, pp. 132-139.

Messner, Michael. *It's All for the Kids: Gender, Families, and Youth Sports.* University of California Press, 2009.

Mitchinson, Wendy. "Mother Blaming and Obesity: An Alternative Perspective." *Obesity in Canada: Critical Perspectives,* edited by Deborah McPhail, University of Toronto Press, 2016, pp. 187-217.

Sobal, Jeffery and Albert J. Stunkard. "Socioeconomic Status and Obesity: A Review of the Literature." *Psychological Bulletin,* no. 105, no. 2 1989, pp. 260-275.

Statistics Canada. "Overweight and Obesity in Children and Adolescents: Results from the 2009 to 2011 Canadian Health Measures Survey." Statistics Canada, 2015, https://www150.statcan.gc.ca/n1/pub/82-003-x/2012003/article/11706-eng.htm. Accessed 4 Mar. 2019.

Valentine, Gill, and John McKendrick. "Children's Outdoor Play: Exploring Parental Concerns about Children's Safety and the Changing Nature of Childhood." *Geoforum,* vol. 28, no. 2, 1997, pp. 219-35.

Chapter 5

Spatial Practices of Care, Knowledge, and Becoming among Mothers of Children with Autism

Karen Falconer Al-Hindi

Introduction

Controversy surrounds every aspect of autism—from its diagnosis, therapy, and treatment to its implications for society. Underlying some of these controversies is the tension around whether autism is a condition that can be ameliorated or whether autism is characteristic of certain human beings in the way that, for instance, cerebral palsy can be (compare with Clare). Among the most controversial responses to an individual's exhibition of autistic-like behaviours or diagnosis is biomedical intervention. The moniker "biomed mom" is sometimes embraced by mothers who believe that autism (autism spectrum disorder) has a complex etiology and that this etiology—not a lack of scientific evidence—is the reason why biomedical interventions that heal one child with, say, gastrointestinal distress, may not help another. This relatively small but significant group of mothers of children on the autism spectrum is the focus of this chapter.

In the 1950s, as today, many mothers were blamed for their children's apparently voluntary withdrawal from the world (Waltz), but during the same period, a few parents implemented changes that

lessened their children's autistic behaviors (Rimland). Today, many families make changes, termed biomedical interventions, in their children's lives that result in improved function; some of these children ultimately lose the diagnosis of autism (McCarthy and Kartzinel). The defining criteria for an autism spectrum disorder diagnosis are deficits in communication, behavior, and social interaction as compared with typical developing peers. Today one in every sixty-eight American children is affected by autism; the number for boys is one in forty-two (Centers for Disease Control and Prevention).

Biomed moms are persuaded that some of their child's autism symptoms, at least, may be lessened by remediating some aspect of their child's physiology; this distinguishes them from other "autism moms" who believe that autism is innate. Kim Stagliano, mother to three girls on the autism spectrum, defines biomedical treatment as the following: "Autism treatments that include the use of prescription and nonprescription medications, supplements, diet, and other alternative methods to treat the physical manifestations of autism spectrum disorder with the assumption that addressing the physical issues will lead to an improvement in the behavioral and psychological symptoms" (219). In implementing these treatments, these biomed mothers position themselves outside the boundaries of conventional parenting for neurotypical children as well as for children with autism, what Rachel Robertson has termed "misfit."

The data about biomed mothers' spatial practices come from biomed moms' autobiographical writings, which are available in published, printed form (as opposed to, say, on social media). As Patty Douglas argues, their first-person narratives may function as case histories (107), and they represent an existing data source that scholars should use before asking for more of this population's precious time. Interviews, for example, can be a fine source of information and may even be empowering, but they are an imposition (Gill and Liamputong; Landsman). Furthermore, for autism mothers, eliciting the type of information required for the present study may add to their distress (Pengelly et al.). Following extensive reading and notetaking, written pieces were selected from a much larger number of autism mothers' narratives because they focus on their experiences with children around biomedical intervention. As such, excerpts from these writings are illustrative, not representative, which is suitable for research that

offers a theoretical conceptualization of such a phenomenon as mother-led biomedical intervention.

In this chapter, I argue that this subset of mothers of children on the autism spectrum create, use, and hold open new physical, meta-phorical and virtual spaces for their children, themselves, and others, which sustains a rhizomatic community that supports families pursuing biomedical intervention and recovery. The next section develops the idea of the "rhizome" (after Deleuze and Guattari), as mothers search for ways to help their children. In the section that follows, biomed moms' words convey their early experiences with their children's differences. Encounters with information about biomedical intervention empower some mothers to create and use spaces in specific ways, and these are illustrated in the following section. The conclusion enlarges the vision of the biomedical intervention rhizome and revisits the point that biomedical intervention is controversial and is only one among many paths that mothers follow in an effort to aid their children.

Conceptualizing Biomedical Intervention

A dizzying array of potentially helpful interventions in the life and geography of a child diagnosed with autism are available. Biomedical (e.g., dietary change) is just one. Others include developmental (e.g., Relationship Development Intervention), behavioural (e.g., applied behavioural analysis), structured teaching (e.g., social stories), and clinical therapy (e.g., speech therapy) (Wiseman). Some mothers cannot, or elect not to, intervene. Although all of the responses listed require intensive mothering, I focus here on mothers' deployment of spatial strategies of evaluation, learning, and treatment when they use biomedical intervention with their children.

Biomed families are just one group within the millions of people affected by autism. There are many other groups with diverging beliefs about autism spectrum disorder; there are too many to mention here, but I wish to highlight two. In addition to biomed moms, a second group is composed of people who feel that autism is one kind of "brain difference," one form of neurodiversity among many, which should be accommodated and ultimately celebrated (Davidson and Orsini). Although some biomed moms are also neurodiversity advocates, other

neurodiversity supporters regard attempts to change people with autism as morally wrong (Jack). A third group merits attention as well: those who view autism as primarily a social construction, or a linguistic or communication phenomenon (McGuire; Runswick-Cole et al.; Nadesan). These along with other groups within the broadly defined world of autism offer important analyses.

Despite the wide variety of perspectives and approaches available, biomed moms feel the urgency of providing medical and nutritional support to their children and regard autism as a clinical illness. Ken Bock, MD, describes one such sick child: "He had numerous food allergies, gross deficiencies of many nutrients, and excesses of others... Despite the roundedness of his yeast-infested, allergy-inflamed belly, the cells in his body and brain were starving" (Bock and Stauth 26). Following the biomedical intervention implemented by his mother, her son, Paul, on his fourth Halloween, "dressed up in costume and went trick-or-treating for the first time" (Bock and Stauth 27). Children with autism are as reliant on their mothers for help as they would be with an injury such as a broken leg. Andrew Zimmerman, for example, has written about how he recovered thanks to his mother's biomedical intervention. For Andrew, dietary changes and nutritional supplements brought about particularly notable improvements in behavior, communication, and social interaction.

How are we to conceptualize this group of autism mothers as spatial agents and practitioners of a specific sort of intensive mothering? To make sense of these mothers' work and the spaces they inhabit, use, and transform, the scholarship of Gilles Deleuze and Felix Guattari is helpful. Conventional mothering with neurotypical offspring falls largely within a range of expected and usual parenting behaviours (though constrained by gendered, classed, and racialized norms). The practices of biomed moms, in contrast, would be termed "molecular" in Deleuzo-Guattarian parlance, and their decisions and actions move such mothers along unique paths in new directions, termed "lines of flight." For these scholars, "a line of flight" moves towards "innovative ideas and unusual notions" and "mark[s] new ways of thinking" (Moss and Falconer Al-Hindi 13). As such, these mothers' work is creative and positive; it produces new knowledge, relationships, resources, and other things (such as nonprofit autism organizations).

Furthermore, Deleuze and Guattari's notion of the "rhizome" is

useful. As they find themselves moving away from some settings—such as regular classrooms, doctors with conventional views, and playgroups—and towards alternative educational settings, autism-aware doctors, and other parents pursuing biomedical intervention, parents forge new connections that may be described as "rhizomatic": "The rhizome pertains to a map that must be produced, constructed, a map that is always detachable, connectable, reversible, modifiable, and has multiple entryways and exits and its own lines of flight" (Deleuze and Guattari 21). Multiple entries and exits are particularly salient given the many contributing factors in autism and the many possible routes to improvement (Wiseman). Perhaps a chance encounter with one knowledgeable professional leads to others (Bock) or a search of the Internet leads to a biomedical interpretation of a symptom (McCarthy) or a perusal of the library shelves leads to a treatment guide. No one is in charge of the rhizome; there is no hierarchy or central control (as there is, for example, with the American Academy of Pediatrics). The relationships mothers establish among themselves, as well as with helpful professionals and autism-friendly resources, are the lines connecting any point to any other point within the rhizome (e.g., Ryan and Runswick Cole).

Social Spaces and a Diagnosis of Autism

Parents often become aware of their child's differences, and the possibility of an autism diagnosis, by the responses of other family members, other children's parents, teachers, or even strangers to the child's unexpected behaviour in spaces, such as homes, preschools, playgrounds, and grocery stores. Denise Brodey, mother of a boy named Toby, found herself running interference between Toby and other children who tried to play with him: "On the playground ... I was the mom explaining to another child that... Toby had a 'space bubble' around him ... then [I would] tiptoe around him... pointing and poking at the imaginary bubble" (12). Denise actively created a safe zone for her son rather than just supervising him. Children's and parents' experiences in such environments transform the spaces' meanings for them and proximate others. For example, far from an unmarked space, shopping in the grocery store becomes "like a giant game of chess. You have to think several moves ahead to ward off potential problems" (Stagliano 22).

Of course, all mothers of children with autism want optimum health and improved function for their children. Leigh Ann Wilson's expression of pain around her child's rejection as well as her own, is common among autism moms. The experience pushed her away from the parents of other children and the classroom, and towards other parents whose existence she might not have discovered otherwise: biomed moms. Leigh Anne describes "watching my baby get rejected by peers as he whirled and shrieked around them, after watching him get expelled from school and listening to the parents of his classmates express relief *to my face* that he was away from their children" (my emphasis, Wilson 153).

The experiences of Brodey, Stagliano, and Wilson set them apart from the parents of typical developing children (Zibricky). As each mother moved along her own line of flight, she became different from the person she was, even moments before, as she entered into and enlarged the connectivity and spatiality of biomedical intervention. She also moved away from conventional mothering and mothers. This process leads to a deterritorialization—the loss of space for being and doing. In the rest of the chapter, I follow biomed moms and one medical doctor as they encounter evidence for, find support from, and discover rhizomatic connections with biomedical intervention into autism.

The Spatiality of Biomedical Interventions and the Hope of Recovery

Dr. Bernard Rimland diagnosed his son with severe autism. His 1964 book *Infantile Autism* helped to debunk the notion that "refrigerator mothers" (those who were perceived as emotionally distant from their children) were to blame for their children's withdrawal. Rimland told how he first learned about what was later called biomedical intervention:

> Somewhere in my files are the letters from an Air Force family whose autistic daughter showed great improvement when the family was transferred to northern Canada, in the mid-1960s ... on the family's return to the Midwest [in the United States of America] ... the daughter's severe autism returned. Strange! The answer: the autistic girl could tolerate reindeer milk, the only kind available, but not cow's milk!

Two aspects of Rimland's story are important. First, without the move to Canada and subsequent return to the United States, the family might never have discovered how to help their daughter. Theirs was an accidental spatial intervention. Second, Rimland believed the story. This doctor's validation established the precedents for both biomedical intervention and for clinicians to listen to parents. At the same time, it added rhizomatic connections within the biomedical intervention community.

Information about biomedical intervention is available in books and newsletters, on websites, and via social media, but person-to-person contact is especially important. Michelle Woods's son experienced internal bleeding and severe autism, so she "went to the [biomedical intervention] conference and that was it [and] everything was different from then on" (67-68). Woods's participation in the conference established a connection between her line of flight and the rhizome that is biomedical intervention.

Travel to a conference is impossible for many full-time caregivers. Instead, Lisa Ackerman, mother of a boy named Jeff, transformed her home into a respite and education centre: "I began a support group in my living room with only ten parents ... and we gave each other action items to do or try out. I call these people 'the first ten' because ten people quickly turned into sixty people... So we moved and called ourselves TACA, for Talk About Curing Autism" (101). Today, TACA serves over forty-five thousand families and has chapters in twenty-seven American states.

Mothers gain confidence as their children respond to biomedical treatment and as they advocate successfully with medical professionals (Altiere and Von Kluge). They create and inhabit space alongside, among, and between others' spaces for being and doing.

Drawn along their lines of flight, biomed moms consider and select from among various interventions (Yochim and Silva). The gluten-free and casein-free (roughly, wheat- and dairy-free) diet is among the most widely used (Carlon et al.). Changes such as these are difficult; they do not always result in improved health or function, and they may bring unwelcome changes to otherwise familiar meanings of a place. Nicole Yantzi and Mark Rosenberg, for example, found that the meanings of home become ambiguous for mothers of children with long-term care needs. As Kim, biomed mom to a very young child, relates: "Imagine

following your diapered toddler around the house for twelve straight ... hours while he wanders from corner to corner dry-heaving from withdrawal.... But after three days without the ... bread, cereal, and pasta ... he looked at me. I mean, really looked at me" (Spencer 285-286). Would Kim ever see her house the same way again? Could the child? The child's exhibition of new, more typical behaviours validated Kim's intervention and provided new knowledge.

Children's healing may involve other spaces as well. For example, Rebecca, biomed mother to a school-aged boy named Caleb, enlisted the help of his teacher and classmates: "One of Caleb's challenges is trying new foods ... So each day ... he has to try one of the lunch foods the Little School provides, in addition to the lunch I pack him" (Stern 132). The school becomes a space for enhancing Caleb's health through improved nutrition, which is part of his biomedical recovery.

Kim Spencer's biomedical intervention crossed multiple geographic scales—from the micro (their home) to the regional—as she identified and accessed interventions for her son:

I treated Patrick with diet and supplements.... The big miracle came when we were able to get an appointment with a ... specialist in Florida, a few hours away from us in Georgia ... we convinced a local integrative pediatrician to help administer IVs to pull out the heavy metals, get us into a hyperbaric chamber, and fine-tune his treatment plan. (Spencer 287)

Kim found herself moving along a unique path that crossed those of other mothers; the more relationships she forged with other parents and practitioners, the more supported, relocated, and regrounded she felt. This is a process of *reterritorialization*—the creation of a new space for being and doing (Deleuze and Guattari). Even though Kim's town may appear as the very same town, it had become a remarkably different place for Kim, as she and her son joined the rhizomatic biomedical intervention community.

Conclusion

Each family's autism journey is unique, and the reasons range from the structural inequalities of race, class, and gender to the many possible factors contributing to each individual child's manifestation of the

diagnostic criteria. But no family wishing to pursue biomedical intervention has to go it alone. Furthermore, a mother can pursue biomedical intervention while adhering to the ideas of the neurodiversity community, and can be persuaded that linguistic and communicative analyses of autism and people with autism are also important. Or she may participate more in one community at one time and less in another (compare, for example, Ryan and Runswick Cole with Runswick-Cole et al.). These multiple points of entry and myriad connections are invaluable.

In addition to guiding mothers towards one biomedical intervention or another, the biomedical intervention community offers children with autism spectrum disorder and their neurotypical siblings the chance to make friends. Beyond the biomedical approach, parents discuss different school placements and therapists; they even share tips about insurance coverage to make addressing their children's needs more affordable. Nonprofit organizations and even some for-profit companies offer grants. Above all, the rhizome can support mothers as they ascend the steep learning curve of biomedical intervention to begin healing their children (Bock and Stauth; Wiseman).

Mothers of children diagnosed with autism spectrum disorder are often blamed for the child's behaviors in specific places that become the basis for a diagnosis (McDonnell). In this chapter, I have argued, however, that those who seek to help their children may succeed by engaging in specific tactics of spatial praxis. For example, they use their homes as testing and treatment sites; they engage schools as evaluation and treatment spaces, and they travel hundreds of miles to get help from autism specialists. As important, they reach out to others for information, relationship, and to offer help. Biomed moms are rewarded by their children's progress and by their own sense that they have done everything to aid their children. Megan Davenhall, a biomed mom to a son named Rob, writes: "If you are like us and believe that your child can recover from autism, it will cost you everything.... It is worth every drop of blood, sweat, and tears because while autism has been transforming your child it has also been reshaping you" (277).

Eli Clare argues that treatment is welcome while the search for recovery may be interpreted as a desire for annihilation (of those with disabilities, including autism). The challenge for biomed moms—

indeed, for every mother—is to love their child as they are while offering treatment that may change "body-minds for the better" (76).

Works Cited

Ackerman, Lisa. "Mother Warrior to Jeff." *Mother Warriors: A Nation of Parents Healing Autism Against All Odds,* edited by Jenny McCarthy, Dutton, 2008, pp. 86-101.

Altiere, Matthew J., and Silvia Von Kluge. "Searching for Acceptance: Challenges Encountered While Raising a Child with Autism." *Journal of Intellectual and Developmental Disability,* vol. 34, no. 2, 2009, pp. 142-152.

Bock Kenneth, and Cameron Stauth. *Healing the New Childhood Epidemics: Autism, ADHD, Asthma, and Allergies.* Ballantine Books, 2007.

Brodey, Denise. "Taking Care of You." *The Elephant in the Playroom: Ordinary Parents Write Intimately and Honestly About the Extraordinary Highs and Heartbreaking Lows of Raising Kids with Special Needs,* edited by Denise Brodey, Hudson Street Press, 2007, pp. 45-49.

Carlon, Sarah, et al. "Parent Reports of Treatments and Interventions Used with Children with Autism Spectrum Disorders (ASD): A Review of the Literature." *Australasian Journal of Special Education,* vol. 38, no. 1, 2014, pp. 63-90.

Centers for Disease Control and Prevention. *Centers for Disease Control and Prevention CDC 24/7: Saving Lives, Protecting people.* CDC, 2012.

Clare, Eli. *Brilliant Imperfection: Grappling with Cure.* Duke University Press, 2017.

Davenhall, Megan. "Sunshine's Song." *The Thinking Moms' Revolution: Autism beyond the Spectrum,* edited by Helen Conroy and Lisa Joyce Goes, Skyhorse Publishing, 2013, pp. 267-281.

Davidson, Joyce, and Michael Orsini, editors. *Worlds of Autism: Across the Spectrum of Neurological Difference.* University of Minnesota Press, 2013.

Deleuze, Gilles, and Felix Guattari. *A Thousand Plateaus: Capitalism and Schizophrenia.* Foreward and translation by Brian Massumi. University of Minnesota Press, 1987.

Douglas, Patty. "Refrigerator Mothers." *Journal of the Motherhood Initiative*, vol.5, no. 1, 2014, pp. 94-114.

Gill, Jessica, and Pranee Liamputong. "'Walk a Mile in My Shoes': Researching the Lived Experience of Mothers of Children with Autism." *Journal of Family Studies*, vol. 15, 2009, pp. 309-319.

Jack, Jordynn. *Autism and Gender: From Refrigerator Mothers to Computer Geeks*. University of Illinois Press, 2014.

Landsman, Gail Heidi. *Reconstructing Motherhood and Disability in the Age of "Perfect" Babies*. Routledge, 2009.

McCarthy, Jenny. *Louder than Words: A Mother's Journey in Healing Autism*. Dutton, 2007.

McCarthy, Jenny, and Dr. Jerry Kartzinel. *Healing and Preventing Autism: A Complete Guide*. Plume, 2010.

McGuire, Anne. *War on Autism: On the Cultural Logic of Normative Violence*. University of Michigan Press, 2016.

McDonnell, Jane Taylor. "On Being the 'Bad' Mother of an Autistic Child." *'Bad' Mothers: The Politics of Blame in Twentieth-Century America*, edited by Molly Ladd-Taylor and Lauri Umansky. New York University Press, 1998, pp. 220-229.

Moss, Pamela, and Karen Falconer Al-Hindi. "An Introduction: Feminisms, Geographies, Knowledges." *Feminisms in Geography: Rethinking Space, Place, and Knowledges*, edited by Pamela Moss and Karen Falconer Al-Hindi, Rowman & Littlefield, 2008, pp. 1-27.

Nadesan, Majia Holmer. *Constructing Autism: Unravelling the 'Truth' and Understanding the Social*. Routledge, 2005.

Pengelly, Sue, Phil Rogers and Kerri Evans. "Space at Home for Families with a Child with Autistic Spectrum Disorder." *British Journal of Occupational Therapy*, vol. 72, no. 9, 2009, pp. 378-383.

Rimland, Bernard. *Infantile Autism: The Syndrome and Its Implications for a Neural Theory of Behavior*. Meredith Publishing Company, 1964.

Rimland, Bernard. "Foreword." *Special Diets for Special Kids*, by Lisa Lewis. Future Horizons, 1998.

Robertson, Rachel. "'Misfitting' Mothers: Feminism, Disability and Mothering." *Hecate*, vol. 40, no. 1, 2014, pp. 7-19.

Runswick-Cole, Katherine, et al. editors. *Re-Thinking Autism: Diagnosis, Identity and Equality.* Jessica Kingsley Publishers, 2016.

Ryan, Sara, and Katherine Runswick Cole. "From Advocate to Activist? Mapping the Experiences of Mothers of Children on the Autism Spectrum." Journal of Applied Research in Intellectual Disabilities, vol. 22, no. 1, 2009, pp. 43-53.

Spencer, Kim. "Blazing a Trail to Recovery." *The Thinking Moms' Revolution: Autism beyond the Spectrum,* edited by Helen Conroy and Lisa Joyce Goes, Skyhorse Publishing, 2013, pp. 283-292.

Stagliano, Kim. *All I Can Handle—I'm No Mother Teresa: A Life Raising Three Daughters with Autism.* Skyhorse Publishing, 2010.

Stern, Rebecca. "My Friends are Waiting for Me." *The Elephant in the Playroom: Ordinary Parents Write Intimately and Honestly About the Extraordinary Highs and Heartbreaking Lows of Raising Kids with Special Needs,* edited by Denise Brodey, Hudson Street Press, 2007, pp.127-133.

Waltz, Mitzi. *Autism: A Social and Medical History.* Springer, 2013.

Wilson, Leigh Anne. "Why We Chose Meds." *The Elephant in the Playroom: Ordinary Parents Write Intimately and Honestly About the Extraordinary Highs and Heartbreaking Lows of Raising Kids with Special Needs,* edited by Denise Brodey, Hudson Street Press, 2007, pp. 149-153.

Wiseman, Nancy D. *Autism Spectrum Disorders: An Essential Guide for the Newly Diagnosed Child.* DaCapo Press, 2009.

Woods, Michelle. "Mother Warrior to Kevin." *Mother Warriors: A Nation of Parents Healing Autism against All Odds,* edited by Jenny McCarthy, Dutton, 2008, pp. 61-74.

Yantzi, Nicole M., and Mark W. Rosenberg. "The Contested Meanings of Home for Women Caring for Children with Long-term Care Needs in Ontario, Canada." *Gender, Place and Culture,* vol. 15, no. 3, 2008, pp. 301-315.

Yochim, Emily Chivers, and Vesta T. Silva. "Everyday Expertise, Autism, and 'Good' Mothering in the Media Discourse of Jenny McCarthy." *Communication and Critical/Cultural Studies,* vol. 10, no. 4, 2013, pp. 406-426.

Zibricky, C. Dawn. "New Knowledge about Motherhood: An Autoethnography on Raising a Disabled Child." *Journal of Family Studies*, vol.20, no. 1, 2014, pp. 39-47.

Zimmerman, Andrew Luke. *What Is My Mother Doing to Me? A Teenager's Journey to Recovered Health Through Biomedical Interventions.* CreateSpace Independent Publishing Platform, 2010.

Chapter 6

A Global Positioning System: On Finding Myself as a Mother in the Romantic Landscape

Elizabeth Philps

It often seems as if the edges of the maternal body are indistinct, blurring synonymously into the home in our cultural conceptions of the role. In her analysis of Bobby Baker's *Kitchen Show*, Griselda Pollock describes the mother as "not a person so much as a place, a supportive texture for other people's lives" (178). In 2013, the Photographers' Gallery in London titled an exhibition on contemporary motherhood as *Home Truths: Photography and Motherhood*. Ways of thinking about motherhood, space, and self within dominant Western discourses remain underpinned by the ideologies of the maternal as a selfless background which emerged from the imperialism of the eighteenth century. I suggest that attention to these residues may unclog thinking around the idealization of the mother as, and in, the home, and of the qualities she may or may not exhibit. Although I recognize the validity of responding to this location from within, in my own work, I consider what happens to maternal identity when the mother leaves the physical space of the home and moves independently by creating art through walking. Here I offer an articulation of motherhood that is not entangled with the duties of domesticity, as well as a re-evaluation of solitary walking as an artistic and leisure activity through which selfhood can be renewed.

Before continuing, it is important to acknowledge that maternal labour outside the home has not been ignored by academics. For example, Lisa Baraitser uses the supermarket or shopping mall to destabilize Habermasian binaries of private-public, arguing that it is "in what Marc Auge has termed the 'non-places of supermodernity' where much of the day-to-day material practices of mothering in Western, late-modern urban contexts actually occurs" (8). But how we articulate being a mother in common or public land, or the openness of the Romantic wilderness, where our understandings of being a mother in space meet the metaphorical *maternal* as space, remains complex and contradictory. My work lies at this intersection.

The Construction of Selflessness

A subjective self is not recognized in a body that is owned. The most rudimentary understanding of the ideologies of eighteenth-century colonialism reminds us that like the land it works, a body can be conceived of as a resource and can be constructed in relation to landscape and its ownership. That the privilege, relative status, and security enjoyed by white middle-class mothers were generated as a result of such classed and racial exploitation cannot be overemphasized. What is less evident is that this ideological structure can also be seen as foundational to contemporary notions of good mothering. As the "domestic, familial counterpart to land enclosure at home and imperialism abroad" (Perry 206), a white middle-class mother's duty was as a social tool—to raise citizens for the state and its empire. This role prescribed a selflessness and infinite resource of love constructed as equally natural as the colonization it supported. While the servitude of enslaved people and workers was enforced, the white middle-class mother became expected to perform self-sacrifice, which was offered to her family as a moral choice. In return, she received the reward of security and social status not bestowed on immigrant or working-class mothers or mothers of colour—all of whom might have been, or been hindered from being, equally generous (or perhaps equally ambivalent) towards their children. Willingly or not, her role became complicit in the broader structures that conceived it.

Literature by men and women of the time illustrates these constructions. Rousseau's *Emile* (1762) prescribes the ideal conditions for

the development of the (male) child which were enthusiastically reiterated during the late eighteenth century via the conduct book, a precursor to the parenting manual. These texts were frequently authored by women; even the famous early feminist Mary Wollstonecraft wrote one, since it not only allowed these women a public voice but also conferred and confirmed the moral (and thereby practical) advantages of their class and race. Meanwhile male Romantic poets frequently cast themselves in the metaphorical role of the child to reiterate this ideology once again, describing the landscape as a selfless maternal presence against whose mute benevolence and comfort the white male artist subject can articulate his position: "Dear nature is the kindest mother still," exclaims Byron (127). These constructs reinforce the colonial concept that natural resources—be they of fecundity, labour, or care—are, or should be, limitlessly available to those this ideology benefits. In these idealizing paradigms, it is only *this* male subject's selfhood which is contained and finite. Paradoxically, the infinity and freedom that the maternal as space represents are not available to the human mother herself in any space; the specifics of good-mothering-as-selflessness keep her tightly bounded.

In contemporary maternal discourses, the notion of the mother as space remains intact, and although we can mark greater shifts in scale, subjectivity still remains elusive. The Romantic and colonial framing of the maternal as background is echoed for example in cultural responses to the ultrasound sonograph of the fetus. Feminists such as Donna Haraway and Rosalind Pollack-Petchesky argue that the mother's invisibility in the image foreshadows a selflessness that Western culture continues to prescribe in metaphors that become very real when reproductive rights or birthing decisions are discussed. In response to this passive framing, some maternal artists make bold and necessary claims towards agency in the representation of their birth experience; they celebrate the fecundity of their own body to bring forth and support life while successfully negotiating decisions surrounding this self-representation. Ana Alvarez-Errecalde's self-portraits of the moments after giving birth are a particularly inspiring contemporary example. Nevertheless, artists who mother must make subtle and politically complex considerations to avoid conflating the natural with the biological or the practical and emotional decisions of motherhood with selflessness—not only during pregnancy and birth

but throughout the maternal experience. In wider, more popular representations, the longevity and recurrence of notions of the mother as space and as background to the child subject offer a kind of potentiality for something to happen; Pollock's "supportive texture" on or against which the subject makes a mark remains a pervasive cultural shorthand. I walk in the landscape as a mother to interrogate these ideas.

Lines, Threads, and Paths

I have been using another tool developed in service of the state—a global positioning system (GPS) tracker—across several performance-walking projects to exploit the metaphors inherent in the to-ing and fro-ing of its signal. GPS was invented by, and is still controlled by, the US military. It has been identified as central to ground and air combat in both Gulf wars (Thomas 10). Not only these uses but the very functionality of the device illustrates the continuation of eighteenth-century imperialist behaviours and ideologies, where people and places become spatialized backgrounds to a conquering self. The tracks created through movement of the user mirror the accuracy of an embroidery needle, but one "stitching" far from the domestic space in which this gendered display of accomplishment was once prescribed. My appropriation of this technology to express my maternal subjectivity as embroidery is both a deliberate allusion to the classed and colonial agenda behind these constructions of motherhood, and a challenge to the aesthetic categorizations of that era, which continue to inhibit maternal art today.

As Romantic scholar Jacqueline Labbe explains, these hierarchies, which guided artistic transitions from Classical reason to Romantic awe and wonder, celebrate an intellectual and objective mastery of the sublime in nature, usually constructed as a result of solitary and heroic encounters, such as walking in the Romantic landscape. This walking is often focused around the high point of the journey, called the "prospect view," since it was from here that the colonial prospector could survey, rather than experience, his property. While women and workers laboured within the home or on the land, this controlled (and controlling) perspective was beyond their reach, both in practical and aesthetic ways. Within this hierarchy, only the privileged white male

can achieve the enlightenment of far-reaching perspectives, meaning only he can achieve the selfhood deemed to define the artist. The distanced overview contrasts with the myopic detail found in so-called beautiful feminine pursuits, such as embroidery; Labbe explores in detail how these forms were reconceived as craft, not art. Over two hundred years later, these frameworks remain all too familiar in art-world discourses surrounding both what is expressed and by whom.

The GPS tracker creates and then references an awe-inspiring and sublime vastness far beyond Romantic conceptions of space and time. It is factual and objective, as it records an exact position, speed, duration, and altitude. Nobody could call it a sentimental object. Drawing on cultural geographer Tim Ingold's correlation between the lines of wandering, weaving, and writing, I walk in order to embroider. The digital traces of these walks become artworks, but they are also deployed performatively to evidence the spatial practice and enactment of my mothering. In common with maternal labour more broadly, my walking practice goes unnoticed, and is certainly not readily interpreted as performance. The GPS helps to make this performed labour visible; it locates me in conceptual as well as spatial terms.

After all, whether or not home is sweet, sometimes we just want to get out of the house. When my daughter was nine months old, I carried her the fifty miles between my home and my mother's house. A performative acknowledgement, both of the duration of my mother's work raising me and of the difficulties of meeting the demands of the role myself, I called the walk *The Pilgrimage of the Prodigal Daughter,* and this embroidery of my tracks is taken from that journey. Unlike travel in search of work or safety, pilgrimages are a choice, although like motherhood they are a struggle at times. It is easy to forget that travel has not always been for pleasure, but the Romantic fashion for walking (also hugely influenced by Rousseau) only came about as roads became safer and transportation easier. Indeed, the etymology of the word "to travel" references the French for work: *travail.* In old English, this is also the word for maternal labour. My travail/travel was veiled by its cultural encoding as an outdoor leisure activity. Leaving no trace behind me on the physical landscape, my path was tracked on the map alongside country lanes, main roads, and motorways, those arteries that facilitate the transportation of goods, workers, and services. This mapping of my journey was a way not only to record my efforts but to

place them alongside other working journeys, such as that of the company car driver, whizzing up the motorway to another meeting—to make the maternal visible as more than a canvas on which the real and metaphorical travels of others are described.

Figure 1. E. Philps, The Pilgrimage of the Prodigal Daughter (four stills), 2013.

Semi-abstract images such as mine are not typical of maternal embroidery. These have historically tended towards proverbial, religious, and linguistic iterations rather than records of embodied and nonverbal acts. However, as Rozsika Parker's history of women's approaches to embroidery demonstrates, to claim embroidery is a way to recognize and then often to subvert a particular attitude to mothering and the feminine. Walking my embroidery beyond the domestic space responds to the ideologically constructed maternal by willfully illustrating the chasms between this ideal and its spontaneously enacted performance.

In the eighteenth and nineteenth centuries, as the Romantic hero wandered, the colonizer charted more efficient trajectories and enslaved people spanned the globe, the white middle-class mother was largely conditioned to stay within much narrower boundaries, quiet,

neat, and purposeful. As discussed earlier, being reconceived as a domestic moral compass allowed these women a voice within society, often articulated via the conduct book. However, the effect of the tight prescriptions they contained also created a circumstance in which the individual was almost certain to fail; a situation that has increased exponentially since. Drawing our attention to the contemporary sense of maternal inadequacy created by this phenomenon in the media and online, historian Rebecca Davies states, "Idealised maternity cannot be performed, only written, as the written word is considered parenting, perfected *through careful thought*" (my emphasis, 3).

The lived experience of parenting, by contrast, is nothing if not immediate. In the moment, faced with real or metaphorical obstacles—lack of map-reading skills, bad preparation, and all the shortcomings of one's own body—the individual's route may be messy, misguided, or even deviant. Reminiscent of nineteenth-century domestic samplers which warned of God's constant witness, the GPS is a twenty-first century view from above. However, although it surveys and locates me, the GPS device contrasts the idealized textual or the invisible ultrasound representations of the mother by showing me my activities *as a subject*. It details and declares the inefficiencies in my walking. It shows where I have followed the route of others (along public footpaths, for example) and where I have intentionally strayed from, or struggled to maintain, the directions that previous consensus has laid out, either in print or on the land in front of my feet. The map is probably not the journey of even the most proficient navigator; like the written maternal Davies describes, it is a considered prescription or a retrospective representation. By contrast, this recording of my own walked embroidery is created in the moment and, thus, is far from ideal. The threads and knots cannot be reworked or hidden at the back of the canvas but are there for all to see.

The display of my own imperfections then becomes a challenge to the idea of maternal perfection itself—replacing prescribed textual representations with lived reality. Embodied rather than linguistic, my performance queries the objective and dispassionate perspective it utilizes. This feels satisfyingly subversive, and I could frame my GPS embroidery as a Byronic trinity of transgression: I am beyond the domestic, I am visible as a mother, and I am messy, lost, and deviant. But such an illusion of childlike rebellion remains a privilege. As a

mother, I am subject to intense surveillance, but not to the levels experienced by mothers with differing identities from mine. It is uncomfortable that the morality historically associated with my own white middle-class position is arguably reiterated further here, but I am further impelled to use a surveillance tool to challenge the societal scrutiny of mothers precisely because not everyone can.

The Illusion of the Solitary Walker

The shattering of selfhood that motherhood brings, particularly but not only for artistic identity, has been well rehearsed. We might argue that the solitary pin of the GPS tracker reflects back to me the individual subject position that I am not alone in having craved. And yes, in this mediated image, I am offered a representation of my encounter with the sublimity of space and/or technology, which could mistakenly confirm a heroic narrative. But as I zoom out, becoming tinier and tinier on a map that covers an area greater than the limits of the furthest horizon, the screen, in fact, inverts the power of the prospect view by showing that I am not separate from the world below or around me but a dot within it. The residues of Romantic heroic individualism are even further destabilized when we are reminded of the less evident fact that the device functions by positioning itself against at least three separate satellites. Confounding singularity, the GPS tracker relies on something the Romantic poet (and many a contemporary solitary walker) chooses to ignore: the individual can only locate themselves as such by referring to others. GPS, like most orientation devices, is relational. My use of GPS combines sublimity and subversion, but is also a simple record of embodied, *inter*-bodied practice.

To retain the eighteenth-century Lockean idea that we are born as solitary and disconnected individuals focuses only on the child, not the mother. Although popular parenting discourses continue to wring their hands over child development, there has been little discussion until recently about the effect on the mother of attempting to enact these prescriptions. I have problematized the relationship between the mother in or as landscape, and I remain skeptical about the metaphor, but perhaps it can be usefully reclaimed. We know now that the landscape is not impervious to the effects of the human subject. Environmental movements have demonstrated the effects of this one-

way exploitation of what are, in fact, finite resources and have concluded that such demands are unsustainable. So, too, with the twenty-first-century human mother, who does not have limitless patience, time, and energy. Both can fail to yield if overworked.

We are at a tipping point in our relationship towards natural resources; our centuries-old conceptualizations are changing. In walking comes a reciprocal encounter between the idealized metaphorical mother and the subjective, lived experience of that role—conceived both as and in space. The GPS tracker embroiders the dance of this silent conversation. Claiming and using this technology in this way allows me to continue to examine and attempt to articulate the profound impact of this culturally loaded identity on my sense of self.

Works Cited

Alvarez-Errecalde, Ana. "Birth of My Daughter." *Alvarezerrecalde*, 2005, alvarezerrecalde.com/portfolio/el-nacimiento-de-mi-hija/. Accessed 20 June 2017.

Baraitser, Lisa. "Mothers Who Make Things Public." *Feminist Review*, vol. 93, no. 1, 2009, pp. 8-26. Web. June 5th 2017.

Bright, Susan, editor. *Home Truths: Photography and Motherhood*. Art/Books, 2013.

Byron, Lord George Gordon. *Childe Harold's Pilgrimage*. Echo Library, 2007.

Davies, Rebecca. *Written Maternal Authority and Eighteenth-Century Education in Britain: Educating by the Book*. Ashgate Publishing, 2014.

Haraway, Donna, "The Virtual Speculum" in *The Gendered Cyborg: A Reader*, edited by Gill Kirkup, et al., Routledge, 1999, pp 50-58.

Ingold, Tim. *Lines: A Brief History*. Taylor & Francis, 2007.

Labbe, Jacqueline M. *Romantic Visualities: Landscape, Gender and Romanticism*. Macmillan Press, 1998.

Parker, Rozsika. *The Subversive Stitch: Embroidery and the Making of the Feminine*. I.B.Taurus, 2010.

Perry, Ruth. "Colonizing the Breast: Sexuality and Maternity in Eighteenth-Century England." *Journal of the History of Sexuality*, vol. 2, no. 2, 1991, pp. 204-234.

Pollack-Petchesky, Rosalind, "Foetal Images: The Power of Visual Culture in the Politics of Reproduction" in *The Gendered Cyborg: A Reader*, edited by Gill Kirkup et al., Routledge, 1999, pp 171-193.

Pollock, Griselda. "Daily Life 1: Kitchen Show." *Bobby Baker: Redeeming Features of Daily Life,* edited by Michele Barrett and Bobby Baker, Routledge, 2007, pp 177-186.

Rousseau, Jean Jacques. *Emile.* Everyman, 1993.

Thomas, Clive.*GPS for Walkers.* Ordnance Survey and Crimson Publishing, 2006.

Wollstonecraft, Mary. *Thoughts on the Education of Daughters.* Verlag, 2016.

Part II

In and Out of Place: Pregnancy, Mothering, Research, and the Workplace

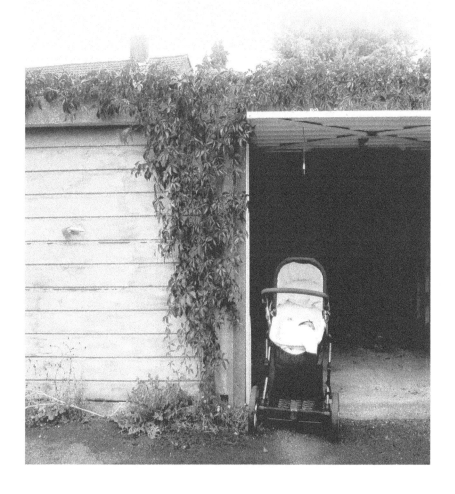

Chapter 7

Good Mothers? Geographies of Sexualized Labour and Mothering in the Strip Trades in Northern Ontario

Tracy Gregory and Jennifer L. Johnson

Introduction

Mothers earning a living through stripping or erotic dance have significant reason to maintain a separation between geographies of work and home. Not only does the stigma attached to sexualized labour affect women engaged in this labour, it also simultaneously adheres itself to those they support or who associate with them, including, but especially, their children (Bahri; Bruckert; Dewey; Goffman; Hannem and Bruckert). We frame our entry to this discussion with field notes from Tracy in which she reflects on the questions that drove her to interview other mothers with similar experiences to her own. Her field notes illustrate how mothers find themselves treading around the boundaries of good motherhood by virtue of their participation in stripping as paid work.

> We choose carefully how we present ourselves in different social spaces, not dressing too sexy, second guessing everything, feeling outside of conversations— maintaining appropriate conversations with other parents. What is appropriate? Feeling alien.

Looking for acceptance as a good mom trying to fit in with what we think a good mom is. Feeling like your identity as a sex worker is a glaring neon sign that follows you in every context of your life. It's a really complicated internal negotiation ... I don't know how to conceptualize it, but it's real, and it takes up a lot of energy and space in our everyday lives, especially when we are in spaces with and for our children.

In this chapter, we bring together narratives elicited by Tracy, whose graduate work as a peer researcher with strip club dancers in Northern Ontario contributes the bulk of the data, and the contributions of Jennifer—a former committee member for Tracy's graduate research and later a supporter of Tracy's continued work in establishing the Sex Workers Advisory Network of Sudbury (S.W.A.N.S.). Together, we apply the insights of feminist geography and sex-work-informed thinking to the issues of spatial awareness and relations of power described by the participants in the study.

A legitimate fear facing mothers who dance is that scrutiny by school and other authorities can lead to the social punishment of their children and even the removal of children on the basis of their mother's association with such spaces as a strip club (Canadian Alliance). The threat of being outed as a stripper is logically present in the minds of the women who contributed to this study. These concerns may not be particular to women working in Northern Ontario, where the five mothers in this study live and work, but they are perhaps heightened by the comparatively small population of this region where no city exceeds a population of 160,000 and the trajectories of their work opportunities include even smaller towns. At the same time, the mothers express pride in their work and seek to articulate how their paid work as dancers intersects in positive ways with their ability to provide good lives for their children.

To understand their particular experiences of motherhood, we elaborate on a number of ways in which mothers construct spatialized boundaries around their paid work at the strip club and unpaid work in their homes, children's schools, and recreational activities. We argue it is these boundaries, in part, that allow children to thrive in a social context in which the popular notion of who can be a good mother is difficult to reconcile with paid sexualized labour. The spatiality of women's unpaid work as parents and their paid work as

mothers in the strip trades constitute a maternal geography structured primarily by acts of separating places of importance to them. These separations between the club and places associated with the care and education of their children require active management, which is itself a form of work particular to women who dance. The maternal geographies they construct demonstrate the mothers' ability to provide for their families even as they must negotiate the social limitations placed on how mothers combine sexuality with paid work.

Placing the Voices of Sex-Working Mothers

Many significant scholarly works by, about, and with sex workers now exist that amplify their voices. The literature approaches the experiences of mothering and sex work in ways that centre the experiences of sex workers (Bromowich, Jaremko and DeJong). Scholars explore the ways in which sex work activism has developed in different sectors and among sex workers of diverse gendered, racialized, and classed backgrounds; motherhood is sometimes a theme in these (Bahri; Dewey; Durisin et al.; Ferris and Lebovitch; Rose; Van der Meulen). But for the most part, general literature about sex work from a wide variety of scholarly fields, including geography, tends not to have been done in collaboration with or by sex workers and focuses narrowly on women working outside in public spaces. Where mothers are concerned, the literature either directly or inadvertently selects approaches to representing sex-working mothers that undermine their voices. Mothers may be represented as caring about their children but are understood as being constantly at risk of maternal and personal failure (Sloss and Harper). The mothers interviewed here represent themselves in a different way.

All of the mothers interviewed identify first and foremost as dancers and spoke directly to their experience of dancing. We must also recognize that dancing has become embedded in a more encompassing definition of sex work. While individuals may identify uniquely as 'dancers' the global sex work movement identifies sex work as inclusive of any erotic or sexual exchange for compensation, including erotic dance.[1] The distinctions between these forms of work and how they have been debated within sex worker communities are well discussed elsewhere (Bahri; Davies; Purvis et al.; Van der Meulen).

With regard to erotic dance, scholars have detailed the ways in which various provincial legislation and municipal bylaws in Canada have historically sought to regulate and criminalize certain urban spaces as sites of sexual 'deviance.' These efforts to regulate public commerce in sexuality vary over time and place and have targeted among others, burlesque performance in clubs, massage parlours, and later, strip clubs in urban areas (Bruckert; Clipperton). Despite the complex histories and range of activities falling under the categories of dancing or stripping, and of sex work more broadly, it can be irrelevant to outsiders whether or not someone has directly sold sexual services—the stigma attached to dancing serves to associate women with other forms of sex work anyway.

Where mothers working in the strip trades are concerned, the shift towards partial decriminalization of prostitution in Canada as of 2013[2] still does not stop the overt public shaming many mothers face when they are outed as strippers—a practice that is frequently associated in the public mind only with the legal definition of prostitution. So even though overt blame is shifted to the purchaser as opposed to the seller under Canada's new laws, the new legislation has many other consequences for criminalizing and limiting sex worker's abilities to negotiate safer working conditions (Butterfly; P.A.C.E.; Peers; P.O.W.E.R.; Stella, l'amie de Maimie; S.W.A.N.S.). Specifically, we argue, the new laws limit the access of sex workers and their dependents to services and, often, their ability to live in the community. For women in the strip trades who may or may not consider themselves sex workers, the stigma still follows them whether the act of selling sex is criminalized or not and whether or not they are, in fact, providing direct sexual services in addition to dancing. Although stripping is considered to be "legal", it is still heavily burdened by the uncertainty of the laws and by-laws, criminalization, lack of labour rights, shame and stigma.

Methodology for Collaboration

Between 2005 and 2006, Tracy conducted qualitative open-ended interviews with five participants who identify as mothers and dancers in Northern Ontario. All five participants had one or more children and worked at various strip clubs throughout this largely rural and

remote area of Canada. Interviews were held in their place of work, before or after a shift, at Tracy's home, or at the participant's home. Several mothers were interviewed more than once, depending on their time and interest. All participants were adult and cis women, who were of French, English, and Indigenous descent. Most had grown up in Northern Ontario.

Our decision to work together to analyze the interviews was a practical one. Since doing the interviews Tracy has worked to launch a new organization providing peer support to people who have lived experience of sex work but has had little time to publish and make the voices of the mothers in this study heard (S.W.A.N.S.; Gregory). Jennifer is a latecomer to this project, so we had to think through how to interpret and do justice to the extensive interviews Tracy conducted. Throughout the chapter, we write as "we" to indicate where we have produced knowledge together, but occasionally we use the first person "I" or "we" in reference to the views of an individual or those held in common by Tracy and the participants through their interviews. Although we and the interviewees share experiences of the care and responsibility for children it is important to accept that at any moment, a researcher or a participant (or both) could feel conflicted about various research decisions, as each confronts boundaries around sexuality, sex work, and social location (Orchard and Dewey). Research with other mothers, whether as part of a research team or as participant, conjures notions of nurturing, friendship and empathy, but there is no reason to assume solidarity or even friendship between the researcher and the researched (Kirsch; Presser). We feel it is important to acknowledge these multiple voices because we do not want to collapse the subject positions of "dancer," "researcher," and "mother"; instead, we wish to make evident how these identities intersect based on our different relationships to these terms. We write as 'we' and 'I' in an attempt to acknowledge that collaboration between non-sex workers and those with lived experience of sex work needs to be carefully and openly negotiated (Van der Meulen).

The Good Mother and Sex Work

Here, we explore how limits placed on ideas about who can be a good mother shape how mothers working in the strip trades engage in the spatial organization of their lives. Feminist scholarship on mothering challenges the idea that the only good mother in Western societies is a self-effacing and self-sacrificing cis woman who is biologically related to her children. Feminist scholars point out that under neoliberalism, the category of the good mother has expanded to include morally appropriate forms of economic citizenship. The notion that the best mothers stay home to care for their children has fallen by the wayside in economies in which single incomes rarely afford financial security. In an age of neoliberalism, the good mother is also economically productive through paid work. In stark contrast to the ideals of white, middle-class motherhood of the 1950s, when unpaid domestic labour was idealized, good mothers must now generate an income (Douglas and Michaels; Hays; O'Reilly; Thurer). The spectre of the good mother in neoliberal Western economies is one that fits all too easily with the mother who provides for and sustains a family financially, even if this involves years of drudgery in poor working conditions with low pay. The good mother equips her children emotionally, educates them, and develops them into upstanding moral citizens by her own example, but part of this morality includes being a good economic citizen who does the right kinds of work. This mother—who in Western contexts is frequently racially, economically, and otherwise privileged—continues to haunt the complex maternal geographies negotiated by many sex workers.

The world created for children by the participants is one framed by notions of justice and entitlement to a good education, healthcare, food, and what they suggest is time to just be a kid. Under pseudonyms chosen by each participant, the mothers described their children's dependence upon income gained from their mothers' stripping in the same way that any parent might describe providing for their child. As Veronica stated, "Everything is paid for from dancing. Her whole life." Another participant, Penny, very proudly described the types of things she was able to afford for her child as a result of her income as a stripper: "My daughter is involved in Western style horseback riding, gymnastics and swimming." She went on to describe the various costs of one of these activities. "Riding competitions cost between $100 and

$150 per day—with entry fees, meals, transportation, and inoculations. She has her own horse that I purchased two years ago." When asked what dancing means to them, other mothers cited dental and healthcare needs, such as new braces for a teenage son. Penny's and Veronica's livelihoods are directly related to the security of their domestic lives; they create opportunities for their children and provide them with things they could otherwise not afford if they worked in a morally sanctioned form of work that paid less.

Mothers who combine sexual intimacy and the goal of financial wellbeing for their children may find themselves criminalized and intensively regulated through the social welfare and criminal justice systems, including the surveillance of their bodies, reproductive choices, and maternal activities (Canadian Alliance; Griffiths). These pronouncements are most hurtful from those who are close to them. Veronica said, "My family doesn't judge me. I feel judged by my child's father. [He told me once:] 'Stripper, whore, teaching my daughter to be degraded by men. Strippers aren't the mothering type'."

The notion of a good mother in Western culture is evident through the discourses found in parenting literature, media, and social welfare policy, but it also has its own geography. Although mothers who dance may provide very well for their children, they do so in a way that is not culturally or socially approved. As a result, the work of good mothers can be thought to happen in certain sites, such as domestic spaces and schools, and indirectly through paid work that is not criminalized or sexualized. We agree with Jacqueline Davies who writes that "the moral ground at the stigmatized intersection of commerce and sexuality" is a challenging space to claim (80). We add that this stigmatizing moral ground comes to be mapped onto the lives of sex-working mothers when it is known that they engage in sex work, which renders spaces in which good motherhood is supposed to be demonstrated—such as the school, recreational spaces, and even their private homes—morally suspect. Out of necessity then, mothers engaged in sex work actively negotiate the boundaries of good motherhood across time and space.

"She Doesn't Know What My Job Is": Stigma and Space

Even if it is not technically illegal for mothers to use income earned from sex work to support a family, there are many other ways in which a price is exacted from women for engaging in sexualized labour. This price alone is reason enough to keep work and home life rigidly separate in time and space. All mothers stated that the peace of mind of their children, as well as their right to learn about their mother's work at the right age, was of great importance to them. Below, a primary concern of Afton, another participant, is to keep paid work in the strip trades as separate as possible from family, and this was out of an interest in her son's wellbeing: "No. I'm not afraid of how he will see me. But I'm afraid of what it will do to him. How he will see himself and what he will internalize. I'm going to wait until he's a little bit older so we can actually talk about it." Afton creates distance between paid work and mothering so that she can better control the discourse about sex work her son is exposed to and at what age. Her concern is not that she will one day discuss sexuality, dancing, and sex work with him but that he may otherwise adopt negative stereotypes about dancers and sex workers.

The mothers interviewed in this study characterize harmful responses to the association of sex work with mothering as a "stigma"—a term used frequently to refer to the imposition of false and damaging assumptions made by others. Some described how shame was "heaped" onto them by some family members, by Child and Family Services workers, by their children's teachers, and, sometimes, even by other dancers and sex workers. The weight of this shame is evident in the problematic assumption that Penny confronts in the following statement by a Children's Aid worker: "Children's Aid asked me 'how do you do what you do and stay away from the drugs and the alcohol?' I don't go to work and do anything that makes me feel shame. Other women do—that's why they drink and do drugs. I'm sure that's why they use drugs and drink. Mask the shame for the job that they do." Here, Penny confronts a generalization about how she copes with what must be an impossible set of roles to combine (mothering and strip-trade work). Penny articulates the stereotype of sex work as inherently degrading to motherhood and confronts it as a dehumanizing product of stigma, described by sociologist Erving Goffman. Goffman suggests that in our effort to define ourselves, we fixate on noticeable differences in others. In this case, the aid worker theoretically cannot criticize

Penny because after all, she stays away from drugs and alcohol, but, at the same time, she is defining Penny as morally suspect when she asks Penny "how do you do what you do?"

Furthermore, if Goffman's observations still hold some truth, then what it means to actually be and what it means to be read as or identified as a stripper become interchangeable in practice. The conversation with the aid worker was a forced one, but it is relatively easy for others, such as customers, to mobilize stigma against a sex-working mother outside of the club. Whether someone is actually a dancer or is simply thought to be a dancer presents equally damaging prospects for mothers and their families. The mothers who were interviewed repeatedly described their struggle to have their identity of a stripper and a mother co-exist; their strategy was to fulfill both these activities while keeping them spatially separate. It was only by keeping these forms of paid and unpaid work separate that they could negotiate motherhood and stripping on their own terms.

Boundaries between the Club and the School

The club and the school—or for other participants, the club and the spaces inhabited by children and the terrain in between them—are organized separately from one another. As long as these spaces remained separate, mothers were in control; where they frayed at the edges, however, mothers worked extra hard to maintain boundaries. Stigma, as defined by Goffman, puts a great deal of pressure on groups—such as mothers who are also dancers—to confine parts of their identities to certain spaces and try otherwise to "pass." Goffman says: "he who passes can also suffer the classic and central experience of exposure during face-to-face interaction, betrayed by the very weakness he is trying to hide, by the others present, or by impersonal circumstances" (84). Passing is a very real concern in the lives of strip-trade-working mothers because clients will often see them outside of the club and attempt to engage them in conversation.

Mothers keep knowledge of their status as a mother out of the club when it comes to customers. As Veronica put it, when at the club, "I always wonder 'oh shit' [if I see] one of the kid's dads...there, and I have recognized a few fathers"—meaning that a parent of a child from her daughter's school may appear at the club given how small the city

is. The club is a space where she consents to be looked at, and this looking forms part of an agreed upon interaction with customers. Her effort to set boundaries is evident in that she has to figure out who in the club may know her child from elsewhere and, as a result, whom she may decline to work with.

Ivy's and Veronica's accounts describe the work they do to help maintain spatial boundaries between the club and the spaces occupied by their children as a way that helps them pass. Unfortunately, their ability to pass is limited by some customers' self-entitlement to breach the space of club and school. Ivy described how when she was out with her son, men who recognized her from the club would call out to her by her "stage name" or claim to "know her from somewhere." The exact intention and meaning of their calls could vary by context, but all signal a sense of entitlement to breach the spaces of motherhood and family life set out by the dancers. Ivy expressed that these situations are always awkward. One example of this was when she was at her son's school basketball game, and a teacher from the school turned out to also be a customer from the club she worked at. He thought it appropriate to engage her in lengthy conversation full of innuendo, and he then proceeded to observe her throughout the time she watched her son's game.

In a school setting, the fact that a customer would approach a dancer to speak about her work highlights the limitations placed on her choices due to the threat of being outed and then subjected to stigma. Ivy's and Veronica's experiences are important because they demonstrate that although a customer holds the status in the club as a paying client, some clients assume this status extends to spaces outside the club. The strategy for maintaining a boundary here, then, is silence. Unless Ivy outs herself, his privacy will be respected, and he is not subject to a censure for having paid someone for a sexualized interaction. The mothers in this work relationship cannot access the status of mother in the club without the risk of a customer gaining that knowledge, and they cannot safely use the identity of dancer when they are not at the club because of the stigma attached to combining sexuality with good mothering.

Just as maintaining the separateness of the club and the school is pivotal for their sense of personal safety, some mothers also used the boundaries of these spaces for the purpose of creating safer spaces for

their children. In one case, a mother was forced to speak up when her daughter was verbally abused by another child on the basis of her mother's work as a dancer. The school ultimately supported the mother and sought an apology from the other family. The mothers who shared their experiences about similar situations also vocalized the kind of support they would be denied in many other contexts. When things go wrong, it means a lot for mothers to receive support from a peer or reassurance from their own children—to hear, as Josie's daughter said to her, "That's okay. You're a good mother."

The mothers interviewed here spend an extraordinary amount of time trying to hide and manage their sex work experience; however, the consensual disclosure or the deliberate breaching of these spaces for a well-defined purpose was understood as empowering. One mother described the strength that comes from having a peer to lean on or having relationships that assist women in more safely navigating the distance between the club and school. This was so in the case of Penny, who as a result of previous negative experiences adopted a very direct approach to dealing with her child's teachers: "The teachers have all been very supportive. Every year at the beginning of the school year, I tell her teachers that I dance for a living: 'This is my daughter. If you have any problems, please let me know.' If I'm going to be judged, at least judge me fairly. I'm judged with more scrutiny as opposed to a parent who is a banker." Being able to name one's identity and attachment to these two spaces—the club and the school—on her own terms allowed Penny to locate herself and her daughter at a safer intersection of motherhood and sexual identity.

In this chapter, we follow the organizations and scholars who have argued that people who work in sex-related industries have to be afforded the right to decide when and where it is safe to disclose sex work experience. Mothers themselves describe that non-consensual disclosure—the breaching of the club space and the school space through non-consensual or coerced disclosure—can potentially have dangerous and damaging implications in their personal and professional lives. We suggest that mothers know best when it is safe to disclose and how to use this to their advantage to make spaces safer for their children.

Conclusion

In the disparate urban constellations of towns in Northern Ontario, mothers construct boundaries to safeguard their children's access to family income, recreation, and educational resources in their own communities. We have suggested that the subject position of the good mother who both earns a living and provides devoted emotional care for her children is often unavailable to women who engage in stripping. Although many parents of all genders like to keep the stresses and joys attached to paid and unpaid work separate, those engaged in stripping to provide for their children often experience discrimination and marginalization—they are often interrogated about their ability to parent. Although the subject position of the good mother, as defined by the dominant heteronormative discourses of child welfare, is largely unattainable for most mothers, those who engage in stripping find that the associated stigma fuels the separation of work and home in ways that other parents do not normally have to endure. Mothers produce a maternal geography premised on acts of separation. By keeping the club and the school separate, mothers negotiate spaces of paid and unpaid work as a daily struggle as well as a source of pride and accomplishment.

It is the position of many sex-worker-led organizations that laws based on the assumption that all sex workers are victims of exploitation creates and perpetuates harm (Canadian Alliance). They argue that such a position deepens the shame and stigma associated with all sexualized labour, including stripping, and removes any semblance of human agency over decision making, such as the ability to parent our children without suspicion of inadequacy. We hope to add these mothers' voices to those conversations. The voices of mothers who are dancers demonstrate how sex-work-involved people are taking up space and using their voices in the club, on the streets, as well as in the spaces of schools and domestic life. They refuse to be excluded from their children's lives.

Endnotes

1. "Sex work includes various activities such as soliciting on the street or in other public areas, nude dancing with or without contact, providing erotic massages, visiting or receiving through an escort service, acting in pornographic movies, animating erotic phone or webcam conversations, and offering specific or specialized services

like domination or fetishism. Sex work is diverse and may apply to sexual or erotic activities for payment. It therefore goes beyond prostitution, which exclusively describes the exchange of sexual services for payment" (Stella 2).

2. A watershed moment for sex worker rights came when Canada's prostitution laws were struck down as unconstitutional in 2013 (Canada [Attorney General] v. Bedford). The federal government was given a year to modify, replace, or continue without criminal laws specific to sex work, and it responded with Bill C-36, The Protection of Communities and Exploited Persons Act, which became law on 6 December 2014. Under this new law, those purchasing sexual services are criminalized while those persons selling sexual services are no longer seen as criminals but are, in fact, now considered victims of prostitution.

Works Cited

Bahri, Jacenta. *Stigmatized in Stilettos: An Ethnographic Study of Stigma in Exotic Dancers' Lives.* University of Manitoba, PhD dissertation. 2017.

Bromowich, Rebecca Jaremko and Monique Marie DeJong, editors. *Mothers, Mothering, and Sex Work.* Demeter Press, 2015.

Bruckert, Chris. *Taking It Off, Putting It On: Women in the Strip Trade.* Women's Press, 2002.

Butterfly. Asian and Migrant Sex Workers Support (Ontario). *Butterfly,* 2017, www.butterflysw.org. Accessed 5 Mar. 2019.

Canada (Attorney General) v. Bedford. SCC 72, [2013] 3 S.C.R. 1101, https://scc-csc.lexum.com/scc-csc/scc-csc/en/item/13389/ index. do. Accessed 5 Mar. 2019.

Canadian Alliance for Sex Work Law Reform. *Safety, Dignity, Equality: Recommendations for Sex Work Law Reform in Canada,* 2017. 30 May 2018, sexworklawreform.com/wp-content/uploads/2017/05/ CASWLR-Final-Report-1.6MB.pdf. Accessed 5 Mar. 2019.

Clipperton, Deborah. "Work, Sex, or Theatre? A Brief History of Toronto Strippers and Sex work identity." *Selling Sex: Experience, Advocacy, and Research on Sex Work in Canada,* edited by Elya M. Durisin, et al., University of British Columbia Press, 2013, pp. 29-44.

Davies, Jacqueline. "The Criminalization of Sexual Commerce in Canada: Context and Concepts for Critical Analysis." *The Canadian Journal of Human Sexuality*, vol. 24, no. 2, 2015, pp. 78-91.

Dewey, Susan. *Neon Wasteland: On Love, Motherhood, and Sex Work in a Rust Belt Town.* University of California Press, 2011.

Douglas, Susan J., and Meredith W. Michaels. *The Mommy Myth: The Idealization of Motherhood and how it has Undermined all Women.* The Free Press, 2004.

Durisin, Elya M., et al., editors. *Selling Sex: Experience, Advocacy, and Research on Sex Work in Canada.* University of British Columbia Press, 2014.

Ferris, Shawna, and Amy Lebovitch, editors. *Sex Work Activism in Canada.* Arbeiter Ring Press (forthcoming 2019).

Goffman, Erving. *Stigma. Notes on the Management of Spoiled Identity.* Simon and Schuster, 1963.

Gregory, Tracy. "SWANS: Calling Out Adversity and Finding Community through Sex Worker Advocacy in Sudbury, Ontario." *Sex Work Activism in Canada,* edited by Shawna Ferris and Amy Lebovitch, Arbeiter Ring Press (forthcoming 2019).

Griffiths, Curt. *Canadian Criminal Justice: A Primer.* 4th ed. Thomson Nelson, 2011.

Hannem, Stacey, and Chris Bruckert, editors. *Stigma Revisited: Implications of the Mark (Alternative Perspectives in Criminology).* University of Ottawa Press, 2012.

Hays, Susan. *The Cultural Contradictions of Motherhood.* Yale University Press, 1998.

Kirsch, Gesa E. "Friendship, Friendliness, and Feminist Fieldwork." *Signs: Journal of Women in Culture and Society,* vol. 30, no.4, 2005, pp. 2163-2172.

Maggie's Toronto Sex Workers Action Project (Toronto). *Maggie's,* 2011, maggiestoronto.ca. Accessed 5 Mar. 2019.

Orchard, Treena, and Susan Dewey. "How Do You Like Me Now?: Exploring Subjectivities and Home/Field Boundaries in Research with Women in Sex Work." *Anthropologica,* vol. 58, no.2, 2016, pp. 250-263.

O'Reilly, Andrea. *Mother Outlaws: Theories and Practices of Empowered Mothering.* Women's Press, 2004.

P.A.C.E. Providing Alternatives, Counselling and Education Society (Vancouver). *Pace Society,* 2016, www.pace-society.org. Accessed 5 Mar. 2019.

Peers Victoria Resources Society. *Safer Sex Work,* 2018, www.safersexwork.ca. Accessed 5 Mar. 2019.

P.O.W.E.R. (Prostitutes of Ottawa/Gatineau Work Educate and Resist). *Power Ottawa,* www.powerottawa.ca/home.html. Accessed 15 Mar. 2019.

Presser, Lois. "Negotiating Power and Narrative in Research: Implications for Feminist Methodology." *Signs: Journal of Women in Culture and Society,* vol. 30, no.4, 2005, pp. 2067-2090.

Purvis, Lara, Chris Bruckert and Frédérique Chabot in collaboration with POWER. *The Toolkit: Ottawa Area Sex Workers Speak Out - A Toolkit of Information, Strategies and Tips for Service Providers Working with Sex Workers. Action,* 2018, www.actioncanadashr.org/wp-content/uploads/2018/02/POWER_Report_TheToolkit.pdf. Accessed 5 Mar. 2019.

Rose, Ava. "Punished for Strength: Sex Worker Activism and the Anti-Trafficking Movement." *Atlantis,* vol. 37, no. 2-1, 2015/2016, pp. 57-64.

Sloss, Christine M., and Gary W. Harper. "When Street Sex Workers are Mothers." *Archives of Sexual Behaviour,* vol. 33, no. 4, 2004, pp. 329-41.

Stella and Maria Nengeh Mensah. "Sex Work: 14 Answers to Your Questions." Stella and UQAM's Service aux collectivités, 2007.

Stella, l'amie de Maimie (Montreal). *Chez Stella,* 2015, chezstella.org. Accessed 5 Mar. 2019.

S.W.A.N.S. Sex Worker Advisory Network of Sudbury. *Swan Sudbury,* 2018, www.swansudbury.com.

Thurer, Shari L. *The Myths of Motherhood: How Culture Reinvents the Good Mother.* Houghton Mifflin, 1994.

Van der Meulen, Emily. "Action Research with Sex Workers: Dismantling Barriers and Building Bridges." *Action Research,* vol. 9, no. 4, 2011, pp. 370-384.

Chapter 8

PLACEnta: Finding our Way Home

Jules Arita Koostachin

A placenta is amazing. The placenta is an organ, is fully an organ
that our body makes just for that baby. So a woman's body, when
she gets pregnant that egg that has been fertilized starts to grow,
grow, and grow. One of its first jobs is to create a placenta that
attaches to the mothers' uterus, and that placenta is going to be
where all of that blood where that baby will need, will exchange
oxygen and nutrients with the mothers blood. The baby can get all
the things that it needs to grow—Midwife, Sara Wolfe, Seventh
Generation Midwives Toronto, *PLACEnta*, 2012

Prior to telling my story, it is customary for me to position myself
as the storyteller, just as I did at the beginning of my documentary
PLACEnta, a short film about finding an appropriate place for my
twins' placenta ceremony. My teachings inform me that the placenta
ceremony ties the *spirit* to *PLACE*, and it ensures that a new and/or a
returning soul will never feel lost; it will always have a *PLACE* to call
home. It is imperative that before I share the stories woven within my
film, I will respectfully adhere to the protocols according to the
InNiNeWak (Cree) of my ancestral lands, the MoshKeKoWok. I identify
as a mid-career digital storyteller gifted with the richness of orality and
a bundle of generational stories. I am the mother of four sons, the
daughter of a residential school survivor, and the grand-daughter of
Zabeth, a warrior in every sense of the word—*this is who I am*. I affirm

that I speak from a distinct location in regards to motherhood, one that is embodied in InNiNeWak cultural life. I spent much of my younger years with my grandparents in what is now called northern Ontario; they have enlightened my worldview, and my relations with them have informed the way I have chosen to raise my children. My relationship with my mother has taught me the importance of healing—KaMiNaChik MaTiSiWin—living a good life. By positioning myself, I am declaring that *PLACEnta* is my story to tell, and one that I have considered carefully. I carry the authority to unravel some of the threads found within the intergenerational narratives witnessed in the film. Also, I concede that *we* as Indigenous peoples share our stories from a specific social location, ancestral land base, and from a distinct and inherent *way of being*. We express ourselves from a *herstory*, one that lives within our collective memory. When I choose to use the word "herstory" in this chapter, I am honouring the stories of the InNiNeWak IsKweWak (women) who have walked these lands before me. I also use herstory to resist Western patriarchal ways of thinking, ways that have excluded voices of Indigenous women. Additionally, in reflecting upon my film *PLACEnta,* I recognize that it will one day become my descendants' herstory. Also, in asserting that *spirit* lives within our stories and stories carry agency, *we* as storytellers are creating an informed space for engaged listeners/viewers.

Interestingly enough, when I watch *PLACEnta*, I am reminded of my own birth story, one that I believe to be a fragmented *truth*—fortunately a truth that is mine to share, even if the narrative is broken into pieces. Knowing even a small part of my birth story is empowering, and it supports my journey in finding my *PLACE* in this now colonial world, but with that stated, it also reminds me of how intergenerational trauma still plagues my family. My mother was severed from her community as a young girl because of the residential school system, and although the cultural teachings were uprooted by this collective experience, I am consciously and intentionally weaving our family stories back together through my media arts practice. My birth story goes something like this: *I was born into this world with birthmarks around my eyes; my face was pale, and my hair was red. My mother was frightened by my appearance and thought I was sick. Kokoom (grandmother) was present; she welcomed me as I left my mother's warmth and held me in her arms. She then whispered the language of her foremothers*

into my ear. From my understanding, this sacred act ensured that I was claimed, both by her and by my InNiNeWak ancestors. *She carefully placed me on my mother's chest, but my mother pushed me away—she was afraid of me. Kokoom placed me upon her once again, and after a few moments, my mother surrendered and let me rest upon her, skin-to-skin and heartbeat-to-heartbeat.* This is my birth story, as I know it to be ... yet I still have some unanswered questions. *Did we bond? Does my mother know the ceremony? Why am I left with only fragments?*

For many of us, all we have is fragments of story, but these incredible pieces of narrative have allowed us to weave new stories, as seen in many of my documentary projects. My film *PLACEnta* was conceived during an Indigenous storytelling residency; as an invited storyteller, my work involved developing ideas that would easily translate into a digital story. At this particular time, my partner and I had our five-year-old twins' placenta frozen in our freezer, and since this seemed to be a shared experience among many of my Indigenous friends, it became a critical narrative to explore. My journey comm-enced immediately after the closing of the residency, and in 2012, I found myself in full production. *PLACEnta* has allowed me the opportunity to ask pertinent questions in relation to Indigenous birthing ceremonies, and, most importantly, it has afforded me the time to disentangle the threads of truth. In a way, being a media artist has also cleared a path, allowing me to reveal meaningful narratives on my own terms. I wholeheartedly believe that the arts are a pathway out of this colonial chaos. Our stories lead to a space where art can reach far beyond consciousness. As an Indigenous artist myself, I have explored several genres and forms of storytelling throughout the years. I have spent a lot of time and energy building upon my existing documentary skills and practice because of how accessible, creative, and diverse documentary is as a storytelling platform.

Furthermore, I often use my first language InNiNiMoWin to ground my creative process because language connects storytellers to the past. The more I remember InNiNiMoWin the more grounded I am in my identity. I recently discovered that there is no word for documentary in my language, which sparked my curiosity. The late James Luna—a Payómkawichum, an Ipi and a Mexican-American artist—and I met a few years back, and we had a discussion regarding Indigenous documentary. He stated that *Indigenous documentary* could

be understood as a form of memory—*docu-memory*. Indeed, documentary is similar to memory because it has become an innovative and creative way to connect our people through time and space. Documentary has also allowed for the articulation of stories deeply impacted by colonial violence, and it has provided a means to celebrate, (re)claim, and (re)imagine our prior lives. The stories we tell, often times, derive from our own communities; storytellers are expected to follow protocols specific to the community and/or the person being filmed. It is, therefore, important to be attentive and to honour the transmission of the story according to protocols of the community in order to avoid harm and exploitation. The stakes are high for Indigenous storytellers; these are our relationships and our personal lives. In turn, we have a responsibility to ensure that the person sharing the story not only knows the story well but also has the authority to share it. It can be a complicated process, just as in the case with *PLACEnta*; the stories are personal and many are unresolved.

Based on years of working in the film and television industry, I assert that documentary as a storytelling approach has been exceptionally fitting for Indigenous storytellers, particularly because it is so closely linked to oral tradition practices. Documentary storytellers are contributors in (re)capturing—*with the camera*—the *spirit* of our *pre*-settler existence; we attentively summon the old stories back into our lives through film. I argue that with this great responsibility, we need to understand the camera as a powerful tool; therefore, there is an obligation to the stories that are gifted to us, especially if they are collectively cared for. *PLACEnta* may be perceived as a personal story, but stories like mine are informed by an Indigenous consciousness, and they are an expression of our past, lived experiences, languages, and knowledge. Scholar Robina Thomas suggests that storytelling is subjective, and she states, "The beauty of storytelling is that it allows the storytellers to use their own stories on their own terms" (184). I concur. It is through the act of sharing our stories *on our own terms* that documentary as a storytelling practice can be a form of talking back—a counter-narrative to the colonial one, wherein the storyteller can emphasize different aspects that may have been subject to erasure and/or assault. Historian Donald Fixico suggests, "Narrative and oral tradition produce a kind of social history, telling you also about the culture of the people" (29). Fixico stresses that oral tradition is a rich

and crucial form of communication. It is an avenue to better understand ourselves as Indigenous people and our *PLACE* in the world. Stories are interactive, just as documentary storytelling is today, wherein we pass esteemed and relevant knowledge through the generations. Renate Eigenbrod and Renee Hulan emphasize that the conduit of exchange exists in many extraordinary ways, allowing community to (re)connect with an Indigenous *way of being*. "Oral traditions are a distinct way of knowing and the means by which knowledge is reproduced, preserved and conveyed from generation to generation. Our oral traditions form the foundation of Aboriginal societies, connecting speakers to the listener in the communal experience and uniting past and present in memory" (7). They propose that oral tradition keeps us rooted and informed, continuously influencing the way we think of stories in present time. Documentary in a way is similar to orality. The films I have produced over the years have become a record of what once was—compilation of interviews and footage of daily lives playing out on screen. My documentary productions have become a collection of stories, narratives that will transcend time and space.

Since releasing *PLACEnta*, it has prompted positive community change; it now acts as a resource and an advocate for many without the teachings. It has (re)connected many to culture, spirituality and community action. It is a vessel of exchange and a permanent record for future generations. The very thought that my descendants may be able to access *PLACEnta* in years to come is intriguing; there lies a link to the future, and knowing that my story may fill the void for someone is comforting. My documentary was a creative platform acting as a guiding light in a way—leading me in the right direction in terms of unearthing cultural knowledge. It is a constant reminder of the importance of finding *PLACE*, connection, and, most notably, how our cultural practices like the placenta ceremony can assure our overall wellbeing.

However, as witnessed in *PLACEnta*, our stories have been torn apart by the residential school experience, and even in birth, we are facing colonial violence because most of us are in a state of recovery mending our stories with bits and pieces. Our ceremonies have been intentionally severed from our families, yet I acknowledge that communities are determinedly unearthing, nurturing, and healing

through stories like *PLACEnta*. The documentary touches on my mother's trauma, inflicted by years of imprisonment. There is no separating the suffering from the past from the suffering of today. Sorrow is shared within family and community; grief is inter-generational. The residential school system is a Western paradigm implemented and policed for decades, wherein families, communities, and, more specifically children were the direct targets of genocide. *PLACEnta* considers the reasons why my mother was at such a loss for words when asked about our birthing ceremonies; this moment in the film leaves the audience questioning. There is a significant exchange occurring between the storyteller and the listener/viewer. Tanana Athabascan scholar Dian Million writes, "They are a felt knowledge that accumulates and becomes a force that empowers stories that are otherwise separate to become a focus, a potential for movement" (32). The unveiling of my mother's story entices the listener/viewer to engage, question, and reflect; the story itself has the power to invite them in. Stories demand a response.

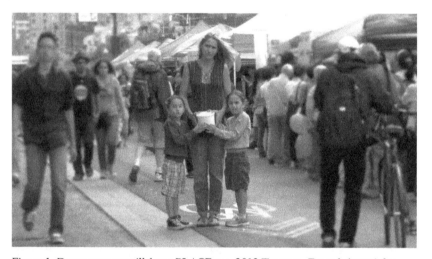

Figure 1. Documentary still from PLACEnta, 2012 Toronto. From left to right: Tapwewin Koostachin-Chakasim, Jules Koostachin, and Pawaken Koostachin-Chakasim. Photo credit: Rick Miller

I know my mother's story well; as her daughter, I have had to live with her trauma. At the age of five, she was stolen and taken to Ste. Anne's Residential School, and after eleven long years, she was finally released. She was left with horrific memories of abuse, yet somehow, she found the courage to face each day. I have come to the conclusion that I have lived in the shadow of her struggle. With that stated, I am also who I am because of her courage, and my creativity is informed by her strength of spirit. The herstory I have inherited has forced me to confront my own trauma, and documentary has afforded me the opportunity to further explore how intergenerational trauma continues to impact our communities. Also, by examining our own herstories, we begin to assert our own stories into replacing the colonial narrative of *us*, with each story told from within our community, we not only strategically dismantle colonialism, we have essentially created a sacred space to share our Indigenous knowledge with community.

When listeners/viewers invest themselves in the story, it does something remarkable; it creates a necessary space for meaningful exchange, yet it also clears a trail to understanding. Therefore, our stories deserve our commitment and utmost respect. According to my teachings, stories reside within our *living/body/spirit* memory, our connection to *spirit* and land, our kinships, and even in the blood flowing through us. Story has the power to reconnect us to *PLACE*— emotionally, spiritually or physically. Judy Iseke writes, "Spirit inspires finding meaning in the connections. Spirit also inspires us to consider the role of stories in understanding identity and life journeys as well as in creating and making meaning within pedagogical moments" (571). The *spirit* of my foremothers lives deep within the words and moments shared in *PLACEnta*; my ancestors reveal themselves in the silences, in the laughter, and, most notably, in the carefully selected words of my mother. They appear in the playful exchanges with my children and, of course, through me, the storyteller. Stories have such an astonishing way of weaving their way back into our lives, mending our spirit with guidance; they remind us of our humanity, our connection to each other, and, most importantly, where we belong, our *PLACE*.

Our stories are comprised of generous offerings. Yet, remarkably the receiver, the listener/viewer of the story, interprets meaning based on their own experience and on their own time. It becomes experiential

because they become part of the story through the emotional gateway. Curiously, it has been my experience that when one seeks answers, usually a good story can provide direction. *PLACEnta* has provided answers to questions regarding our rights as Indigenous mothers, and through my challenging but rewarding documented journey, my hope is that I have gifted a viewer with hope. Mi'kmaq filmmaker Catherine Martin states, "This telling of story as a way to begin a healing process is one of the most powerful methods that I know to help begin a dialogue over what many have been silent about. The telling of story, from the perspective of those whose lives it impacted is vital to getting to heart of the story, to the truth" (55). Uncovering *truth* by breaking through the shielded silences, as in the case with my mother, must be done with care. As a storyteller, I have reluctantly delved into crimes against humanity, and so I am often faced with the vulnerabilities of individuals; I fully understand why protocols are in place, especially when sharing Indigenous stories.

Indigenous *ways of being* are sustained through knowledge reciprocity of *storyteller* and *listener/viewer*, and this exchange of story is entrenched in the principles of oral tradition. As Sto:lo scholar Jo-Ann Archibald writes, "I believe that sources of fundamental and important Indigenous knowledge are the land, our spiritual beliefs and ceremonies, traditional teachings of Elders, dreams, and our stories" (42). When working with story, we often find ourselves in a critical position; we ourselves need to be aware of the power we hold as storytellers to ensure we do not exploit the stories in our care. For instance, Maori scholar Linda Tuhiwai Smith stresses that as researchers (I would also include storytellers), we must tell the stories right, and we must tell them well; we are obligated to perform both (Smith 357). Indeed, our stories inspire creativity, resiliency, and resistance; they fill the gaping void left by colonialism with a pathway to our pre-settler existence.

PLACEnta reminds the listener/viewer that the stories of our Indigenous ancestors are alive within us, permanently rooted here, and tied to our lands, the *PLACE* we call home. As stressed in the film, I am the daughter of a survivor, and so my own story has been not only interrupted by intergenerational trauma but also enhanced by our resilience as a people. My comprehension of motherhood is complicated, to say the least. As previously stated, documentary as a form of storytelling has allowed me the opportunity to explore how *being* the

daughter and granddaughter of warrior women, who have sustained so much suffering for being Indigenous, has impacted my life. It is through documentary that I have been able to mend my family's story and share the beauty of our powerful culture; I have found meaning, connection, and hope by creating a platform for dialogue, as well as, hopefully, the possibility of self-reflection for those who dare to engage with the subject matter.

PLACEnta was an attempt to understand, (re)create, (re)emerge, as well as establish a meaningful space to examine generational experiences. I understand Indigenous storytelling to be fixed in our herstory; it is actively communicating our complexity and richness as a people. As media scholar Steven Leuthold suggests, "Indigenous media express particular points of view; they reflect the intentions of their authors, whether to persuade, entertain, celebrate, criticize, inform, or combine these goals" (56). PLACEnta invites viewers inside to witness our stories unfold. Leuthold also states, "We can understand indigenous media from a rhetorical framework in a broad sense of the term: as forms of communication intended to move the viewer to *identification* and, ultimately, *agreement* with the author or speaker" (56). PLACEnta positions the listener/viewer; it gently pushes personal boundaries by demanding them to confront who they are in relation to the story. It has the capacity to alter mindsets by questioning their colonial history and replacing it with the blood-soaked truth, the herstory of these lands. Documentaries such as PLACEnta uphold our visibility, employing the listener/viewer to grapple with and expose their relationship with Indigenous peoples and culture.

Documentary storytelling as an arts practice has the capability to reach far and wide, linking people from all walks of life. PLACEnta, too, has created an opportunity for universal discussion; it has travelled around the world sparking critical discussions regarding the reclamation and the welcoming of our customary practices back into our lives. According to scholar Kristin Dowell, "Indigenous filmmakers alter the world as seen onscreen by presenting indigenous stories that draw on uniquely indigenous cultural traditions" (380). PLACEnta certainly does draw upon significant cultural practices, and it is through sharing our narratives, which are comprised of cultural, communal, and personal meaning, that PLACEnta has transformed lives.

Over time, I have come to accept that sacred stories, such as birth stories, can provide an entryway to embracing spirit, once explained to me as the "sacred breath." I have been taught that in the space between our very first and last breath is where the spirit resides—the moment we acknowledge the spirit is truth and truth is clarity, the feeling when you are fully present in mind, body, and soul. In *PLACEnta*, my mother speaks her truth regarding the loss of her Kokoom, she recalls, "I remember my grandmother told me when someone dies you have to sing because to [sic] make the spirit free" (*PLACEnta*). Since the film's release, I have learned that we sing to the spirit when they take their first breath, and as my mother states in the documentary, we also sing when they take their last breath. While her stories are brief, the embers of teachings she revives through her words support the belief that birth and death are of the same, and breath is the doorway—this is why the birthing ceremony is necessary in our healing as a people. Listeners/viewers are gifted with InNiNeWak knowledge; the ceremony has found its way back to my family, and through *PLACEnta*, it has also found its way back to community. It is through myself as storyteller that this healing story emerged as it did.

PLACEnta has also travelled across international borders, sparking crucial dialogue in regards to the importance of restoring and sustaining our Indigenous birth ceremonies. As scholar Sophie Mayer states,

> Jules Koostachin's beautiful short documentary *PLACEnta* (2014) narrates the inverse of this, as Koostachin seeks the correct spot for a traditional Cree Nation placenta ceremony after her son's birth. On the way, she (and we) learns from elders and young women who are reviving and carrying forward the traditions, repairing not only family bonds, but the larger social bonds damaged by colonialism. (161)

The film has had a positive impact, inspiring others like myself to search for their own ceremony. *PLACEnta* reflects upon how our customary practices are central to our wellness, as Judy Iseke states, "Indigenous peoples engage oral traditions, historical/ancestral knowledges, and cultural resources to examine current events and Indigenous understandings in ways consistent with traditional worldviews and cosmologies" (559). Although our lives have been

interrupted and, in some cases, devastated by colonialism, our stories continue to carry agency and sustain our connection to our diverse ideologies, principles, livelihoods, and *ways of being. PLACEnta* is one of those stories.

The most profound moment in *PLACEnta* was when my mother remembered the birthing ceremony. Miraculously, the camera was rolling just as she was flooded with memories of childhood: "When I heard about placenta, about [sic] my grandmother told me. I don't really remember what she said about it because I was really young and I didn't pay attention too much about it. They told me they used to wrap it up in a cloth, tie it up with a string, and hang it in a tree." Although my own birthing ceremony is fragmented, fortunately my twins have a very different story than mine; both of their grand-mothers and my Kokoom welcomed them into the world. Their father also greeted them with a whisper in InNiNiMoWin. They were also born under the care of an Anishnawbe midwife, and because of the important advocacy work of her practice, they fought for mothers like myself to take their placentas home from the hospital. As witnessed in *PLACEnta*, my soul-seeking search for an appropriate place to perform the placenta ceremony was vital. I have come to the conclusion, based on various Indigenous teachings from around the world, that the resting place of the placenta is one of the most fundamental facets of the ceremony. In May 2017, I finally returned to my home community of Attawapiskat First Nation and hung the ashes of my twins' placenta in a tree, just outside of the community. While back home, I found myself wondering what it would have been like if my mother had conducted our ceremonies, but instead of dwelling, I quickly replaced those thoughts with feelings of gratitude. I did it. I found my way back home for all of us. My children are now forever tied to their placenta's resting place, the *PLACE* where my ancestors soar.

In conclusion, as Indigenous documentary storytellers, we *ourselves* have embraced technology and have transformed storytelling practices to assist in both the renewal and sustaining of our knowledge systems and our cultural practices. As storytellers, we are breathing life back into our responsibility to the story. The knowledge within our stories is to be shared conscientiously, and it is vital to pay respect to the root of the story. It has a home, and when gifted with story, the listener/viewer can also carry the obligation to learn from it. This is reciprocity.

Through the stories, we choose to tell and share; we have created a platform to explore our customary practices that still exist within our communities. Through documentaries such as *PLACEnta*, a space for sharing was strategically crafted to facilitate the uncovering of many *truths*. In honouring our stories, we also pay tribute to the Indigenous knowledge systems that continue to feed and sustain our connection to our *PLACE* on this Earth, our first to our last breath, our ancestors, our *spirit*, and our future generations.

Works Cited

Archibald, Jo-Ann. *Indigenous Storywork: Educating the Heart, Mind, Body, and Spirit*. University of British Columbia Press, 2008.

Dowell, Kristin. "Indigenous Media Gone Global: Strengthening Indigenous Identity On- and Offscreen at the First Nations/First Features Film Showcase." *American Anthropologist*, vol. 108, no. 2, 2006, pp. 376-384

Eigenbrod, Renate, and Renee Hulan. *Aboriginal Oral Traditions: Theory, Practice, Ethics*. Fernwood Publishing Company, 2008.

Fixico, Donald L. "Oral Tradition and Traditional Knowledge." *The American Indian Mind in a Linear World: American Indian Studies and Traditional Knowledge*. Routledge, 2003, pp. 21-39.

Iseke, Judy. "Indigenous Storytelling as Research." *International Review of Qualitative Research*, vol. 6, no. 4, 2013, pp. 559-577.

Leuthold, Steven. "Rhetorical Dimensions of Native American Documentary." *Wicazo Sa Review*, vol. 16, no. 2, 2001, pp. 55-73 doi:10.1353/wic.2001.0022.

Martin, Catherine. "The Little Boy Who Loved with Muin'skw (Bear Woman)." *Aboriginal Oral Traditions: Theory, Practice, Ethics*, edited by Renate Eigenbrod and Renee Hulan, Fernwood Publishing, 2008, pp. 53-59.

Mayer, Sophie. *Political Animals: The New Feminist Cinema*. I.B. Tauris & Co. Ltd, 2016.

PLACEnta. Jules Koostachin. The Commonwealth Foundation, 2012.

Smith, Linda Tuhiwai. *Decolonizing Methodologies, Research and Indigenous Peoples*. 2nd ed. Otago University Press, 2012.

Thomas, Robina. "Honouring the Oral Traditions of the Ta't Mustimuxw (Ancestors) Through Storytelling." *Research as Resistance: Revisiting Critical, Indigenous, and Anti-Oppressive Approaches*, edited by Leslie Brown and Susan Strega, Canadian Scholars' Press, 2015, pp. 177-198.

Chapter 9

Pregnancy, Gender, and Career Progression: The Visible Mother in the Workplace

Danielle Drozdzewski and Natascha Klocker

Introduction

There is a common adage that the identity of a mother is always on display. Indeed, Barbara Eversole and her colleagues have asserted that "mothering is always a public text, visible and open to scrutiny" (164-165). When we are with our children in public and in our homes, our identities as mothers are very much on display. Yet when we are without our children, these mothering identities are not always visible, nor are they obvious. Ruth Panelli's assertion that "identities use or take up space" and that "they can be differently interpreted on [and in] various spaces" reminds us that in certain spaces and circumstances mothers may inhabit and/or perform mothering identities differently, or, arguably, not at all (149). In such situations, some mothers may be able to "selectively and explicitly engage with strategic identities—both those [we] wish to promote and support, and those [we] wish to challenge or contest" and perhaps even silence (Panelli 138). In this chapter, we investigate how mothers negotiate their mothering identities alongside their careers when in the workplace. The chapter stems from research on visible parenting in

Australian workplaces, which through a nation-wide survey has sought to better understand the choices mothers and fathers make about revealing (or concealing) their parenting identities at work. Visible parenting encompasses bringing children into the workplace and including them in the verbal discourse of work life. It includes but is not limited to the following: pregnancy, talking about children in the workplace, breastfeeding or expressing breastmilk, taking designated carers' leave to care for sick children, negotiating workload balances and flexible work arrangements with supervisors, and openly refusing and/or adapting work tasks because of parenting responsibilities.

Our interest in the choices that parents make regarding visible parenting in the workplace was heightened by a recent Australian Human Rights Commission (2014) study on the pregnancy and return to work experiences of Australian parents. In that study, 49 percent of mothers reported workplace discrimination during pregnancy, parental leave, or on return to work. Such discrimination offends human rights. It also has "a cost" for the individuals involved, for the workplaces, and for the economy (Australian Human Rights Commission 1). In some professions and employment sectors, having children places women at a distinct career disadvantage, denoted by Mary-Ann Mason and her colleagues as a baby "penalty" (80). Yet there are few publications (in either the academic literature or policy) that focus on the visibility of parenting identities in the workplace. Our research addresses this gap. As we are mothers, the research has personal import and relevance. Our positionality and situated knowledges, forged through our mother identities and previous research on parenting in academia, refract through this work. Like many other mothers, we seek strategies to negotiate our identities as mothers in the different spatial contexts of work and home.

This chapter proceeds as follows. First, we contextualize our research in relation to ideas of good motherhood. Then, we delineate the ascription of value to care and wage work, and explain how these dual roles are made visible, or not, in the workplace. In the empirical portion of the chapter, we focus on the visible mother in the workplace through a discussion of our survey participants' experiences of being visibly pregnant at work and of the gendered norms surrounding their career progression and work roles. We close by considering how refined notions of good motherhood may provide avenues of choice for both mothers and their families.

Good Mothering and Care Work

Underlying much commentary on working mothers is the good mother discourse, which shapes "activities of mothering, constructing and defining what mothers do" and often concurrently chastising them for what they do not do (Goodwin and Huppatz 6; Milkie and Peltola 477). Good mothers are often positioned as acting responsibly, breastfeeding (Boyer, "Neoliberal Motherhood"), and staying at home to be with their children (Gorman and Fritzsche; Ekinsmyth). As Teresa Arendell contends, this "motherhood ideology ... shapes women's very identities and activities" at work, at home, and elsewhere (3). However, ideas of good motherhood are neither universal nor static; they are fluid and shaped by class, racialization, ability, and sexuality. Thus, for instance, a good mother stays at home with her young children—unless of course she is a single, stay-at-home mother, in which case she will be judged for staying at home too much and for being dependent on welfare. Here, we run up against a key limitation of our survey data: we asked general demographic and work-related questions but not questions about ethnicity, sexuality or ability. This chapter's analysis is limited to the data available, and, hence, we are unable to discuss the important ways in which visible mothering and ethnic/racial identities, for instance, intersect to produce divergent experiences.

Susan Goodwin and Kate Huppatz have contended that notions of good mothering (and our conscious or subconscious subscription to them) regulate families and family life, control reproduction of the next generation of citizens, and are implicated in the shoring up of dominant cultures (6). Goodwin and Huppatz argue that (re) productions of the good mother perpetuate and entrench gendered expectations related to mothers in the workplace (6). Scaffolding from their contention, we suggest that these expectations jut up against the expectancies of the good worker.

Different valuations and spatiality of wage work and care work tie in and inform conversations about good mothering. Once again, the diversity of mothers' experiences needs to be acknowledged because it is well established that access to work—especially well-paying and secure work—is a privilege distributed unevenly along class and ethnic/racial lines (Booth et al. 548). Linda McDowell has argued that a good mother is now one who also enters "the labour market to raise her income for the benefit of her children" (156). The good (employed)

mother signals a radical (re)working of the "connections between domesticity, femininity and mothering" because she disrupts the traditional balance of two different spatial realms—women at home and men in the paid workplace (Adkins and Jokinen 146). Today, a "changing geography of where care-work tak[es] place" means that mothers' identities are shifting across, within, and between the spatial and temporal borders of home, work, and beyond (Boyer, "Of Care and Commodities" 431). Paid work often happens at home; it can change duration and location with the onset of caring responsibilities. Equally, care work intersects with the workplace through practices of visible parenting, for example through parental leave. These "new geographies of care have implications for understanding work, as care practices cross boundaries between different domains of what is constructed as 'labour'" (McEwan and Goodman 104). Because care work is commonly unpaid and traditionally undertaken by women in the home, its value, especially within "neoliberal economised notions of independence," is still routinely underestimated or goes uncounted (England and Henry 569).

Unpaid care work within Australian families is overwhelmingly performed by women; "women in Australia spend 64.4 percent of the total work per day in unpaid care work, compared to 36.1 percent for men" (WGEA 3). Correspondingly, "the onus is placed on women to manage change to their [paid] working arrangements," once they have children, to incorporate two types of labour (Goodwin and Huppatz 42). Many more mothers in our survey worked part time than fathers, as is the case in Australia more generally. Accordingly, women's identities as mothers are typically more visible and visibly different in their workplaces than are men's identities as fathers—with implications for their career progression.

The Visible Mother

In what follows we draw from responses to visible parenting in the workplace survey. The survey was comprised of short and long answer questions, and a combination of closed, Likert Scale (graded from strongly agree to strongly disagree) and other graded scale questions. Participants were recruited through university-based online list servers as well as through a nation-wide survey distribution company, which

provides payment for survey completion. The latter distribution method enabled us to secure wide representation of industries, employment types, and tenures. Respondents had to have at least one child aged sixteen years or younger at the time of the survey and be in paid employment. From a total of 1047 surveys, 733 surveys from self-identified female respondents were analyzed for this chapter. The findings discussed herein derive from this sub-sample and can be contextualized by certain demographic variables provided in figure 1.

Figure 1: Survey Sample Demographics

GENERAL DEMOGRAPHICS	
Age (%) (n=729)	
20-29	9.1
30-39	52.5
40-49	37.4
50 +	1.0
Relationship status (%) (n=729)	
No partner	11.9
De facto/married	87.6
Live with partner (%) (n=733)	
Yes	87.9
No	12.1
Highest level of education (%)(n=729)	
School	11.4
Vocational	21.8
University	66.9
Gross annual income (AUD) (%) (n =725)	
<$41,599	23.6
$41,600-$77,999	41.0
$77,800-$103,999	18.9
>$104, 000	13.8

CHILDREN

Number of children (%) (n = 733)

1	37.7
2	44.3
3	12.3
4 or more	5.7

Age of youngest child at time of survey (%) (n = 726)

2 or under	33.1
3 to 5 years	26.9
6 to 10 years	25.9
11 to 16 years	14.2

WORK-RELATED DEMOGRAPHICS

Employed status (%) (n=733)

Full-time	52.1
Part-time	41.3
Casual	6.5

Occupational categories (%) (n = 732)

Managers	14.6
Professionals	44.4
Clerical and administration	22.4
Other	18.6

Employment sector (%) (n=726)

Public	50.7
Private	43.3
Not for profit	6.1

Average hours worked per week (%) (n = 730)

14 or less	6.2
15-24	23.8
25-34	19.5
35-44	40.7
45 or more	9.9

Employment tenure (%) (n= 727)	
Permanent/continuing	75.5
Fixed term contract	13.9
Casual	10.6
Industry/Field of employment (%) (n =641)	
Healthcare and social assistance	15.8
Education and training	42.1
Public administration and safety	8.3
Professional, scientific, and technical services	6.1
Construction, mining, and manufacturing	7.5
Wholesale and retail	10.1
Information, media, and telecommunications	4.4
Financial and insurance services	5.8

In this chapter, we explore two aspects of the survey data: being visibly pregnant at work and discussions of career progression. The first relates unavoidably to the visibility of the mother, while the second tackles the less tangible cumulative outcomes of mothering for careers over time. From the outset, it is important to note that we found the quantitative survey data surprisingly positive. The numerical data—in isolation from the long-answer responses—suggest that the majority of women in our sample did not experience discrimination either when pregnant or on their return to work; they had access to some form of parental leave, had flexible working conditions, and felt comfortable and secure in talking about their parenting responsibilities in the workplace. Although we found this overall response reassuring, we were also a little surprised not only because we had heard very different stories but also because the recent Australian Human Rights Commission Report *Supporting Working Parents* had presented far less positive data.

While we were certainly not trying to look for a bad news story, here we have paid close attention to data from the long answer responses to questions about being visibly pregnant and on gendered career progression. We have taken this approach for two key reasons. First, we think that pregnancy-related discrimination in the workplace

is intolerable at any level—some discrimination, in any quantity, is not good enough. Indeed, Sara Ahmed argues that in pursuing a "feminist agenda, often what you aim to bring to an end some do not recognise as existing" (5-6). The responses of those who indicated that they had endured discrimination (13.5 percent of respondents) detailed appalling stories of redundancies, lesser duties, and decreased opportunities. Second, a sizeable proportion of our respondents provided neutral responses. Read in combination with the long answer responses, this neutrality appeared indicative of a deep-seated stoicism and acquiescence regarding the normative status quo of mothers' caring roles and the implications of these for their opportunities in the workplace. Many of our female respondents did not identify the possibility of sustained periods of paternity leave as an alternative, which is already found in many Scandinavian countries. They also did not consider how they could benefit from workplace programs designed to support the career progression of female employees returning from maternity leave, such as flexible work arrangements or mentoring schemes that support working mothers' promotion ambitions (see Klocker and Drozdzewski). Worse still, such alternatives appeared to be entirely unknown. More common was a seeming acceptance of the fact that they (mothers)—rather than their (usually male) partners—were primarily responsible for their children's care, as evidenced through the high rates of part-time employment and flexible work arrangements. Correspondingly, there was an acceptance that this reality would necessarily (perhaps even justifiably) have negative career implications for them. For example, one participant stated the following: "I knew when I got pregnant I would be put on the scrap heap just like other women who are parents in my workplace. So, it was just hard to be visibly pregnant. It reminded me of what was going to happen" (Participant 487, August 2016). This quote sets the scene for our modest discussion of two aspects of the visible mother in Australian workplaces.

On Being Visibly Pregnant in the Workplace

A protruding pregnant belly is often hard to miss. Its visibility projects the identity of the mothering body. Robyn Longhurst has suggested that "when women tell people at work they are pregnant their identity is fractured" (*Maternities* 22). This identity fracturing occurs because the previously normative singular subject "becomes a maternal subject who is no longer one but two (or more)" (Longhurst, *Maternities* 22). Longhurst has contended that the "normative subject in most workplaces is an individuated subject" (*Maternities* 27); the good worker is measured by their devotion to "full-time continuous work, a high level of organisational commitment and long hours on the job" (Goodwin and Huppatz 10). Alongside the changing pregnant body, sets of social and cultural discourses emerge surrounding the ability of this now two-person body to continue functioning in its pre-pregnant state of individuation. The good individuated worker juxtaposes sharply with what often happened among our female survey participants. Mothers pulled "back on paid work to do more of the unpaid work that accumulates around the home" (Crabb 4). Moreover, the visibly pregnant body appeared to disrupt the possibility of continuing to work under the same conditions predicated on the Cartesian separation of a singular mind-body. In our survey, participants were asked a series of questions relating to being visibly pregnant (figure 2). They were also asked to describe positive or negative workplace experiences relating to their visibly pregnant body and how these experiences made them feel; there was also an open response question asking them about announcing their pregnancy in the workplace. Three key themes predominated in the long answer responses: comments on the mother's physical appearance; comments related to the mother's job, including her ability to fulfil her role and contribute to the workplace; and the evaporation of career progression opportunities.

Figure 2: On Being Visibly Pregnant

Q. When you were pregnant with your youngest child, how did you feel being pregnant at work? (n=711)

Very relaxed or relaxed	46.0%
Neither relaxed or stressed	21.0%
Very stressed or stressed	33.1%

Q. How did you supervisor/manager responded when you announced your youngest child? (n=727)

Positive/supportive response	67.8%
Neither positive nor negative	27.1%
Negative/unsupportive response	5.1%

Q. I tried to hide my pregnancy for as long as possible. (n=711)

No, this did not happen.	67.5%
Yes this happened; it was not uncomfortable.	18.7%
Yes this happened; it made me feel uncomfortable.	13.8%

Q. My colleagues commented on my body size/shape. (n=711)

No, this did not happen.	42.9%
Yes this happened; it was not uncomfortable.	43.6%
Yes this happened; it made me feel uncomfortable.	13.5%

Q. My colleagues touched my belly. (n=711)

No, this did not happen.	50.1%
Yes this happened; it was not uncomfortable.	39.8%
Yes this happened; it made me feel uncomfortable.	10.1%

Q. My colleagues joked about me having pregnancy/baby brain (n=711)

No, this did not happen.	54.3%
Yes this happened; it was not uncomfortable.	33.5%
Yes this happened; it made me feel uncomfortable.	12.2%

Class also played a role in affected women's experiences of pregnancy in the workplace, but not how we expected. Highly educated women were more likely to perceive discrimination, or to experience dis-comfort, than less educated women. For instance, 15.8 percent of women with an undergraduate university degree and 15.8 percent of those with a postgraduate degree reported experiencing workplace discrimination after announcing their pregnancy, compared to 3.7 percent of those with a high school education. Moreover, 19.3 percent of women with an undergraduate degree and 13.8 percent of those with a postgraduate degree tried to hide their pregnancies for as long as possible, compared to 3.7 percent of those with a high school qualification.

A sense of being uncomfortable during pregnancy was pervasive in the survey's long responses. Respondents noted that colleagues or supervisors had commented on their size, stage of pregnancy, width, and diet. For example, one participant noted, "constant comments on my size … made me feel uncomfortable" (Participant 401, February 2015). For some, negotiating their pregnant bodies at work was difficult, and they experienced discrimination, unwanted comments, and limited opportunities. We ponder whether such comments are symptomatic of their purveyor's discomfort being in the presence of pregnancy in the spatial context of the workplace. Not only do pregnant bodies defy a norm of individuation, but they are also frequently messy bodies—they lactate, seep colostrum, sweat, and their amniotic fluid can break and/or leak (Longhurst, *Bodies*). They (potentially) disrupt orthodox spaces of work; they are visible markers of difference, as one participant noted: "The way it was constantly commented on made me realize how threatening or destabilizing the presence of a (visibly) pregnant body is in our society … I felt my body singled out as dangerous or 'Other'" (Participant 468, March 2016).

Participants cited being treated differently once they announced that they were pregnant. They noted that supervisors, managers, and/or colleagues stated that their pregnancies were indicative of a lack of commitment to the job or that they were letting other colleagues down. For some participants, work tasks evaporated, or they were given less interesting work to do. In one instance, a pregnant woman was told that she should not interact in person with clients, as her pregnant body may discourage the client's faith in the organization's ability to complete the project. Different participants had similar experiences:

My ability to do my job was assumed to be decreased—no one asked if that was the case. (Participant 125, February 2015)

Comments were constantly made by my direct supervisor that I was abandoning the team. (Participant 193, March 2015)

My line manager said that I did not respect my work, me taking maternity leave was unfair on my male colleagues. (Participant 240, July 2015)

These discriminatory experiences were based on assumptions made for these women by others regarding what a pregnant mother can do in the workplace. Such assumptions denied those women both opportunity and agency. The following section considers how pregnancy—and other aspects of visible mothering in the workplace (including flexible and part-time work arrangements)—had career implications for our research participants.

Gender, Visible Parenting, and Career Progression

Anne-Marie Slaughter once provocatively stated "women can't have it all." Motivating Slaughter's comment was the pressure of juggling a high-level government secondment away from the family home and the pull to be at home with her children. Evidence of the struggle to combine mothering with wage work also emerged in the survey's questions on career progression, either in response to our targeted question or to questions about being visibly pregnant. The latter suggests that the career impacts of motherhood were felt soon after disclosing pregnancy in the workplace. Several participants commented on feeling these effects:

Once I advised them of my pregnancy ... all of the extra training and opportunities to learn new tasks stopped. (Participant 140, February 2015)

I missed out on opportunities and existing opportunities were withdrawn once I announced I was pregnant. (Participant 269, August 2015)

When I announced I was stepping down to take parental leave there was an audible sigh in the room. I had previously been

considered leadership material but construed the sigh to mean that I was no longer considered so. (Participant 183, January 2015)

Was told I could not go on business travel anymore, my maternity leave replacement was brought in 2 months before I was due to go on leave and for the last two months I was told not to attend meetings which meant no business input and they sat me in a corner at work shredding paper rather [than] doing what I do best. (Participant 1166, November 2015)

We asked participants to contemplate whether gender had influenced their career progression since having children. This question required them not only to think about the ways that their careers had been affected by having children but also to contemplate whether these effects differed for mothers and fathers. Of our female respondents, 43.5 percent responded "no," 36.5 percent replied "yes," 16.5 percent were "unsure." We found that those who were university educated, in professional occupations, and had children six to ten years of age were more likely to think that motherhood had impacted their career progression. This outcome accords with existing research that has interrogated the misalignment of many professional women's career paths with the orthodox linearity expected of standard career progression (Chesterman and Ross-Smith 45). Mothers' career paths are rarely linear; rather, they are dotted with periods of maternity leave, part-time employment, and, most often, the challenges of teaming wage-work with at-home caring responsibilities outside the working day. Time on the job begets experience, and experience precipitates opportunities for promotion. Time taken out of their careers was a point of focus in our participants' reflections on career progression. One participant said the following:

Reducing my hours from full time to part time has reduced my productivity in a highly competitive academic environment. Doing this at a time when I should have produced multiple papers, when others were, has substantially reduced my competitiveness for funding and promotion." (Participant 95, February 2015)

Some explicitly noted that the impacts on their career progression were justified due to their career breaks, and they did not connect these impacts to their gender: "I have taken three sets of maternity leave in four and a half years; I don't believe it was my gender that affected my career progression [but] all the time away I've had" (Participant 216, April 2015). But others identified distinct patterns of gendered disadvantage: "When I went for a promotion (unsuccessful), my feedback was I better hope for a different panel next time as a particular male couldn't see around all the breaks to the [career] trajectory" (Participant 265, August 2015).

The data indicate that visible mothering in the workplace frequently has negative career implications. It is no surprise, then, that some women who responded to our survey actively employed strategies to hide their mothering responsibilities when in the workplace. One in five women surveyed agreed or strongly agreed with the statement: "I try not to talk about my child/ren with, or in front of my supervisor" (n = 137). Of those participants, nearly two-thirds (64 percent) thought their gender affected their career progression. One participant said, "I still hide the amount of time I care for my children by using other leave categories," (Participant 86, February 2015)" whereas another one noted, "I have overcompensated for my caring responsibilities and hidden them to reduce their impact on my career progression" (Participant 179, March 2015). While such strategies may generate career benefits for the mothers involved—and are indicative of women's capacity to exercise agency in revealing or concealing their mothering identities in the workplace (under some circumstances)— they do little to shift workplace norms that equate the good worker with individuated subjecthood.

Good Working Mothers?

Being visibly pregnant in the workplace was a source of concern for some mothers who were confronted with assumptions about their continuing capabilities as good workers while pregnant. But the apparent incompatibility of the good mother and the good worker was also expressed in other ways by our participants. Indeed, the long responses were replete with the respondents' own value judgments

regarding the attributes of good working mothers. References to not wanting to be "that kind of mother" demonized mothers who worked full time, while others valorized part-time work with references to putting their children first. Such value judgments demarcate the boundaries of the good (working) mother. Not only are such comments hurtful (for full-time working mothers such as ourselves), they also inhibit change. They further entrench the social and cultural expectations that pit the good mother against the good individuated worker, and they set assumptions about the ideal tenure of mothers' employment (i.e., part-time not full-time work). They also show the predominance of traditional gender-based caring norms. For example, one respondent noted, "as a mother, I need to dedicate much more time to care for my son than my husband, which will affect my productivity," (Participant 172, March 2015) and another stated, "this comes from the cultural obligation for the mother to prioritize taking care of her children rather than thinking about her career progression" (Participant 358, January 2016).

Although not all mothers in our survey (or in the wider community) may want to change their patterns of care and wage work, the societal norms that sustain the good mother and good worker dichotomy undoubtedly need unpacking. Colleen Chesterman and Anne Ross-Smith have argued that "broader societal conceptions of good mothering need to better acknowledge the merits of non-traditional domestic arrangements" (47). Yet strikingly absent in our survey responses was the possibility of challenging the system and offering alternative frameworks for managing care work and wage work. There are international examples that endorse sharing parental leave equitably between parents so that a mother has choice of employment tenure after the baby, which unsettles the traditional expectation that mothers work part time (Ravn and Wetternerg; Ellingsæter and Arnlaug). The little discussion on other options among our survey respondents suggests a level of acceptance of the status quo and is indicative of a need to (re)define and refine notions of what it means to work, to care, to achieve success, and to progress. Yet any demand for such (re)definitions seems moot amid an atmosphere of stoicism and a seeming acceptance of negative outcomes related to gender, part-time work, and flexible working arrangements.

That many of our participants did indicate positive workplace

experiences across the spectrum of motherhood signals that most were indeed happy with their circumstances and ability to make certain choices. But in acknowledging the less optimistic components of our dataset, we seek a continued campaign for change and are motivated by the ever-thoughtful words of Ahmed, who reminds us that "feminism is about how to live, about a way of thinking how to live" (1).

Works Cited

Adkins, Lisa, and Eeva Jokinen. "Introduction: Gender, Living and Labour in the Fourth Shift," *NORA,* vol. 16, 2008, pp. 138-149.

Ahmed, Sara. *Living a Feminist Life.* Duke University Press, 2017.

Arendell, Teresa. *Hegemonic Motherhoods: Deviancy Discourses and Employed Mothers' Accounts of Out-of-School Time Issues.* Working Paper number 9, Centre for Working Families, University of California, 1999.

Australian Human Rights Commission. *Supporting Working Parents: Pregnancy and Retrain to Work National Review.* Australian Human Rights Commission, 2014.

Booth, Alison, et al. "Does Ethnic Discrimination Vary Across Minority Groups? Evidence From a Field Experiment" *Oxford Bulletin of Economics and Statistics,* vol 74, 2012, pp. 547-571.

Boyer, Kate. "Of Care and Commodities: Breast Milk and the New Politics of Mobile Biosubstances," *Progress in Human Geography,* vol. 34, no. 1, 2011, pp. 5-20.

Boyer, Kate. "Neoliberal Motherhood: Workplace Lactation and Changing Conceptions of Working Motherhood in the Contemporary US," *Feminist Theory,* vol. 15, 2014, pp. 269-288.

Chesterman, Colleen, and Anne Ross-Smith. "Good Executive, Good Mother: Contradictory Devotions." *The Good Mother: Contemporary Motherhoods in Australia,* edited by Susan Goodwin and Kate Huppatz, Sydney University Press. 2010, pp. 25-51.

Crabb, Annabel. *The Wife Drought,* Erbury Press, 2014.

Ekinsmyth, Carol. "Mothers' Business, Work/Life and the Politics of 'Mumpreneurship.'" *Gender, Place & Culture,* vol. 21, 2014, pp. 1230-1248.

Ellingsæter, Anne Lise, and Arnlaug Leira. *Politicising Parenthood in Scandinavia: Gender Relations in Welfare States.* Policy Press, 2006.

England, Kim, and C. Henry. "Care Work, Migration and Citizenship: International Nurses in the UK". *Social & Cultural Geography,* vol. 14, 2013, pp. 558-574.

Eversole, Barbara, et al. "Reimaging in the Fairytale of Motherhood in the Academy." *Mothers in Academia,* edited by Mari Castaneda and Kirsten Isgro, Columbia University Press, 2013, pp. 160-169.

Goodwin, Susan, and Kate Huppatz. "The Good Mother in Theory and Research: An Overview." *The Good Mother: Contemporary Motherhoods in Australia,* edited by Susan Goodwin and Kate Huppatz, Sydney University Press, 2010, pp. 1-25.

Gorman, Kristin, and Barbara Fritzsche. "The Good Mother Stereotype: Stay at Home (or Wish That You Did!)." *Journal of Applied Social Psychology,* vol. 32, 2002, pp. 2190-2201.

Klocker, Natascha, and Danielle Drozdzewski. "Career Progress Relative to Opportunity: How Many Papers is a Baby 'Worth'?" *Environment and Planning,* vol. 44, no. 6, 2012, pp. 1271-1277.

Longhurst, Robyn. *Bodies: Exploring Fluid Boundaries.* Routledge, 2001.

Longhurst, Robyn. *Maternities: Gender, Bodies and Space.* Routledge, 2008.

McEwan, Cheryl, and Micheael Goodman. "Place Geography and the Ethics of Care: Introductory Remarks on the Geographies of Ethics, Responsibility and Care." *Ethics, Place and Environment,* vol. 13, no. 2, 2010, pp. 103-112.

McDowell, Linda. "The New Economy, Class Condescension and Caring Labour: Changing Formations of Class and Gender." *NORA,* vol. 16, 2008, pp. 150-165.

Mason, Mary-Ann, et al. *Do Babies Matter? Gender and Family in the Ivory Tower.* Rutgers University Press, 2013.

Milkie, Melissa, and Pia Peltola. "Playing All the Roles: Gender and the Work-Family Balancing Act," *Journal of Marriage and Family,* vol. 61, 1999, pp. 476-490.

Panelli, Ruth. *Social Geographies: From Difference to Action.* SAGE Publications Ltd, 2004.

Ravn, Anna-Birte, and Christina Carlsson Wetterberg. *Gender Equality and Welfare Politics in Scandinavia: The Limits of Political Ambition?* Policy Press, 2009.

Slaughter, Anne-Marie. "Why Women Still Can't Have It All." *The Atlantic*, July/August, 2012. Workplace Gender Equality Agency, *Unpaid Care Work and the Labour Market*, Commonwealth Government of Australia, 2016.

Chapter 10

Belly, Baby, Boundaries: The Effect of Pregnancy on Research Relationships

Shana Calixte

Once upon a time, the Lone Ethnographer rode off into the sunset
in search of his "native." After undergoing a series of trials, he
encountered the object of his quest in a distant land. There, he
underwent his rite of passage by encountering the ultimate ordeal
of "fieldwork." After collecting "the data," the Lone Ethnographer
returned home and wrote a 'true' account of the culture.
—Rosaldo 30

W hen searching for analyses about fieldwork, I have found few discussions about the embodied experience of pregnancy on field sites (see Ortbals and Rincker, for one more recent example). It is not hard to understand why. The reality of children, pregnancy, and parenting has little space in academic cultures, and, as a result, most researchers try hard not to be pregnant in the field. Those planning to have children through pregnancy (or through adoption, deliberately blending one's family through re- partnering or assuming care of extended family) do not often plan this event to occur at the same time as important events in their academic career, or even during the work they do in academe in general. As Janet Shope states, this is called the "No Uterus Rule." How, she asks, "does one make space for an expanding uterus within the walls of an ivory

tower that has historically privileged the 'life of the mind'?" (53).

In methodological reflections on fieldwork and ethnography, feminists have made necessary interventions and have raised the importance of critical self-reflexivity in the work we do as feminists and as researchers (Bain and Nash 100). Feminist researchers and geographers in particular urge us to look at how our spatial and social locations are interwoven and are further imbedded in our ways of knowing and seeing the world. In effect, what many scholars argue is that we must work to decolonize our methodologies, such that our research interrogates the "travelers' tales," which historically have been used to silence and explain the "other" in nonproductive, oppressive, and disciplining ways (Smith).

Itemizing a feminist methodology is not of interest to me here. What is of interest for me in this chapter is interrogating how my own ideas of how a feminist and an anticolonial or a decolonizing methodology can be spatially aware. In my case, this approach emerges from and has been moulded by my experience of living in a pregnant, feminized, heterosexualized Black body. I want to examine how the experiences of my body impacted the ways I went about collecting information, and my own interpretations of how my methods changed as a result of my embodiment in the spaces of fieldwork.

The body and embodiment are sites of immense importance in feminist theorizing. The body is a site of "discourse and action ... a form of representation ... and intimately linked to biography and the crafting of the self" (Coffee 59). The body is also of importance in our ethnographic inquiries, as it serves as an "agent of cultural reproduction and as a site of cultural representation" (59). Fieldwork then, as a site of relationality—or, as Amanda Coffee states, as a space "reliant upon the analyses of bodies and body work"—necessitates that we think about our experiences in the field as an embodied practice (59).

This chapter, then, is an analytic narrative of my experiences as an embodied researcher, as a pregnant participant in the field. Through it, I challenge the notion of a disembodied fieldwork practice outlined by Renato Rosaldo at the opening of the chapter. I ask feminist researchers to once again place importance on our bodies in the field. I ask that we discuss how these embodiments have an effect on how we choose our field sites and how our research practice and data collection are

also affected and changed by our various embodiments.

What I discovered through this research process was that I became the "expectant" interviewer—such that my embodied state of pregnancy was continuously reified within the research relationship. I was expected to disclose information about my bodily state: how many months pregnant I was; when I was due; what I expected to do after the birth; and how this would affect my future academic performance. In addition to these interactions, my body was also interpellated through notions of sexuality, family, and nation, often in normative ways. While thinking back on the experiences I had in the field, I have found that my methodological practice shifted, and my ways of collecting data, or even how I thought that data should be collected, altered as a result.

The fieldwork body, as Coffee states, is produced, managed, and negotiated as we seek to access our field sites and informants (66). In order to do so, we "craft" our bodies as part of "crafting the fieldwork site" (66). What we wear, how we present ourselves, and how we perform our various roles in the field are all parts of making our fieldwork body legible and legitimate. My fieldwork body then was read by informants in three ways—as a site of connection and shared memory, as a site of monstrosity and (hetero)inaccessibility, and as a site of normativity. Looking back at my time in the field, I read my experiences as being enmeshed in a complex embodied practice, as the various readings of my body by my informants has had a range of implications for my research.

Following Alison Bain and Catherine Nash, I argue that the body itself is a "research tool." They contend that the body needs to "be rendered explicitly visible as a contested site of knowledge production," such that a feminist approach to fieldwork challenges the idea of the disembodied researcher (99). I extend and explore this idea through the experience of the pregnant body in fieldwork, and I suggest that the body is especially valuable as a case that brings into relief the various relations of power. Awareness of the body reveals practices of legitimation: defining who can be an ethnographer, a researcher, and an expert and, thereby, deepening our understanding of how the field and pregnancy co-produce each other.

Moving the Package Abroad

In January 2006, when I was seven months pregnant with my first child, I ventured out to conduct fieldwork for my dissertation—three countries in the Caribbean (St. Lucia, Antigua, and Barbados). The timeline was short; I had two months to visit all three locations and carry out qualitative interviews with between thirty and forty people. My research investigated the experiences of women who had been members of the Girl Guides in these three countries in order to examine their relationships with the organization as well as their own ideas around girlhood, sexuality, and colonial racial scripts pre- and postcolonial independence (1930s to 1970s). Ultimately, my objective was to see how the Girl Guides organization enacted ideas about the making of young Caribbean women into good commonwealth citizens and how these women worked to subvert dominant ideologies around citizenship at that time.

I would like to say that I was hesitant about venturing out into the field and that I was worried that being pregnant would affect the data I was collecting. However, other than acquiring ethics approval (which came two weeks prior to my trip), there were no other barriers I foresaw with proceeding. Why would my body infringe on my ability to carry out research?

My methodological approach to my research was situated as a grounded theory project, where I intended to "discover theory from data" and to use the information I collected in the field to guide me towards larger understandings of the phenomena I was researching (Martin and Turner 142). This process included multiple readings of each interview after they had been completed and restructuring my questions and my theoretical approach based on the ideas gleaned from these meetings. From the moment I began my interviews, I started to realize that my body, my pregnant body, was quickly becoming a part of my research process and was figuring into the data I was collecting. As Wendy Hall and Peter Callery note about many who choose to engage in a grounded theory approach, it became clear that "interview data [are] ... a representation of the relationship between researcher and researched" (Hall and Callery 257). My body was definitely implicated in this project, whether I liked it or not.

Pregnant bodies are public bodies, available to be touched, asked about, and commented on. As one who is specifically racialized and

classed, able bodied and queer, I am already aware of my conspicuous body. Being pregnant, I became hyper aware of how public my body was. Our bodies, our fieldwork bodies, affect this supposed seamless immersion in the field in a number of ways. Race, class, gender, and ability all affect the reading of our bodies and how well we will fit as insiders or outsiders in the field. How a body looks or is perceived can signal to an informant, a community, and others whether you belong or if you do not. Pregnancy, of course, can be added to the list of factors that make one's body conspicuous.

Although these concerns may seem obvious to some, for many researchers, the body (not to mention the social location of that body) is assumed to be irrelevant to the collection of data and the science of the social, the positivist model. Though routinely critiqued by scholars, a dominant image of the researcher continues to govern understandings of the process of fieldwork. This image, shared at the beginning of the chapter, is of the lone, childless, and, usually, male researcher, who has left behind his family far away at home. He spends months seeking out knowledge in solitude. Alone, in an unblemished objective research space, this lone researcher is unencumbered by any ties, especially to his or anyone else's body (Frohlick 50).

Even though I was and still am critical of this approach, I wondered: who was I to bring not only my leaking, protruding, swelling, and, frequently, urinating body out in the field, but also ask my mother to tag along? Fieldwork is supposed to be "a stoic, solitary endeavor that we must suffer through alone in order to prove ourselves" (Frohlick 50). How could I possibly gather so-called objective data with so many hangers-on?

Now looking back, I must have had some hesitation about doing research alone and pregnant, since I asked my mother to come along with me. We rarely talk about "accompanied research"—the idea that we often do research with assistants. Even so, those who do come with us (whether they are guides, translators, or aides) are never included in our research; indeed, we often strive to keep our perspectives somewhat objective by not talking about the other folks in the room (Frohlick 49). Even mentioning in this chapter that my mother joined me on my research trip worries me; I am worried that my peers and colleagues, all of you reading this chapter, will question my research and the ethics of obtaining my data. I mention my mother because I

think she was quite influential in my data collection and in my fieldwork experience as a whole. I speak more about her presence in my work a bit later.

Body as a Site of Connection and Shared Memory

It is often said that as researchers, we try to thoroughly immerse ourselves in the field site we choose to study. The term, to "go native" becomes the problematic nomenclature of a practice that has been seen as a renegade research practice. I suggest that to immerse oneself completely in the field (assuming that is possible considering the problematic ways in which researchers may seek commonality with their research participants through appropriation of language and culture) challenges the academy's needs for objectivity, rationality, and detachment in research practice (Letherby 183). Liz Stanley, for instance, advocates for this deeply immersed ethnographic and methodological practice and argues that it more thoroughly enables a feminist engagement with the subject—a subjective, emotional connection, as "knowledge is always rooted in the particular perspective of knowledge producers" (qtd. in Letherby 185).

However, many feminists have taken a more critical approach to this at once power-laden and power-free version of ethnography and methodological practice. How can we really immerse ourselves so thoroughly that our bodies no longer matter? Who gets to be the "native," and how does using this very problematic signifier once again reiterate the colonial structure of the knower versus the known?

As someone who was born in what we now call Canada yet has parents who are from the Caribbean, it may seem that I would have an "in" with research participants, compared to another scholar seeking immersion but having no common history. However, my own experience of place, space, and home has often been complicated—similar to many children of immigrants of colour who have been born in the West. In the country of my birth, Canada, I am repeatedly asked, "but where are you really from?" and in the Caribbean, I am identified as having "come from foreign." Postcolonial feminist scholars have talked about this dilemma: how can someone be knowable as a researcher yet remain unknown (Narayan)?

In my fieldwork experience, my pregnant body became a central

focus of my research from the time I introduced myself to my respondents. Many commented on my dedication to my research project by coming into the field "in my condition."

My "condition" also connected me to my research site in ways I did not expect. For instance, I spent a lot of time talking to older women about their experiences as Girl Guides organizers, as mothers and as wives. Not being either at the time, I never thought that my impending birth would be seen as an "in" to discussions of motherhood. Many of my respondents talked to me about having their children with them while in meetings and about the importance of linking motherhood with their lives as guides. They would then turn to me and ask how a new baby would affect my methodological practice:

Respondent 1: And I see the whole Guide thing as a family, and it has been a way of life for me. My children [laughs] didn't have any choice! They lived Guiding and breathed Guiding as well. They were camping from—

Respondent 2: As babies.

Respondent 1: Yes.

Respondent 2: Her youngest girl, about so long, spent many nights out there in a tent.

Me: Really [laughing].

Respondent 1: They came here in the pram; we didn't have transportation then ... Pushed her here in the pram. She's on the patio and the Guides will take turns and going to looking at her to see if she's okay. And they have come along that way. Will you bring your baby with you next time?

My experience of pregnancy and eventual motherhood allowed these women to tap into a series of memories about mothering—about including family in their own organizing—and then they connected this experience to my own. Pregnancy, therefore, became "important sources of shared knowledge and credibility" (Reich 356). To acknowledge the embodied experience of fieldwork allowed me to keep

in mind how these connections came about, and my data were enriched by acknowledging my body as a research tool.

Body as Monstrous and Hetero(Inaccessible)

Let me share another story on my fieldwork journey when my embodiment affected my field experience. In this excerpt from my field notes, I am at the local HIV/AIDS secretariat office waiting for an interviewee. A bit from my field notes:

> One man, who was in the office and intent on picking me up, tried to inform me that the publication I was reading was for men. I told him I knew, that I was a researcher and it would add to my notes. He then continued to try and pick me up. Up to this point, no one in Antigua or St. Lucia had tried to pick me up. The pregnant body (and the fact that the ring that my partner had given me for my thumb now only fits on my marriage finger) made it so that no man was interested. This man, however, did not notice I was pregnant. After he told me I looked beautiful, I told him that I was pregnant. He immediately moved across the room, sat in a chair, and refused to look at me.

Recently, I have been teaching my students about the body as "abject," specifically the female body as monstrous and grotesque. The pregnant body is one such monstrous body, as it crosses the boundaries of the rational singular person; its corporeality extrudes beyond the limits of the human (Ussher). At this moment, my fieldwork body shifted, such that I went from a (hetero)accessible body (albeit feminized, first-world body) to a monstrous, inaccessible, and heterosexual body. Although pregnant bodies are often seen as nonthreatening, in this instance, I felt as if my body were threatening. Heavy with fecundity, what did my body represent to this man? Commitment? Financial risk? Some other man's property? Was I indeed wearing, as Helen Morton states, a "symbolic chastity belt?" (127). If I had been able to glean any information from this person, who could have been a potential informant, his experience of my body would have already affected the data I would eventually collect. In perhaps a problematic way, but in a way makes the point that bodies matter, R. Behar argues the following:

The woman anthropologist, the woman who writes culture, also has breasts, but she is given permission to conceal them behind her pencil and pad of paper. Yet it is at her own peril that she deludes herself into thinking her breasts do not matter, are invisible, cancer won't catch up with them, the male gaze does not take them into account. (qtd. in Reich 356)

And the question should not be how well you fit in your field locale. For those of us asking feminist questions about methodologies, we understand that "going native" is not something we would want to do if we are questioning the effect of our presence on our subject matter. What is important is to understand that through the process of fieldwork, we continue to embody various notions that will affect our experience in the field.

Body as Normative Nation Builder

My body was also implicated in normative ideas of family, sexuality, and gender. In such ways, my embodiment of pregnancy, Blackness, and assumed heterosexuality worked to shape me as a normative (re) producer for a number of respondents. I never outed myself as queer or as pregnant from donor sperm. The cultural reference in the Caribbean, however, did not require much talk about a father or even of marriage. Even still, it was assumed that I had both of these things present in my experience of pregnancy and motherhood.

In many of my interviews respondents asked me about my pregnancy and my thoughts on family. Many asked me if I wanted a boy or a girl, or as one respondent said, "a little boy scout or a little girl guide." This was not surprising to me, as many people had already asked me this outside of the field, as the general discussion of pregnant women's bodies and future children happens quite often. However, when reading my transcripts, I noticed how often my body and the body of my (as yet) unborn child would be interpellated into the colonial organization of guiding and into "new racialized genders." As I have argued elsewhere (Calixte), girlhood structured through guiding subverts normative assumptions about class, race, and gender for young Caribbean women, and I take this reading as important for these field relations. These discussions revealed one way my embodied

experience of pregnancy enacted various discourses of normativity within my research relationships and influenced the data I collected in the field.

Two experiences highlight this for me. Firstly, my embodied experience of race, class, and pregnancy (and, therefore, sexuality) was mostly viewed as a space of normative nation building. For instance, one respondent in our first interview took no time asking me about my plans for my child:

Respondent: What you hoping for boy or girl?

Interviewer: I'm actually hoping for a boy [laughing].

Respondent: Like first boys carry on the family name.

This question was the first one asked by my informant after I said, "is there anything you would like to ask of me?"

A more complex reading of normativity onto my pregnant body occurred in my second field site with a seventy-year-old Barbadian woman who had been a girl guide and leader in the early 1940s. This respondent shared with me her thoughts on unwed mothers being allowed to serve as leaders in the organization.

Respondent: But I find children nowadays are well ... they will tell you it's a different age and tell you you're old-fashioned and so on. But even some of the leaders would think I suppose that I'm old-fashioned in my methods and things when I was commissioner.

Me: Really? Why do you think so?

Respondent: When I was the chief commissioner ... they had a rule that if you are an unwed mother you couldn't be a leader.

Me: You couldn't be a leader.

Respondent: No. Well before I left, they, most of the guiders, were saying that they don't see that. That everybody is accepting unwed mothers and everything. I said, "Yes. But I mean if you are an

unwed there are certain things that if you are going to be face-to-face with the child itself." I'm not saying that they weren't good leaders either though, but you know.

What were her assumptions about me, such that she felt she could share this information with me? Her "but you know" statement implies a shared understanding—a shared assumption that single motherhood, or even unmarried mothers, would not make good leaders or were flawed in terms of their moral conduct. As I sat in front of her, was she assuming that I was properly paired off and was bringing this child into her idea of a stable nuclear family?

What is more interesting than her assumptions of my position as a normative (re)producer is the effect of my bulging belly on her mind. Would she have shared this information with me if I were not pregnant? Did she think I would be easier to sway with her opinion, since I am obviously invested in the process of baby making, mother-hood, and, therefore, cementing the ideal nuclear family? Of course, I will never know. However, this experience made me realize the significant effect my body had on my relationships with my respond-ents as well as the inability to ignore the realities of the body. As Jennifer Reich states, "the body invokes ideas around gender, sexuality and marital status" (362). I would add that those ideas are often normative ones, which invest the body with a significatory power that precludes ideas challenging the nuclear, heterosexual family.

My mother was also present in this exchange, and, in fact, I believe worked to legitimate my presence. Throughout my research, my mother's status as a Diasporic, West Indian born, Black, middle-class woman allowed me access to many of these women who shared similar racial and class positionalities as her. Her presence also legitimated me as a moral and upstanding normative (re)producer and silently vouched for my presence at these interviews. I believe this also affected my informants' ease at talking to me about the moral character of unwed mothers without concern, as my middle-class West Indian mother's presence validated to them that I was not in that category.

Conclusion

> Much of my academic training has been designed to show me
> that I must alienate myself from my communities, my families
> and even from my own self in order to produce credible
> intellectual work. —Collins qtd. in Shope 58

Embodied pedagogy and methodology acknowledge "the
interaction between theory and the particularities of the lived exper-
ience" (Shope 58). Feminists have sought this kind of intersectional
and complex analysis in all the work they do and have encouraged us
to think about how our bodies are present inside and outside of the
field. These three sites of embodiment were crucial for me, as I
uncovered an important aspect of my fieldwork that necessitated an
analysis that made disembodied fieldwork impossible.

The larger question for me is how these experiences, this embodied
fieldwork practice, affected my own understandings of decolonizing
methodologies. As Linda Tuhiwai Smith discusses in her work, the
idea of "distance," which is an outgrowth of a disembodied fieldwork
practice, is itself a colonial practice. By neutralizing the body, you
allow yourself distance from the researched. Distance provides power:
power over the subject and power over their knowledge. By distancing
yourself, becoming an outsider to the research subject, you begin to
stratify knowledge. This is not a methodology I want to participate in.

However, when you make yourself present in the field and
acknowledge the boundaries of your body and the effect your body has
on the research relationship, you initiate a reflexive methodology
necessary for a feminist and anticolonial project. You begin to ask
questions about your social location and about the larger and more
complex network of relations in which you study. You begin to move
towards a decolonized methodology—a practice that insists knowledge
seeking and knowledge production cannot occur without acknow-
ledging the body as a research tool.

Works Cited

Avis, Hannah. "Whose Voice Is That? Making Space for Subjectivities in Interviews." *Subjectivities, Knowledges, and Feminist Geographies: The Subjects and Ethics of Social Research*, edited by Liz Bondi, Hannah Avis, and Ruth Bankey, Rowman and Littlefield, 2002, pp. 191-207.

Bain, Alison L., and Catherine J. Nash. "Undressing the Researcher: Feminism, Embodiment and Sexuality at a Queer Bathhouse Event." *Area*, vol. 38, no.1, 2006, pp. 99-106.

Calixte, Shana L. "Beyond 'Us' vs. 'Them': Transnationalizing Girlhood Studies." *Difficult Dialogues about Twenty-First Century Girls*, edited by Donna Marie Johnson and Alice E. Ginsberg, SUNY Press, 2015, pp. 145-178.

Coffee, Amanda. *The Ethnographic Self: Fieldwork and the Representation of Identity*, SAGE Publications. 1999.

Frohlick, Susan E. "'You Brought Your Baby to Base Camp?' Families and Field Sites." *The Great Lakes Geographer*, vol. 9, no. 1, 2002, pp. 49-58.

Hall, Wendy A., and Peter Callery. "Enhancing the Rigor of Grounded Theory: Incorporating Reflexivity and Relationality." *Qualitative Health Research*, vol. 11, no. 2, 2001, pp. 257-272.

Letherby, Gayle. *"Quoting and Counting: An Autobiographical Response to Oakley."* Sociology, vol. 38, no. 1, 2004, pp. 175-189.

Martin, Patricia Yancey, and Barry A. Turner. "Grounded Theory and Organizational Research." *Journal of Applied Behavioral Science*, vol. 22, no. 2, 1986, pp. 141-157.

Morton, Helen. "My 'Chastity Belt': Avoiding Seduction in Tonga." *Taboo: Sex, Identity, and Erotic Subjectivity in Anthropological Fieldwork*, edited by Don Kulick and Margaret Willson, Routlege, 1995, pp. 168-185.

Narayan, Kirin. "How Native Is a 'Native' Anthropologist?" *American Anthropologist: New Series*, vol. 95, no. 3, 1993, pp. 671-686.

Ortbals, Candace D., and Meg E. Rincker. "Embodied Researchers: Gendered Bodies, Research Activity, and Pregnancy in the Field." *PS: Political Science and Politic*, vol. 42, no. 2, 2009, pp. 315-319.

Reich, Jennifer A. "Pregnant with Possibility: Reflections on Embodiment, Access, and Inclusion in Field Research." *Qualitative Sociology*, vol. 26, no. 3, 2003, pp. 351-367.

Rosaldo, Renato. *Culture & Truth: The Remaking of Social Analysis.* Routledge, 1993.

Shope, Janet Hinson. "Reflections on the No-Uterus Rule: Pregnancy, Academia, and Feminist Pedagogy." *Feminist Teacher,* vol. 16, no. 1, 2005, pp. 53-60.

Smith, Linda Tuhiwai. *Decolonizing Methodologies: Research and Indigenous Peoples.* Zed Books, 2002.

Ussher, Jane M. *Managing the Monstrous Feminine.* Routledge, 2006.

Chapter 11

Fields of Care: An Autoethnography of the Politics of Pregnancy and Foodwork in Aotearoa/ New Zealand

Emma Sharp

Introduction

My experience as a visibly pregnant researcher in the field involved demonstrations of care in ways that were variously subtle, overt, and sometimes unexpected, but above all complex. Spaces of care were enacted in interesting ways when I—and my unborn child—engaged in autoethnographic food studies fieldwork in particular spaces. In this chapter, I discuss the spaces of a foodbox distribution hub and a literal field (of kale). My broader research in Auckland, Aotearoa/New Zealand (Aotearoa/NZ) interrogates research methods, epistemologies, and practices that assemble new and diverse understandings of food normally seen as alternative to conventional food (Sharp et al.). This alternative food is normally discussed in contexts of urban, upper-middle-classes of the Global North. My fieldwork was undertaken from 2013 to 2015 and specifically explored the question: what political work do 'alternative food initiatives' do? (Sharp). This was done using diverse methods, including

questionnaires, ethnography and autoethnography.

One might expect that embodied studies of food systems should involve a food researcher's focus on publicly demonstrating care for themselves and for ethical food production, which includes both human eaters and nonhuman others (e.g., animals, pollinators, or soils). As a visibly pregnant researcher engaged in foodwork, however, I found that care in the field was shown *to me* by research participants as well as *by me* for the actors in the field in unpredictable ways and places.

In this chapter, I ask how spaces of care are constructed in participatory food fieldwork with a pregnant researcher. I address this question by exploring personal and ethnographic evidence that "make[s] social realities and worlds" by enacting rather than just describing (Law and Urry 390). I engage feminist and food geographies in my enquiry and relate these to embodied fieldwork; I couch this discussion in the key themes of the regulation of motherhood, vulnerable bodies, and political food projects as expressed through care. I acknowledge that my account is partial and situated (Haraway), since I consider different care spaces simultaneously: at interstices in the field where my body's affect is materialized, and, my own body as a site of the field's affect. I locate myself and my co-participants in positions of relative privilege in the spaces where we embody food knowledge and politics. In this context, I examine two cases of care for me and by me as a pregnant researcher in the spaces of food fieldwork.

Care in Pregnancy, Food, and Fieldwork: A Review

Although many voices affect the pregnant (food) researcher, there are two dominant ones that I interrogate in relation to performances of care. They are mothers as peers and voices of intensive mothering (e.g., Bobel) and the voice of public health (e.g., Ruhl). Below, I review how these voices speak to, regulate, and construct vulnerable pregnant bodies and build political food projects around them all in the context of feminist geographies.

Contextual Feminist Geographies

Through powerful explorations of embodiment, body politics, and the (de)construction of the gendered subject, feminist geographers have provided a solid platform to assemble the particular areas of interest in this chapter: spaces of care (Puig de la Bellacasa; Fisher and Tronto),

spaces of pregnancy (Longhurst; Bobel), and spaces of foodwork (Probyn; Longhurst et al.). These provocative works have disrupted a discipline charged with cultivating only acceptable geographical knowledge that occupies "a masculine subject position" (Rose 4). Early feminist geographers confronted the privileging of mind over body in the ways that academic knowledge was traditionally produced, and, in so doing, they validated the use of corporeal and embodied knowledge to break down gendered binaries (Grosz). Elspeth Probyn's *Carnal Appetites* queried intersections of self, other, and food—a platform for more recent work on the politics of emotions, the viscerality of food, and the politics of eating (Hayes-Conroy and Hayes-Conroy; Longhurst et al.). Combining these knowledges with Robyn Longhurst's critical work depicting pregnant bodies in space as social constructs allows us to see clearly how spaces of care may be created for a pregnant researching body doing foodwork.

Regulation of the Pregnant, Vulnerable Body

A modern, neoliberal, and Western understanding of the pregnant body embodies the interests of the mother, the unborn baby, and the outside community in a form of collective responsibility (Longhurst; Piering). This responsibility could be read as an obligation to act on behalf of the baby and pregnant woman by controlling, surveilling, or protecting pregnancy. Women's regulation in particular places is due to, in part, a perceived mistrust in a mentally and physically unpredictable pregnant body (Longhurst; Bobel), which poses a risk to a rational public order (Longhurst). The pregnant body's risk to the ordered Western world can be policed reflexively,[1] through peers, via consumer branding, or through the masculinized channels of governmental guidance.

The rhetoric of the risky but also vulnerable pregnancy draws lines around pregnant mothers. Regardless of their socioeconomic status, pregnant women in Western society are seen institutionally, and are translated societally, as objects of concern, which places them in the company of the very young, elderly, and immunosuppressed. State-issued food-safety guidance in Aotearoa/NZ for pregnant women demonstrates the protective care given to them. These guidelines advise pregnant women not to consume foods that may be unsafe for them—for example, raw milk, raw meat or shellfish, soft cheeses, unrefrigerated salads, mayonnaise, or alcohol, and limits are also

placed around substances like caffeine ("Eating for Healthy Pregnant Women"). The impetus to regulate the vulnerable pregnancy also extends to the vulnerable infant, which is clearly seen in debates on the rights and moralities of mother and child in breast- or bottle-feeding politics (Ruhl; Boyer; Lintott and Sander-Staudt). Breastmilk substitutes are made invisible and largely inaccessible through the public health system (including most hospitals and maternity units) based on Aotearoa/NZ law,[2] and images of real babies are not legally permitted to be associated with breastmilk supplement advertising ("Implementing and Monitoring"). Furthermore, a "breastfed is best fed" pop-up appears on infant formula retailer websites in Aotearoa/NZ, which exercises psychological control by requiring viewers to click "I agree" to access their webpages (e.g., Aptanutrition NZ).

A feminist politics of pregnancy has examined the regulation of the pregnant body in liberal governance environments (Ruhl) and has observed that vulnerable, including pregnant, bodies are increasingly being "recast as ... 'clients' and 'consumers'" (Dombroski et al.) as a way of managing and capitalizing on this construction of vulnerability. This trend is also evident in the medicalization of maternal care and birthing practice (Dombroski et al.). The neoliberal language of this care, where the mother is a client or a consumer may indicate that she is just one amongst other shareholders in the assemblage of caring, and cared for, bodies. The medicalization of maternal care may indicate a statistical calibration of the care required, that prioritizes the infant. Therefore, caring for pregnant bodies does not always place mothers' perspectives first. The needs of mothers of unborn and young children are often obscured, whereas the needs of others, often those of the child (and sometimes the partner), take precedence (Benson and Wolf). This prioritization and complexity builds on conceptualizations of the entwined yet discrete ontologies and epistemologies of the pregnant woman and unborn child (Kristeva; Fischer), which are reflected in the complex spaces pregnant women occupy.

Political Food Projects Expressed through Care: The Example of the Organic Child

Recent feminist food studies in the Global North have looked at how "structural/economic and discursive/rhetorical processes work to maintain alternative food movements as largely liberal, white (European-American) upper-middle-class groups" (Hayes-Conroy and Hayes-Conroy 2956). Furthermore, care discourses around risk, regulation, and recommendation are open to different interpretations based on the privileges associated with access to information. The vast majority of Western pregnancy and infant food guidance is found in medical journals (e.g., nutrition guidance), is co-opted by corporations with neoliberal agendas (e.g., advertising of baby foods and mothers' supplements), or is found in online media but without critical engagement.

Although it is largely inaccessible to mainstream audiences, there is critical academic food research that interrogates the privileged politics of natural maternal caring, including feeding (Bobel) and under-standing how some bodies are enacted as privileged eaters (Cairns et al.). Kate Cairns and colleagues discuss how political values influence "careful consumption," which determines the food choices made by carers for children. They show how political food projects are expressed through care in the cultivation of an "organic child," where care of the child is simultaneously an act of caring for the environment and is attributed to light-on-the-earth food production processes. The moniker "vegetarian child" also helpfully parallels the actual ingestion of the politics imbued in the food itself (for example, food produced through caring for the environment as well as the human labour and animals involved). It appears, though, that the political project of the organic child is a project dependent on access to time and money (Cairns et al.). Whereas in other times, places, and geographical spaces, other groups of pregnant women might have found themselves under surveillance for not feeding their babies enough food, the right kind of food, or food not part of the dominant food culture, the "organic child" in the context described above, is a middle-class invention raised by a nutritionally well-informed, media-influenced mother with a disposable income. Health literature and advice around organic food therefore tends to be oriented towards the middle classes (Cairns et al.).

A tiered approach to food guidance is also seen in the Aotearoa/NZ government's approach to maternal care through racially coded food advice (Guthman). The government website "Eating for Healthy Pregnant Women," for example, leads with recommended serving sizes for:"kūmara, cassava ... taro, kamokamo or yam." These are vegetables typically eaten by Māori and Pacific Island families, and less so by Pākehā[3] families. Race and class, therefore, appear to present a different context of care in these spaces of food and pregnancy politics. The organic child is, thus, an iteration of the consumption patterns through which a pregnancy may be moderated or cared for.

Contemporary critical food scholarship connecting pregnancy and more marginalized eating politics also includes the work of Julie Guthman, Sandy Brown, and Egla Martínez-Salazar, all of whom discuss the politics of fetal safety in farm labour. Martínez-Salazar— whose work maps food supply chains and gendered, racialized labour in North America—reflects on her own mother's experiences as a food worker exposed to pesticides, which ultimately caused the death of her infant sister. Further, in Aotearoa/NZ, Naomi Simmonds has documented how mainstream antenatal classes are designed to teach parents about aspects of birthing and parenting, but because of their cultural, political, and social specificity, these teachings can silence marginalized or Indigenous knowledges and practices around such things. These accounts are nearly invisible in public discourse, however.

Embodying Mothering and Food Care Work in the Field

Participant-led ethnographic fieldwork in food studies offers opportunities to work with and eat food: often participants are keen to demonstrate their identity politics by sharing what they eat, grow, or supply. I present such embodied experiences from the field in two cases below and relate them to the feminist, food, and care literatures discussed. These cases illustrate differing moments of care, in which caring for the pregnant body is simultaneously about the regulation of the mother.

Case 1: The Foodbox Packing Shed

As food packers, we assembled weekly at the delivery hub for a foodbox initiative. Boxes we packed were preselected by the customers based on their priority for local or organic food. On the packing line, we noticed the taste and the sense of food, which included eating samples of produce as we worked.

In my final week as a foodbox packer, I had a weak back, as my ligaments softened with pregnancy, and it was difficult to lift produce crates. The regular packers were thoughtful and were, by my perception, caring when they lifted and positioned crates to help me pack customer boxes.

This food packing situation was complex in a way that I had not anticipated when others positioned crates on the packing line for me. By not choosing the crates myself and given the speed that we worked at, I could not decide which produce I was working with, organic or not which, it transpired, I felt rather strongly about as a pregnant woman. In the previous weeks, I had automatically positioned myself to work with the organic produce. Our box packing practices of brushing off soil, removing browned leaves and insects, and, sometimes, tasting food were restricted due to my own comfort with the riskiness of being in repetitive direct contact with produce that may harbour pesticide or herbicide residue. The government's "Guidelines for the Prevention of Pregnancy Discrimination" lists "pesticides, herbicides, and fertiliser" (22) as examples of chemicals that may be harmful during pregnancy and that pregnant women are within their rights, or are obligated, to avoid in the workplace. I perceived the organic produce crates to be safer as I saw insects still roaming around those organic vegetables.

The acts of care produced unexpected consequences that confronted my own self-surveillance, self-control, and self-discipline, as well as my own performance, during the fieldwork. Self-care responses included not eating the produce and ensuring I was wearing gloves. By not eating during my research, I eliminated an immersive aspect of my fieldwork—my sensing of food through taste, which I had resolutely sustained up until this time given my research focus on food's affect. In this case, the enactment of caring spaces also created a disjuncture in

my tacit engagements with food. What this context did offer, however, was the opportunity to consider other types of visceral affects (Hayes-Conroy and Hayes-Conroy) beyond taste that I could still access safely by my own measure. These included attuning to the visible features and odours of the vegetables and hearing the descriptions of taste offered by my fellow participants, which led to further conversations about growing, preparing, and cooking food.

The case presented here was a scenario that eventually led me to curtail my participatory fieldwork with the foodbox initiative, as I struggled to manage the boxes while pregnant. I removed myself as an act of self-care. However, recognizing my privilege to choose my work environment and to maintain my values is critical here. Tellingly, the experiences of pregnant farm workers in precarious positions with limited capacity to protest are rarely discussed in food scholarship or public discourse (Guthman and Brown).

Case 2: The Organic Vegetable Farm

Surrounded by the organic vegetables, I had a sense of safety, wellbeing, and care in my work, particularly where life as a pregnant woman and researcher meant that I was alert to everyday or fieldwork hazards. My experience of wellbeing at the organic farm altered when on a meal break, a farmer offered me raw honey that his brother had harvested from his bees. He had made a special effort to have some ready for me to try as an "alternative food systems researcher." I accepted his offer carefully.

By researching and participating in alternative food in an effort to generate new ethical, political, and economic practices, I perform my politics of care for the environment, for plants and animals, and for producers and consumers. I do have an interest in the politics of raw honey production, especially how it differs from industrial processing and it is mindful of both the bees' and beekeepers' welfare. Even though the benefits of caring for bees were clear to me, the offer of consuming raw honey was not straightforward.

Health departments internationally vary their advice on pregnant women consuming raw honey. Unlike raw milk which is advised

against being eaten, the "Eating for Healthy Pregnant Women" web-site does not have "raw honey' on its do not eat list. It does, however, have "honey" on its safe list. No honey of any description is listed on the "List of Safe Food in Pregnancy" website. To further fuel this ambiguity, individuals on a number of international mothering websites—with mothers as peers and voices of intensive mothering—variously recommend or warn against eating raw honey while pregnant. My participant's caring practice was to offer me a choice in line with his perception of my own care interests. The complexities of fieldwork meant that turning down this offer could also have had consequences for my research and access to this participant and others in the field. I ate the honey in this context; my sense of safety was perhaps mediated by a fieldwork environment where I otherwise felt unregulated and unthreatened by external factors—for example, accessing a mostly chemical-free (certified-organic, at least) worksite and reading national governmental guidance websites that did not discourage me from eating raw honey. My choice to eat honey but limit my exposure to food industry chemicals may seem contradictory, although feminist scholarship is helpful to draw on here to observe that "taking responsibility for what and whom we care for doesn't mean being in charge" (Puig de la Bellacasa 98); rather, it permits power to be relinquished and, thus, transfers agency beyond the self. Given the context of a particular food object, site, and moment, privileged with particular knowledge, I accepted this thought-full gift of food as my own performance of care for what the raw honey symbolised, but also my participant who had offered me a choice.

Complexities in Spaces of Care

I return to ideas of being care-full but simultaneously thought-full by enacting a philosophy of care prioritizing the cared for. My pregnant, eating, and food-researching body enacted care for human and nonhuman others in the field through practicing a particular food politics and accepting thought-full food gifts. The field's *affect* materialised in my pregnant researching body through my attention to the thought-full as well as care-less performances that were intentioned as others' acts of care for my body and baby.

The field's and my own affect materialized in my experiential

learning that total immersion for a perfect ethnographic experience was a fiction. Having undertaken participatory fieldwork without a child on board previously, like Drozdzewski and Robinson, I was compelled to consider how this fieldwork experience was changed by having my unborn baby present. In prior fieldwork, I had similar opportunities to "explore [and] immerse" (Drozdzewski and Robinson 372), somewhat unimpeded. It was clear that these contexts examined above were different, and although there were barriers to certain engagements, these also afforded other opportunities (e.g., sensing food in different ways) for a pregnant body conducting fieldwork.

The "changing geography of where [and how] care-work takes place" (Boyer 231) was reflected in these experiences above—where enactments of care were made with intention. For me, pregnancy in fieldwork meant mixing deliberate care work with fieldwork, and this mixing enacted multiple, unexpected spaces of care, which informed the processes and outcomes of my research and my own subjectivity.

Endnotes

1. Including practices of self-surveillance, self-control, and self-discipline (see Foucault).
2. This law is based on The International Code of Marketing of Breastmilk Substitutes, as executed by the World Health Assembly in 1981 to keep marketing practices compliant with the code.
3. Pākehā here refers to Aotearoa/NZ-born people of European descent. Though controversial in Aotearoa/NZ (Larner and Spoonley), the term is currently used as a category for ethnicity in the Aotearoa/NZ census.

Works Cited

Aptanutrition NZ. *Aptanutrition*. 2017, www.aptanutrition.co.nz/. Accessed 19 May 2017.

Benson, Jennifer, and Allison Wolf. "Where Did I Go? The Invisible Postpartum Mother." *Philosophical Inquiries Into Pregnancy, Childbirth, and Mothering: Maternal Subjects*, edited by Sheila Lintott and Maureen Sander-Staudt, Routledge, 2012, pp. 34-48.

Bobel, Chris. *The Paradox of Natural Mothering.* Temple University Press, 2002.

Boyer, Kate. "The Way to Break the Taboo Is to Do the Taboo Thing: Breastfeeding in Public and Citizen Activism in the UK." *Health & Place,* vol. 17, no. 2, 2011, pp. 430-437.

Cairns, Kate, et al. "'Feeding the Organic Child': Mothering through Ethical Consumption." *Journal of Consumer Culture,* vol. 13, no. 2, 2013, pp. 97-118.

Dombroski, Kelly, et al. "Beyond the Birth Wars: Diverse Assemblages of Care." *New Zealand Geographer,* vol. 72, no. 3, 2016, pp. 1-10.

Drozdzewski, Danielle, and Daniel Robinson. "Care-Work on Fieldwork: Taking Your Own Children into the Field." *Children's Geographies,* vol. 13, no. 3, 2015, pp. 372-378.

Fisher, Berenice, and Joan Tronto. "Toward a Feminist Theory of Caring." *Circles of Care: Work and Identity in Women's Lives,* edited by Emily Abel and Margaret Nelson, State University of New York Press, 1990, pp. 35-62.

Fischer, Sally. "Being Bovine." *Philosophical Inquiries into Pregnancy, Childbirth, and Mothering: Maternal Subjects,* edited by Sheila Lintott and Maureen Sander-Staudt, Routledge, 2012, pp. 191-214.

Foucault, Michel. *Discipline and Punish: The Birth of the Prison.* Translated by Alan Sheridan. Penguin. 1977.

Grosz, Elizabeth. *Volatile Bodies: Toward a Corporeal Feminism.* Indiana University Press. 1994.

Guthman, Julie. "'If Only They Knew': Color Blindness and Universalism in California Alternative Food Institutions." *The Professional Geographer,* vol. 60, 2008, pp. 387-397.

Guthman, Julie, and Sandy Brown. "I Will Never Eat Another Strawberry Again: The Biopolitics of Consumer-Citizenship in the Fight Against Methyl Iodide in California." *Agriculture and Human Values,* vol. 33, no. 3, 2016, pp. 575-585.

Haraway, Donna. "Situated Knowledges: The Science Question in Feminism and the Privilege of Partial Perspective." *Feminist Studies,* vol. 14, no. 3, 1988, pp. 575-599.

Hayes-Conroy, Alison, and Jessica Hayes-Conroy. "Visceral Difference: Variations in Feeling (Slow) Food." *Environment and Planning A*, vol. 42, no. 12, 2010, pp. 2956-2971.

Kristeva, Julia. "Women's Time." *Signs*, vol. 7, no. 31, 1981, pp. 13-35.

Larner, Wendy, and Paul Spoonley "Postcolonial Politics in Aotearoa New Zealand." *Unsettling Settler Societies: Articulations of Gender, Race, Ethnicity and Class*, edited by Daiva Stasiulis and Nira Yuval-Davis, 1995, SAGE Publications, pp. 39-64.

Law, John, and John Urry. "Enacting the Social." *Economy and Society*, vol. 33, no. 3, 2004, pp. 390-410.

Longhurst, Robyn. *Geographies That Matter: Pregnant Bodies in Public Places*. University of Waikato, 1996.

Longhurst, Robyn, et al. "A Visceral Approach: Cooking 'at Home' with Migrant Women in Hamilton, New Zealand." *Transactions of the Institute of British Geographers*, vol. 34, no. 3, 2009, pp. 333-345.

Martínez-Salazar, Egla. "The 'Poisoning' of Indigenous Migrant Women Workers and Children: From Deadly Colonialism to Toxic Globalisation." *Women Working the NAFTA Food Chain: Women, Food & Globalization*, edited by Deborah Barndt, Sumach Press, 1999, pp. 99-112.

New Zealand Ministry of Health. "Eating for Healthy Pregnant Women," *Ministry of Health*, 1 July 2010, www.healthed.govt.nz/system/files/resource-files/HE1805_Eating%20for%20healthy%20pregnant%20women.pdf. Accessed 19 May 2017.

New Zealand Ministry of Health. "Implementing and Monitoring the International Code of Marketing of Breast-milk Substitutes in New Zealand: The Code in New Zealand," *Ministry of Health*, 6 Aug.2007. www.health.govt.nz/system/files/documents/publications/breast-milk-substitutes-marketing-code.pdf. Accessed 19 May 2017.

New Zealand Ministry for Primary Industries. "List of Safe Food in Pregnancy," *Ministry for Primary Industries*, 28 Jan. 2016, www.mpi.govt.nz/food-safety/pregnant-and-at-risk-people/food-and-pregnancy/list-of-safe-food-in-pregnancy/. Accessed 19 May 2017.

Piering, Julie. "The Pregnant Body as a Public Body." *Philosophical Inquiries into Pregnancy, Childbirth, and Mothering: Maternal Subjects*, edited by Sheila Lintott and Maureen Sander-Staudt, Routledge, 2012, pp. 178-190.

Probyn, Elspeth. *CarnalAppetites: Foodsexidentities.* Routledge, 2000.

Puig de la Bellacasa, Maria. "Matters of Care in Technoscience: Assembling Neglected Things." *Social Studies of Science,* vol. 41, no. 1, 2010, pp. 85-106.

Ruhl, Lealle. "Liberal Governance and Prenatal Care: Risk and Regulation in Pregnancy." *Economy and Society,* vol. 28, no. 1, 1999, pp. 95-117.

Sharp, Emma. *Enacting Other Foodworlds: Affective Food Initiatives Performing a Care-full Politics of Difference.* University of Auckland, Te Whare Wānanga o Tāmaki Makaurau, 2018.

Sharp, Emma, et al. "Alternative Framings of Alternative Food: A Typology of Practice." *New Zealand Geographer,* vol. 71, no 1, 2015, pp. 6-17.

Simmonds, Naomi. "Transformative Maternities: Indigenous Stories as Resistance and Reclamation in Aotearoa New Zealand." *Everyday Knowledge, Education and Sustainable Futures: Transdisciplinary Research in the Asia/Pacific Region,* edited by Margaret Robertson and Po Keung Eric Tsang, Springer, 2016, pp. 71-88.

Part III

Spatial Practices and the Regulation of Motherhood

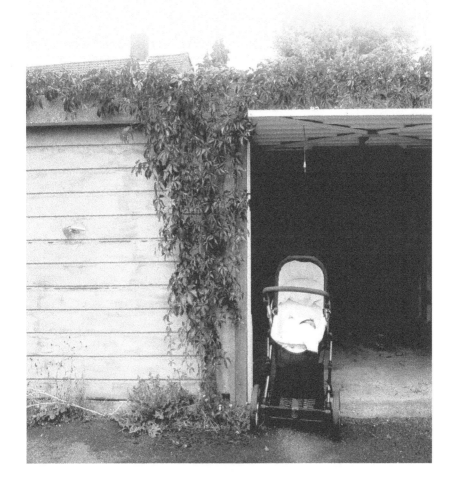

Chapter 12

Engineering the Good Mother: A Case Study of Opportunity NYC

Carolyn Fraker

In the spring of 2010, headlines across New York City (NYC) declared Mayor Bloomberg had failed at his most aggressive antipoverty intervention: Opportunity NYC (ONYC). The *Daily News* boomed: "Program that offered cash rewards to poor families that did the right thing isn't the cure all officials hoped it would be" (Lucadamo), whereas *The New York Times* led with the front-page headline: "City Will Stop Paying the Poor for Good Behavior" (Bosman). Bloomberg's pilot poverty-alleviation program was unable to increase mothers' participation in education, health, and work above the unexpected high levels of engagement among the control group (Riccio et al; Riccio and Miller). After three years, ONYC ended.[1]

The majority of public assistance programs available to poor families in the United States (U.S.) are disciplinary initiatives that use a penalty system to require low-wage work (Soss et al.). In contrast, ONYC was designed to engineer poor mothers through positive incentives for behaviour that the city considered optimal. ONYC paid mothers cash for such activities as ensuring near-perfect school attendance and going to medical appointments (Riccio et al.). Underlying the program's premise were biased views of poor mothers of colour as well as a neoliberal vision that the city could compel mothers into compliant behaviour through a fee-for-service intervention (Brash; Hackworth). ONYC seemed to be an initiative that did not

punish or stigmatize mothers. However, the implication that simply because of poverty, mothers need the government to supervise their mothering feeds directly into the racist stereotype that poor (nonwhite) women who use public assistance are inherently bad or neglectful mothers (Connolly; Park; Tsing; Bridges). In contrast, middle-class and suburban (white) mothers supposedly fall naturally into a mothering role without prodding from outside influences (Connolly).

The work of feminist and critical race geographers offers a starting point for interpreting the sources of racist sexism levelled at mothers through a spatial lens. In her book *Demonic Grounds*, Katherine McKittrick challenges geographers to analyze how space, when assumed static, is used to colonize and dominate minority populations, which is then declared natural, since "space just is" (145-146). McKittrick argues that "practices of domination, sustained by a unitary vantage point, naturalize both identity and place, repetitively spatializing where nondominant groups 'naturally' belong" (xv). This domination is then assumed natural and suggests that "some bodies belong, some bodies do not belong, and some bodies are out of place" (xv).

In the U.S., stigma for receiving government aid correlates closely with the gradual opening of access to public assistance for minority populations (Quadagno; Abramovitz). What was originally a support of white motherhood (Skocpol) turned into a punitive public assistance program for single, nonwhite, and urban mothers who were deemed defective (Abramovitz; Gordon; Quadagno; Soss et al.). By labelling these women "welfare mothers," poverty discourse places value on the (white) married suburban working mother while implicitly devaluing the lives and wellbeing of families dependent upon public assistance. These dependent families are then coded as nonwhite and are assumed to occupy urban environments.

ONYC targeted mothers in impoverished neighbourhoods with majority nonwhite populations. The program presumed that the mothers occupying these specific neighbourhoods were culturally deficient, and, as explained above, this perception of cultural deficiency is tied to the racialization of poverty as "Black." Despite the fact that a large percentage of ONYC mothers identified as "Latino/Hispanic" and not as Black,[2] the total ONYC population was perceived through this same lens of cultural deficiency.[3] In designing ONYC, Mayor Bloomberg's team of experts started with this flawed under-

standing of poor urban mothering. ONYC's design was based on racist, sexist, and classist policy discourses that assume impoverished urban mothers do not meet the basic needs of their children. It was this trope of poor urban nonwhite motherhood that doomed ONYC to failure and obscured the fact that the ONYC mothers were not in need of a government program to fix their mothering to begin with.

The Birth of ONYC

ONYC was modelled after global conditional cash transfer (CCT) initiatives (Peck and Theodore). A World Bank project, CCTs are designed to encourage behaviour changes by attaching monetary incentives to desired behaviours, thereby changing the so-called bad behaviour of the poor (Fiszbein and Schady). A pilot research study using a random assignment model, ONYC enrolled about 4,800 families to the study split between the control and program groups (Riccio et al. 5). The program targeted the six highest poverty districts in the city and earmarked three categories of family life for behaviour change: health, education, and work (Riccio et al.).

To understand the design of ONYC, it is critical to question why these particular activities were selected. The design assumed that there was room for improvement within the program population, and if this assumption proved false, then the program group (despite receiving more money) would not significantly change its behaviour. The success of the program hung on the assumption that mothers in the target neighbourhoods were not maintaining their families' access to health-care, education, or employment.

ONYC's fee-for-service model assumed that the mothers could only be encouraged to do the right thing if paid to do so. ONYC mothers were trapped in the middle of two competing discourses of mother-hood: the deviant or "monster" mom (Tsing) and the "extraordinary mother" (Park). Monstrous for their apparent need of financial incentives, these mothers were also judged against a benchmark that expected them to possess a supermom ability to single-handedly overcome structural poverty and provide a middle-class future for their children. ONYC both overused and re-established these stereotypes, which doomed it to failure because of the designers' own inability to look beyond these tropes of poor motherhood.

The Lived Experience

In the summer of 2013, I interviewed fourteen ONYC mothers.[4] Entering the field, I was keenly aware that as a middle-class white woman, I looked more like the evaluators of ONYC than its participants. In fact, I was a former employee at MDRC,[5] the nonprofit research firm that evaluated ONYC. During interviews, I emphasized that my study was an independent project and not part of the larger ONYC evaluation. However, some women likely perceived me as an evaluator, and this could have led the mothers to approach me with caution. As a former member of the evaluation team, I felt a strong obligation to use my insider knowledge of ONYC to highlight the mothers' stories and to question the possibility that ONYC's design may have been undermined.

ONYC provided families with a substantial financial increase, on average earning "approximately 6,000 dollars during the first two years of the program" (Riccio et al. 7). This increased the income levels of the qualified families who otherwise earned an average of just under 9,900 dollars per year (Greenberg et al. 16). Therefore, when the program ended, many households faced a steep income decline. Knowing this, I was not surprised that every mother I met opened the conversation with a long allegory on the virtues of ONYC. A common refrain was surprise and disbelief when they had first learned the program existed, and then excitement that a city initiative was aimed at supporting poor mothers. As one mother exclaimed, "I couldn't believe it! [The program] was paying people to do what they were supposed to do anyways. I might as well check it out." Whereas ONYC viewed the mothers as negligent at best, the mothers in my sample, at least initially, looked favourably on the program.[6]

ONYC was a contrived program; it was set up as an experiment with a control group that was carefully monitored to make sure it ran smoothly. This included ensuring that no one had to wait in long service lines, that all support staff were respectful and attentive, and that the ONYC payments did not affect eligibility for other programs. The mothers I spoke with all had a history of negative interactions with social services staff. Mothers discussed ONYC in comparison with other social provisions in which they often felt disrespected and dehumanized. A mother of three from Brooklyn explained her view that public assistance was "actually punishing you for being poor."

Studies on public assistance offices and job training sites support this sentiment (Soss et al.; Korteweg). For women who had been treated with disrespect by the state, it did not take much for ONYC to surpass such a low threshold of decency.

"They Picked Me!"

Helen believed that ONYC was a positive reward for good mothering. An African American mother of three, Helen described how she had struggled to find work that paid an adequate wage, to locate safe housing, and to find good schools for her children. She took great pride in her role as a mother and believed that it was due to her success as a mother that she was selected for ONYC: "I was a parent who always kept up ... with my kids—make sure they went to the doctor and stuff. And then all of a sudden see [ONYC] called me. See, I ... always did what I had to do with my kids ... they picked me out as one of the people who often went to the doctor." Helen assumed that ONYC had selected her because she was a good mother. In actuality, Helen qualified for ONYC because she fit the threshold for the randomized sample: she lived in a qualifying neighborhood, received food assistance, and had a child entering fourth, seventh, or ninth grade (Riccio et al.). Helen's interpretation of ONYC's mission protected her sense of self and agency by providing a counter story to those circulating in the media. *The New York Magazine* referred to ONYC as the "good behavior bribe"—placing a clear derogatory connotation on the mothers' perceived need for a bribe in return for good behaviour (Thompson). In contrast, Helen refashioned ONYC as an exciting moment of recognition of her struggles against impossible barriers to motherhood.

Olivia, an African American mother of a teenage boy, expressed shock and amazement at Mayor Bloomberg's apparent personal investment in supporting her as a mother: "This rich white guy coming into the neighbourhood and giving ... money. That's how you feel.... All I known [sic] was that Bloomberg was rewarding my child for doing this program.... He was rewarding my child! ... It's not that I felt important... I felt that I was rewarded for doing good for me and my child." These accounts speak to the major fallacy at the heart of ONYC: the idea that poor urban mothers needed correcting. As one

mother stated, the tasks ONYC asked her to complete were normal: "That's why it wasn't hard for me to do because I was already doing it. I said, 'wow, I can get a little stipend and stuff for things that I'm already doing.'" This did not erase the burden of being told how to mother. Anne, a U.S. military veteran, described how before the program she would sometimes choose to keep her children home on snowy days. However, since they needed near-perfect attendance to receive the payments (Riccio et al.), she was forced to rethink her feelings about exposing her children to long commutes in bad weather.

"Are We That Bad?"

Misi greeted me in the hallway of her apartment, located in an outcropping of public housing complexes in Harlem, with her Chihuahua in her arms. A middle-aged African American mother of four, Misi described how when she first learned about ONYC, she assumed that the program was a hoax: "I am really skeptical about things that come to our neighbourhood ... because we have to fight and struggle so hard just to get a little bit of something.... It just sounded too good to be true.... I'm not going to see the money." Misi's doubt dissipated after submitting her first coupon and the payment showed up in her bank account. But her feelings of apprehension grew: "I'm a smart woman; I understand the program.... [But] I take my kids to the doctor all the time! This is just normal common sense, [and] you're paying us? Then I started feeling bad 'cause then I started saying, 'are we that bad of a race that you had to come into our neighbourhood to make us take care of our kids?'" Misi understood all too well that by filling out the coupons declaring that she had taken her daughter to a doctor appointment she was accepting the city's label of her as a failure. But just as she had faced such stereotypes with public housing, disability benefits, and food assistance, Misi also understood that the need for additional support for her children meant that she must jump through the hoops required by ONYC.

Unlike Misi, other mothers absorbed the negative stereotypes propagated by ONYC. Anne assumed that the program attempted to fix the habits of urban mothers, but she was unsure about why she had been included in the sample: "I feel like some people probably don't take their children to the doctor, and this program was designed for those people. And ... I know, 'cause I felt , 'oh they are paying me to do

stuff that I do anyways?' But there are people who don't do it. So maybe they were trying to find those people and encourage those people." This internalization of negative social stereotypes of poverty has been well documented in studies on public assistance (Gordon; Broughton; Korteweg). Documented by Chad Broughton as an "attribution paradox," women on public assistance often use the same negative language to describe other women on public assistance, and view themselves as an exception. One mother articulated this paradox clearly when talking about ONYC's goal of changing behaviour: "It's a shame that you gotta go through this ... for certain people to do better, but it's true." Given the broader social rhetoric surrounding public assistance, it is not at all surprising that these conceptions are often internalized.

After running for three years, ONYC ended. The program increased household incomes (Riccio et al.), and, as noted by the *New York Times*, "participating families were 16 percent less likely to live in poverty" during the program years in comparison with the control group (Bosman). Despite these positive effects, the program was presented as a failure for its inability to improve participants' behaviours concerning health and school above the control group (Lucadamo; Riccio et al.; Bosman). The press spoke about how "despite the incentives," families did not "do better at improving their health and education then nonparticipants" (Bosman). Left out was the nuance of these findings: the rates for use of preventative healthcare among the control group were already quite high, and "consequently ... [ONYC] had much less room to improve" (Riccio and Miller 57). In education, ONYC was found to have few effects on the performance of students (Riccio and Miller 42), since the challenges facing children who were struggling in school were too complex to be solved by a targeted financial incentive, which did nothing to help the child actualize their goals. Mayor Bloomberg ended the program declaring "If you never fail, I can tell you, you've never tried new, innovative things" (Bosman), which allowed ONYC's reputation to be cemented as a "grand experiment" while ignoring how the flawed assumptions about the target population set ONYC up for failure.

Conclusion

The mothers who shared their stories with me revealed two responses to ONYC. Mothers like Misi and Anne internalized the negative discourse that ONYC employed, and they either found ways to challenge it or assumed that they were mistakenly included in the sample. Meanwhile, Helen and Olivia saw the program as rewarding their already good behaviour, overplaying Mayor Bloomberg's role as picking out mothers to participate. The mothers who believed they were picked for their good parenting were also the most devastated by the program ending. Olivia asked me: "Why did [Mayor Bloomberg] end the program? ... when it stopped it just took something from me... It's like when you work a job, and you love working ... and then suddenly you get fired.... The next year the program was over."

The architects of ONYC fell victim to broad social stereotypes of poor nonwhite urban motherhood, which led to an initiative that did not match the needs of these mothers. This failure of ONYC was not a benign design failure. By implementing this high profile program, the initiative succeeded at reinforcing the stigmatization of the mothers involved. All the mothers had to grapple with ONYC's assumption that their children, neighbours, and selves were the sources of deviant motherhood. Also, newspaper coverage reified the "monster" mom for whom financial rewards could not overcome her neglect (Bosman; Lucadamo; Thompson). This marked the neighbourhoods targeted by ONYC as specific locations that house subaltern populations who are both "naturally" deviant (McKittrick 145-146) and the source of chaos, crime, urban decay, and negligent parenting.

ONYC was duplicated in its 2.0 version in 2011.[7] The new initiative did not have dramatically different results than the original initiative, and the ONYC model was not duplicated again (Miller et al.). Despite this failure, the idea that behavioural nudges should be incorporated into public policy remains a popular notion. Sheldon Danziger, the president of the Russell Sage Foundation, has made calls for policy advocates to incorporate behavioural economic policies into poverty-alleviation programs and to "reject the long-standing assumption that the poor are rational economic actors and embrace behavioural science instead" (Danziger).

When *The New York Times* declared ONYC a "failed program," the implication at the heart of the headline was that poor mothers were so

deviant that not even cash payments could encourage them to change. Mayor Bloomberg simultaneously announced ONYC's negative results and the planned ending of the program. Unintentionally, this public announcement confused both the ONYC mothers and the newspapers. Both misconstrued the program ending as caused by the results. In fact, the program had always been set up as an experimental pilot that would only run for a limited number of years (Riccio et al.). Ultimately, the reality of ONYC was obscured: from the beginning, the mothers who used ONYC were not in need of a government program to fix their mothering.

Endnotes

1. ONYC was designed as an experimental evaluation that would run for two school years (2007-2008 and 2008-2009) and then was extended for a third year until the summer of 2010 (Riccio et al. 1).

2. In the ONYC sample, 46 percent identified as "Hispanic/Latino" and 51 percent identified as "Black." Despite using the label "parent" throughout the official reports, over 94 percent were women and 62 percent were single (Riccio et al. 52). ONYC was a program that targeted single mothers of colour.

3. I use the terms "Black" and "nonwhite" in this chapter to describe both the ONYC population and the racist tropes of poverty that the program design enlisted.

4. All names used in this chapter are pseudonyms to disguise the identities of the mothers interviewed.

5. This organization was formally called Manpower Demonstration Research Corporation, but it officially changed its name to just MDRC in 2003.

6. Since some mothers likely viewed me as representing the ONYC evaluation or as a city representative, they might have felt some hesitation in criticizing ONYC. This might be one reason why so many mothers started the interview by framing ONYC as a positive initiative.

7. ONYC was duplicated in the Bronx, New York, and in Memphis, Tennessee, for a three-year initiative focused on incentivizing the grades and test scores of high school students (Miller et al.). Despite

being a "failed program," Jamie Peck and Nik Theodore explain how through the process of rigorous evaluation, CCTs (conditional cash transfers) are evaluated and duplicated. Peck and Theodore name this process "trans-nationalizing fast policy" and argue that CCTs in particular (as World Bank projects) lend themselves to quick implementation, evaluation, and duplication (2010).

Works Cited

Abramovitz, Mimi. *Regulating the Lives of Women: Social Welfare Policy from Colonial Times to the Present*. South End Press, 1988.

Bosman, Julie. "City Will Stop Paying the Poor for Good Behavior." *New York Times*, 30 Mar. 2010, www.nytimes.com/2010/03/31/nyregion/31cash.html. Accessed 6 Mar. 2019.

Brash, Julian. "The Ghost in the Machine: The Neoliberal Urban Visions of Michael Bloomberg." *Journal of Cultural Geography*, vol. 29 no. 2, 2012, pp. 135-153.

Bridges, Khiara. *Reproducing Race: An Ethnography of Pregnancy as a Site of Racialization*. University of California Press, 2011.

Broughton, Chad. "Reforming Poor Women: The Cultural Politics and Practices of Welfare Reform." *Qualitative Sociology*, vol. 26, no. 1, 2003, pp. 35-51.

Connolly, Deborah R. *Homeless Mothers: Face to Face with Women and Poverty*. University of Minnesota Press, 2000.

Danziger, Sheldon. *The Time to Incorporate Behavioral Insights is Now*. MDRC, 2017.

Fiszbein, Ariel, and Norbert Schady. *Conditional Cash Transfers: Reducing Present and Future Poverty*, A World Bank Policy Research Report, 2009.

Gordon, Linda. "Who Deserves Help? Who Must Provide?" *Annals*, vol. 577, 2001, pp. 12–25.

Greenberg, David, et al. *Learning Together: How Families Responded to Education Incentives in New York City's Conditional Cash Transfer Program*. MDRC, 2011.

Hackworth, Jason R. *The Neoliberal City: Governance, Ideology, and Development in American Urbanism*. Cornell University Press, 2007.

Korteweg, Anna. "Welfare Reform and the Subject of the Working Mother: 'Get a Job, a Better Job, Then a Career.'" *Theory and Society,* vol. 32, no. 4, 2003, pp. 445-480.

Lucadamo, Kate. "Poor Results Doom Anti-Poverty Project Opportunity NYC." *Daily News,* 31 March 2010, www.nydailynews. com/news/poor-results-doom-anti-poverty-project-opportunity-nyc-article-1.173295. Accessed 6 Mar. 2019.

McKittrick, Katherine. *Demonic Grounds: Black Women and the Cartographies of Struggle.* University of Minnesota Press, 2006.

Miller, Cynthia, et al. *Effects of a Modified Conditional Cash Transfer Program in Two American Cities: Findings from Family Rewards 2.0.* MDRC, 2016.

Park, Lisa Sun-Hee. *Entitled to Nothing: The Struggle for Immigrant Health Care in the Age of Welfare. Reform* Press, 2011.

Peck, Jamie, and Nik Theodore. "Recombinant Workfare, across the Americas: Transnationalizing 'Fast' Social Policy." *Geoforum,* vol. 41, no. 2, 2010, pp. 195-208.

Quadagno, Jill S. *The Color of Welfare: How Racism Undermined the War on Poverty.* Oxford University Press, 1994.

Riccio, James, et al. *Towards Reduced Poverty across Generations: Early Findings from New York City's Conditional Cash Transfer Program.* MDRC, 2010.

Riccio, James, and Cynthia Miller. *New York City's First Conditional Cash Transfer Program: What Worked, What Didn't.* MDRC, 2016.

Skocpol, Theda. *Protecting Soldiers and Mothers: the Political Origins of Social Policy in the United States.* Harvard University Press, 1992.

Soss, Joe, et al. *Disciplining the Poor: Neoliberal Paternalism and the Persistent Power of Race.* University of Chicago Press, 2011.

Thompson, Gabriel. "The Good-Behavior Bribe: Can Cash Incentives Pull a Poor Family Out of Poverty?", *The New York Magazine,* 28 Oct. 2007, nymag.com/guides/money/2007/39955/. Accessed 6 Mar. 2019.

Tsing, Anna Lowenhaupt. "Monster Stories: Women Charged with Perinatal Endangerment." *Uncertain Terms: Negotiating Gender in American Culture,* edited by Faye D. Ginsburg and Anna Lowenhaupt Tsing, Beacon Press, 1990, pp. 282-299.

Chapter 13

Mothers Up-Close in Argentine Cinema

Nadia Der-Ohannesian

Argentine cinema has been in the international limelight for the first two decades of the twenty-first century thanks to award-winning films, such as Juan José Campanella's *The Secret in Their Eyes* (2009) and Damián Szifron's *Wild Tales* (2014). A host of Argentine movies of excellent quality now exist that deal with themes central to the human condition. Of particular interest to this analysis are two recent Argentine films about motherhood and convention, which represent women deviating from the norm: *Lengua materna* (2010), written and directed by Liliana Paolinelli, and *Soleada* (2016), written and directed by Gabriella Trettel.[1] *Lengua materna* (*Mother Tongue*) narrates the process of acceptance and learning by a mother who finds out that her daughter is a lesbian. *Soleada* (*Sun Drenched*) deals with the circumstances by which a woman, a mother of teenagers, starts questioning her apparently uneventful and conventional life when she finds herself alone in her family's newly acquired summer home.

Beginning in 2000, the Argentine cinema industry began to receive more state funding, which resulted in attracting wider audiences within the country and abroad. Despite being outside of the mainstream circle, both Paolinelli's and Trettel's films have been well received by critics and viewers, who are more prepared to accept and embrace themes that critique patriarchy or some of its manifestations after the work of feminist filmmakers, such as María Luisa Bemberg in the 1980s and 1990s and Lucrecia Martel in the first decade of the twenty-first century (Stites Mor 138).

In this chapter, I embrace the possibilities inherent in cinema to ex-periment with alternatives to conventional social mores and standards (Kratje). Moreover, much is to be gained in our understanding of the places that are assigned to motherhood—as well as those hostile to it—for conceiving the representations and imaginings of space as inherently made up of gendered power struggles, which are projected onto the filmic text but have an extra-textual referent.

Unearthing the Foundations of the Home

The present analysis can be understood in the context of the spatial turn, which has gained strength since the beginning of the twenty-first century. The spatial turn entails two reciprocal tendencies. First, geographical disciplines have expanded and overflowed their limits so that other human and social disciplines—such as literary theory, religion, economics and so forth—have incorporated the spatial dimension to the analysis of diverse phenomena, which had hitherto not been understood as spatial. Second, there has been an effort from within geography to highlight the socially constructed nature of space (Soja, "The City"). It must be said, however, that feminist geographers have been well aware of the mutually constructed nature of space and the practices of the subjects that inhabit it for a much longer time (MacKenzie and Rose; Tivers; Rose).

The characterization of space that critical geography offers—space is fluid and socially determined and has a symbolic dimension as well as a material one—exposes how it is actually always under construct-ion. Critical geography regards the spatial dimension in its social complexity and not as a mere backdrop. Instead, space is to be thought relationally as "a product of practices, trajectories, interrelations" (Massey, "Geographies" 5); as such, space is provisional and closely connected to the formation of identities. This definition of space can account for the specificity of the tensions, disputes, and negotiations that the mothers in these films experience; such an understanding offers great potential to better interpret these films in their social dimension.

Geographer Edward Soja introduces the notion of "Thirdspace" as a way of challenging the use of dualisms in spatial disciplines. Spatiality is understood by Soja as socially constructed and as the result of the

interaction of material space, represented space, and lived space, or Thirdspace. Thirdspace because it combines and surpasses the real and the imagined, can be "the terrain for the generation of 'counter-spaces,' spaces of resistance to the dominant order arising precisely from their subordinate, peripheral, marginalized positioning" (Soja, *Thirdspace* 68). In the films under analysis, the Thirdspaces the mothers inhabit stretch beyond the limits of the home, and from these vantage points, women can identify what oppresses them and can contest convention. Because of its emphasis on lived reality, the Thirdspace has important potential for the analysis of representations of motherhood.

To better understand why and how women are assigned certain spaces in society (an action that Massey refers to as "spatial control"), I would like to refer to Michel Foucault's notion of "heterotopia." In "Of Other Spaces," a lecture delivered in 1967, he defines heterotopia as a "real site" where all that is different or destabilizing is set apart. Heterotopias exist within society to host those subjects and their practices that are, for different reasons, "the other" in relation to mainstream subjects and their practices. My contention is that even in modern societies—as women deviate from social norms and undergo somatic processes that are read as biological crises, especially in relation to motherhood—they are placed or they place themselves in heterotopias. The films analyzed here propose heterotopic carto-graphies drawn by women in their mothering capacity in order to come to terms with the challenges imposed on them.

Feminist geographer Doreen Massey also regards space as constituted of gendered social relations and, thus, as inherently dynamic. Specifically, Massey insists on the reciprocal influence of space and gender because of "their very construction as culturally specific ideas—in terms of both the conceptual nature of that construction and of its substantive content—and in the overlapping and interplaying of the sets of characteristics and connotations with which each is associated" (*Space* 2). The way in which space and place are thought about is similar to the way in which the notions of female and femininity are constructed because each of these terms corresponds to the devalued element in the pairs that make up a dichotomous system. The problem is that "it is a dichotomy specified in terms of a presence and an absence; a dualism which takes the classic

form of A / not A" (255). And every time the devalued element of the pair is evoked, a list of terms corresponding to that side, also negatively evaluated as not-A, is deployed. Massey points out that place and "Home" (this term is capitalized by the author to imply essentialization) are associated because they belong together on the devalued side of the list of binaries. The idealized, essentialist notion of Home as an unproblematic and romanticized site of nostalgia "is very tied in with gender ... Woman stands as metaphor for Nature (in another characteristic dualism), for what has been lost (left behind), and that place called home is frequently personified by, and partakes of the same characteristics as those assigned to, Woman/Mother/lover" (10). Massey, drawing from Genevieve Lloyd, points out that trad-itional masculinist conceptions of Home as a haven for "the Man of Reason," where a woman will keep his emotions "intact for him" is a view that "searches after a nonexistent lost authenticity, which lends itself to reactionary politics, and which is utterly bound up with a particular cultural reading of something called Woman" (10-11). Home is, thus, constructed as a Woman's place. Consequently, the entry of women to the public or nondomestic sphere, or their unwillingness to perform domestic roles, is perceived by the patriarchal order as a threat. This attempt at spatial control is closely tied to the Western distinction between public and private and is "a fundamental element in the constitution of gender in its (highly varied) forms" (180). Thus, in terms of Western binary thinking, the home, which is coded as feminine—together with the private—has been a devalued element in contrast to the spaces of paid work and public life, which are coded masculine.

Finally, there seems to be a need to construct a notion of home and place that is not bounded and imprisoning for women. In agreement with the view that space is socially constructed—as for Massey, a place is an articulation of social relations at a particular moment— these relations that make a place unique are not constrained to boundaries but are a part of wider networks, which challenge claims to fixed and timeless identities (*Space* 5).

Moving Home

Mothers inhabiting other places than those conventionally assigned construct different mother figures, which are explored in *Lengua Materna* and *Soleada* in connection to the configuration of domestic versus nondomestic spaces. These films present different dynamics in terms of the destabilization of maternal representations and the boundaries of the home. In *Lengua materna*, spatial and identity tensions are projected from the core of the domestic space out to nondomestic spaces in a centrifugal way. As soon as the film begins, Estela finds out that her daughter, Ruth, is a lesbian and that the woman she has been living with for over fourteen years is not her friend but her partner. This happens while the two women are doing the dishes in Estela's kitchen in a middle-class household during an everyday, intimate scene, which seems to give Ruth the courage to come out. This may be due to the fact that domesticity, as a process defined by home-making practices, articulates physical space and with emotion, and this constitutes a feeling of attachment to the home (Gorman-Murray and Dowling). Unable to cope with the somehow shocking news, Estela faints, but as soon as she recovers, led by love and curiosity, she starts a process by which she tries to gain a deeper understanding of her daughter. Such a process involves leaving behind the certainties and regularities the home offers; Estela must situate herself in uncomfortable spaces that will allow her get to know her daughter and herself better. The conceptualization of home, woman, and mother as static entities is questioned in the film from the very beginning and is in agreement with Massey's critique of the negative political implications of locating women in bounded sites of nostalgia.

In contrast, Adriana is transplanted to a new home in *Soleada,* and this new material space produces, as expected, different ways of relating to others and to the environment, which, in turn, destabilizes her identity. At the start of the film, the family arrives at its new country house, but the domestic space represented here is not really a home yet. The precariousness of life in the process of setting up a new home is reflected in the piles of boxes and furniture, the lack of electricity, and the need to clean and fix things and assemble furniture. When her husband has to go back to the city to solve a problem at work, Adriana feels frustrated and overwhelmed at having to deal with the new house alone. Her teenage children's boredom is one more

burden she has to cope with—a mood that adds to the lack of control over the house Adriana experiences. The domestic space is, thus, constructed as imprisoning and ominous. The new country house requires that Adriana re-enact home-making practices in order to make it a second home, which she does mostly on her own.

In the case of *Lengua Materna*, Estela's movement outside the limits of the home becomes necessary when she realizes that her home is no longer the space of maternal authority and control. Something unexpected was going on below the surface of the apparently conventional order of things.

The spaces she needs to go to, however, are gradually beyond what convention expects of a woman of her age, social class, and sexual orientation; they make her reconsider her own identity as a mother, a potential grandmother, and as a woman. In other words, she has to reach out to the outside world, as her domestic surroundings cannot hold the challenge that this new knowledge poses for her identity.

Adriana's sense of alienation in her new house and its surroundings is in close connection to the title of the film, *Soleada*. In Spanish, it involves a play on words between *sola* (alone) and *soleada* (sun drenched), as shown in the opening titles. Both adjectives are conflated to make reference to nature and to the loneliness that Adriana experiences, which help her inner search. Through extreme close-ups, the perspective of the camera in *Soleada* (unlike *Lengua materna*, which employs an objective, more traditional point of view) is very subjective and focused on Adriana. This emphasizes a sense of intimacy, both in the enclosed spaces of the house and in the open space of outdoor locations. This sense reveals one of the main tensions at work throughout the film: the identity re-evaluation process that Adriana undergoes is in connection with the redefinition of the opposition between civilization and wilderness. This dichotomy also activates the tensions implied in the binaries inside-outside, culture-nature, reason-instinct, mind-body, and order-chaos. This tension is most evident in chaos's invasion into the realm of domesticity and in Adriana's resulting loss of control over the household and the house itself. Once Adriana begins to embrace her home in its porousness, it becomes the Thirdspace in which the dichotomies can be overcome.

In *Lengua Materna*, Estela, to the contrary, gains a deeper understanding of her daughter and herself when she goes on an active

quest for knowledge that takes her to spaces increasingly unfamiliar but into which she is accepted and made to feel at ease. She first goes to church to ask the priest for advice (which she does not get), then to a lesbian bar, and, last, to her daughter's home, which is now unfamiliar. These are heterotopias that require the performance of rituals to gain full access. Going to the bar is presented as a bold deed, as she ventures into an unknown world. In fact, she behaves at first in ways that are inappropriate to the codes of behaviour of such places—she arrives too early and is overdressed, and she sits with her friend in a comfortable area that they suddenly recognize as a making-out zone. Eventually, she feels more at ease and learns to play by this heterotopia's rules to the point of accepting the flirting of another woman. Estela can appropriate this space, since the relationships established with the other women there are friendly and relaxed. Unlike the church, where she is told that her daughter will burn in hell, this place does not represent an emotional threat but communion with other women. This bar, which, significantly, from the outside looks like a regular house, is constituted as a Thirdspace—a marginal space in disguise where non-normative subjects can freely express their desire.

Some heterotopias bear a direct relation to certain forms of time, or heterochronies. Such is the case of the vacation village—an ephemeral heterotopia (Foucault). The heterotopia of the vacation village in the hills serves as a setting where Adriana and her children enact similar rites of passage to new stages in their lives. Moreover, the country house is constructed as an unhomely home, as it is located in and reproduces the wilderness that surrounds it. In Thirdspatial terms, it is constructed by its inhabitants as a marginal space but also as a source of stir and discomfort that eventually causes Adriana to evaluate her life so far with a possibility of change.

Mothers Resisting Spatial Control

The different spaces to which Estela resorts—the church, the bookshop, the lesbian bar—spatialize different epistemologies and different ways of knowing the world—through religion, science, or experience. After going to the lesbian bar, Estela visits her daughter's house. This gesture entails a movement beyond understanding and towards acceptance. Touring the house with a new awareness, Estela

finds it unfamiliar, even though she has been there many times before. She explores the rooms as if her daughter had just moved in and appears to be most interested the master bedroom, as it embodies intimacy and sexuality. Finally, the last scene of the movie portrays an encounter between Ruth and her mother at a regular bar, where they discuss arrangements as to Ruth's new apartment: Nora has cheated on her, and Estela involuntarily witnessed it. Estela brings up the possibility of Ruth having children, which Ruth rules out, and Estela becomes upset by this. She goes to the toilet, and Ruth follows after her to offer comfort. What is actually an intimate scene of bonding between mother and daughter is read by the waiter as a sexual encounter, and he throws them out of the bar. Public toilets are loaded with fantasies and symbolisms of homosexual desire, and Estela experiences first-hand what it is like to be a lesbian within the patriarchal system. The film's final scenes—the waiter entering the women's bathroom unannounced and throwing them out of the bar with the words "what a disgrace"—accompanied by the martial drums of the soundtrack and by the two speechless women marching out with appalled expressions—end the movie with powerful symbolic violence. This last scene highlights issues of discrimination and patriarchal violence against non-normative subjects. Moreover, the scene evokes the persecution and repression of dissidence—sexual and otherwise—that emanated from the Argentinian state under the brutal military dictatorship (1976-1983) and upholds heteronormal and Christian family values, which still affects numerous social groups despite some formal gestures, such as the legalization of same-sex marriage. Male presence is virtually absent throughout *Lengua materna*. Yet on the few occasions in which male characters significantly interact with Estela in the film, the encounters are always in nondomestic space (the church yard, the bar toilet) and constitute a threat to her emotional and moral integrity—exposing the power structures that constitute spaces and, more specifically, the attempts at disciplining a mother whose caregiving practices are read as immoral.

In *Soleada*, the domestic and nondomestic spaces represented are closely connected to wilderness. Nature has been recurrently associated with the feminine in Western thought, and this association has been widely identified as responsible for women's oppression. However, as much feminist theory has shown, nature can also be redefined to create positive possibilities for women (Alaimo 3). In

Soleada, non-domestic, natural spaces in the film are, at first, lived as unwelcoming territory. The first time Adriana tries to go with her daughter to the riverside, they get lost, and Adriana is injured by a thorny branch. (Interestingly, it was the father, not the mother, who knew the way to the river.) Gradually, however, Adriana appropriates these spaces. Her perception of nature changes from a threatening space into a place that she can inhabit and she can reassess her identity. The eye of the camera is very significant in the representation of the relationship Adriana establishes with nature. The medium shots shift to close-ups and extreme close-ups focusing on parts of Adriana's body—for example, her foot stepping uncertainly on the rock to reach the water—to suggest a focus on the process she has started. The underwater shots are significant as well, as they expose the symbolism of deep water: what cannot normally be seen, the life below the surface, which is analogous to Adriana's internal turmoil.

The mutually constructed nature of space and social relationships is brought to the fore in Adriana's changing romantic and caregiving practices. When she and her children go to a folk music concert at the local diner and she is left alone, a stranger asks her to dance, and she accepts. The children have left and are shown performing their own rituals of initiation and identity construction as part of the dynamism of growing up. In parallel with their search, Adriana re-evaluates her identity as mother and wife, thus exposing its provisional and also dynamic character. She and the man flirt that evening, and they meet by chance several times on subsequent days. Adriana begins to entertain certain fantasies about him, which viewers infer from her dancing alone in her room and her renewed interest in her appearance. The man has a local knowledge of the area, and he drops by her house to give her directions to a nearby lookout, where she then goes alone. He, however, does not enter the house, as he belongs to the outside world. After the long walk along a difficult and untrodden trail, the long shot reveals a beautiful sight of the valley and the village. This man is situated outside of the domestic realm, in the hitherto feared wilderness, and represents for Adriana the possibility to renegotiate her relationship with nature as well as her roles as mother and wife. Interestingly, the man is not given a name, which suggests that he is an accessory for Adriana's process: he functions as a gatekeeper to a different world but not as an individual.

Civilization and order eventually re-enter the uncivilized space of the new home as the film progresses, and Adriana is shown to have appropriated the space she now inhabits. Moreover, a feeling of belonging is stirred in her thanks to the discovery of an old photo album from the previous owners. By the end of the movie, electric power has been re-established; the glass top for the dining table—a symbol for family unity and nourishment—has been delivered, and the father has arrived. Yet there is no going back for Adriana. Her allegedly accidental dropping of the thick glass panel attests to the irreversibility of the process she is undergoing: something has broken beyond repair. The very concepts of nature and domesticity are not discarded but reassessed for a new stage in Adriana's life. For both mothers, moving into other spaces produces not only a growth in knowledge of the self and of others but also a sense of loss of innocence and a mourning over the paths not taken.

Some Concluding Remarks

This chapter set out to explore the conventions on mothering that these films expose and denaturalize—namely, the restrictions on mothers' mobility outside the domestic realm and the fixity of the maternal identity and role. The films offer representations of mothers actively rebuilding their identities through the appropriation of heterotopic space through trespassing the presupposed limits of domestic space. There is no indictment of domestic space as such in *Soleada* or *Lengua materna*; however, they recognize not only its instability and porosity but also the need to move in and out of it.

The notion of home configured in these films, then, overflows its boundaries in agreement with my proposal that the home is an articulation of social relations at a particular moment and that the relationships that make it unique are just a part of wider networks that do not know of fences or walls. Both films portray mothers experiencing the destabilization of domestic space with a counterpart in their identities. Consequently, the notion of home is reassessed, and new nondomestic spaces that can account for their identity searches are appropriated or negotiated. The limits between domestic and nondomestic spaces, thus, prove to be challenging, elusive, and fluid.

Endnote

1. Thank you to Gabriela Trettel for giving me access to the film *Soleada* shortly after it premiered and before it was released on DVD.

Works Cited

Alaimo, Stacy. *Undomesticated Ground: Recasting Nature as Feminist Space.* Cornell University Press, 2000.

Blunt, Alison and Robyn Dowling. *Home.* Routledge, 2006.

Foucault, Michel. "Of Other Spaces." *MIT*, 1967, web.mit.edu/allanmc/www/foucaultl.pdf. Accessed 7 Mar. 2019.

Gorman-Murray, Andrew, and Robyn Dowling. "Home." *M/C Journal,* vol. 10, no. 4, 2007, journal.media-culture.org.au/0708/01-editorial.php. Accessed 7 Mar. 2019.

Kratje, Julia. "Las periferias del paraíso, los dilemas de la culpa: Figuras heterogéneas de la maternidad en el cine latinoamericano contemporáneo." *Mora,* vol. 20, no.2, 2014. *Scielo* www.scielo.org.ar/scielo.php?script=sci_arttext&pid=S1853-001X2014000200001&lng=es&nrm=iso. Accessed 7 Mar. 2019.

Lengua materna. Directed by Liliana Paolineli, Mandrágora Producciones, 2010.

MacKenzie, Suzanne, and Damaris Rose. "Industrial Change, the Domestic Economy and Home Life." *Redundant Spaces in Cities and Regions,* edited by Jim Anderson et al., Academic Press, 1983, pp. 157-176.

Massey, Doreen. *Space, Place, and Gender.* University of Minnesota Press, 2001.

Massey, Doreen. "Geographies of Responsibility." *The Political Challenge of Relational Space,* special issue of *Geografiska Annaler, Series B, Human Geography,* vol. 86, no. 1, 2004, pp. 5-18.

Rose, Gillian. *Feminism and Geography: The Limits of Geographical Knowledge.* Polity Press, 1993.

Sierra, Marta. *Gendered Spaces in Argentine Women's Literature.* Palgrave Macmillan, 2012.

Soleada. Directed by Gabriela Trettel, Twin Latin Films, 2016.

Soja, Edward. "The City and Spatial Justice." *Justice Spatiale/Spatial Justice,* vol. 1, 2009. Accessed 10 Mar. 2012.

Soja, Edward. *Thirdspace: Journeys to Los Angeles and Other Real-and-Imagined Places.* Blackwell Publishers, 1996.

Stites Mor, Jessica. "Transgresión y responsabilidad: desplazamientos de los discursos feministas en cineastas argentinas desde María Luisa Bemberg a Lucrecia Martel". *El cine argentino de hoy: entre el arte y la política,* edited by Viviana Rangil, Editorial Biblos, 2007, pp. 137-156.

The Secret in their Eyes. Directed by Juan José Campanella, Haddock Films, 2009.

Tivers, Jacqueline. *Women Attached: The Daily Lives of Women with Young Children.* Croom Helm, 1985.

Wild Tales. Directed by Damián Szifrón, Kramer & Sigman Films, 2014.

Chapter 14

Geographies of Care and Peripheral Citizenship among Mothers of the Brazilian *Bolsa Família* Program

Nathalie Reis Itaboraí

I n Brazil, as in other countries, there are multiple experiences of motherhood and a multiplicity of inequalities among them. Brazil is a country with a high poverty rate, and this poverty is racialized and gendered (IBGE 96; Medeiros and Costa), higher among children (IBGE), and organized spatially (Santos). Several structural features contribute to this poverty. First, there is a high formal unemployment rate and a resulting reliance on the informal economy (Lameiras and Carvalho 8). Since formal employment is central to eligibility for social supports (including maternity leave, parental leave, health-related leave, and unemployment insurance), there is also limited access to these crucial supports. In Brazil's growing and unplanned urbanization, poverty has become concentrated in rural areas and in urban favelas— islands of poverty among rich neighbourhoods, as seen in the paradigmatic example of Rio de Janeiro's favelas (Santos). In both instances, the unequal spatial distribution of services—including health, education, and public safety—aggravates social inequalities (Lawson et al. 658). Structural inequalities are accompanied by cultural and ideological processes in which those who are poor are represented

as lazy and irresponsible. As Mirlei Pereira notes, "The poor portion of the population that inhabits cities is often seen as responsible for disorder, crime, urban space entropy, when, in fact, it is the portion that most suffers with this process" (5).

Initiated in 2003, the federal *Bolsa Familia* Program (BFP) represents the first time that social assistance has been made readily available to those in the lowest income brackets in Brazil; in 2012, the program transferred resources to more than 12 million families, and it continues to offer important services that are internationally recognized to alleviate poverty in Brazil. The program prioritizes giving support to mothers, who are the primary recipients of these crucial state benefits. Whereas some see this as strengthening women's authority in households, others argue that the program enforces women's maternal identities and fails to advance women's economic and personal autonomy outside of a motherhood identity.

This chapter aims to qualify such debates. Through combining quantitative and qualitative data, the chapter analyzes the motherhood experiences of BFP beneficiaries in the context of gender, class, and racial inequalities in Brazilian society. The regulation of motherhood is organized spatially through the distribution of state support, which defines limitations and possibilities for peripheral citizenship and delineates geographies of care, including family and neighbourhood relationships as well as the public services that are partially offered. Despite all the difficulties faced by the mothers I interviewed, they are actively searching for better opportunities for their families. The emerging picture shows that these women would perform even more if better social services—such as education, healthcare, and job training—were available; such services would support and broaden opportunities for social and spatial mobility among mothers and their children.

The *Bolsa Família* Program in Context: Advances and Criticisms

The BFP was established to benefit families living in poverty (defined as those with monthly income from R$ 60.01 to R$ 120.00 per capita) as well as families living in extreme poverty (with monthly income below R$ 60.00 per capita).[1] In order to qualify for the program,

children and adolescents must be registered in and attending school, and the health of pregnant women, nursing mothers, and children below six years of age is monitored. The short-term expected effects of the BFP are the alleviation of poverty, and long-term outcomes include the reduction of cumulative social inequalities. The BFP is the first major national initiative to address the systematic inequalities among families in Brazil (Jaccoud). Studies have shown that the BFP is having positive effects on child nutrition, school attendance, and academic standing (Campello and Neri). Goals are being reached, although the effectiveness of these policies depends on the quality of the public health and education services offered (Kerstenetzky).

The BFP has also been the subject of intense debates about the class and gendered dimensions of inequality. The small budget of the program (less than 0.5 percent of Brazil's GDP) has been contrasted with other public policies favouring the middle and upper classes (Schwarzman). Lena Lavinas criticizes conditional transfer programs like the BFP because although they are cheap and easy to administer, they are noninstitutionalized ad hoc instruments and not true rights; they represent a limited and residual model of social protection. In addition, and as noted above, some question whether the program reinforces women's roles as mothers and whether they can be harmonized with initiatives to empower adult women.

Despite these critiques of the program, its positive results on poverty reduction have made it a model that other countries have emulated (Tepperman). In the 2000s, the BFP, together with policies to raise the minimum wage and create jobs, contributed to the reduction of high levels of inequality in Brazil. Between 2005 and 2015, the Gini Index—which measures the degree of income concentration and varies from 0 (equality) to 1 (total inequality)— ranged from 0.548 to 0.491 for income earners fifteen years of age and over (IBGE 91). The administration of the program—with a federal bank (Caixa Econômica Federal) making the payments and a unified system of information and registry (Cadastro Único)—breaks with Brazilian's traditional clientelistic practices. In addition, there was a relevant impact on the economy and consumption in the country, especially in smaller municipalities; the program injected money that was mostly used in food consumption and gave more autonomy to families and women to use resources according to their needs.

A Macro View of Work-Family Balance among BFP Beneficiaries

In the last few decades, Brazilian women have experienced fertility reduction, higher engagement in the labour market, and greater freedom to transform their familial arrangements; they now have more freedom to enter and leave marital unions, whether formal or not (Itaboraí). These processes have been supported by legal and institutional advances in several regards, such as education, work, and reproductive rights. Nonetheless, women continue to be primarily responsible for domestic work and care for dependents, and their job opportunities are affected by the presence of young children. All social classes experience processes of female empowerment, but lower-income women also have lower levels of schooling and greater difficulties balancing work and family, given the still insufficient policies for early childhood education and full-time education.

Data from the National Household Sample Survey (PNAD-IBGE)[2] carried out in 2006 are used to offer a more general picture of the problems faced by *Bolsa Família* mothers. Analyzing the profile of BFP beneficiaries, it is clear that they are concentrated in the lower socioeconomic classes: 73 percent of beneficiaries belong to families of rural workers or unskilled and skilled workers of urban lower classes. Women are 92 percent of BFP beneficiaries, and regarding family arrangements, it is notable that 81 percent of families are heterosexual couples (married or cohabitating) and 17 percent are single parents.

Since the BFP prioritizes families with children, it could be expected that beneficiaries' opportunities for paid work would be hampered by limited access to childcare. Nevertheless, women beneficiaries of the BFP have a similar work profile to the other women of their socioeconomic class. The percentage of women who worked in the paid labour market and in domestic work in 2006, controlled for class, was higher among BFP beneficiaries: 49 percent in paid work and 98 percent in unpaid domestic labour for their own family, contrasted with 43 percent and 89 percent among nonbeneficiaries. Among women who reported working in the survey, beneficiaries are in a more fragile position in terms of labour rights. The percentage of those with a formal contract or contributing to social security is much lower among BFP beneficiaries (19 percent in 2006) than among nonbeneficiaries (50 percent in 2006). In Brazil, there is a remarkable

stratification of maternal rights, since maternity leave is only available to women with formal employment, whereas many women of lower socioeconomic classes participate in the informal labour market. This discrepancy is clear among the beneficiaries of the BFP. Whereas white, middle- and upper-class women can obtain four or six month maternity leaves from their formal work, poor women, frequently engaged in informal work, do not qualify for maternity leave, and they only have recently accessed social assistance (through BFP) to take care of their children (in general less than 20 percent of the minimum wage). The investigation of the female total workload—the number of hours spent working on paid and unpaid domestic workload combined—shows that BFP beneficiaries shouldered a greater overall burden of work.

Beneficiary families are younger, and their heavier workload of paid and unpaid labour is related to a higher dependency ratio (number of children to adult), since one of the conditions of the program is the presence of children and adolescents in the home. Since these women have greater family responsibilities, they also have greater needs for public support through childcare policies. In fact, the public management of access to education prioritizes children enrolled in the BFP, and there is a little more access to school for children between zero and six years of age (43.5 percent for beneficiaries) compared to those of nonbeneficiary families (41.5 percent). However, when I investigated the number of hours that the children normally stay in school or daycare, it is noticeable that the children of BFP beneficiaries regularly spend fewer than four hours at school per day (75 percent of children beneficiaries versus 64 percent of nonbeneficiaries). The time that children spend at school in Brazil is shorter than in other countries (FGV), and since the education of small children is the responsibility of municipalities, they frequently offer fewer hours of education. Nevertheless, since these children have access to the public school system, their access to free meals is more frequent, which contributes to improved nutrition.

Children of families assisted by the BFP are more likely to attend public schools and receive regular meals, but the low number of hours they spend at school often prevents mothers from engaging in paid, formal work unless they have complementary childcare arrangements. In this sense, if access to childcare and education is a right for both

children and families, the right to education, even partially exercised, is constituted by only a few hours and the right of parents to access childcare so to enter the labour market is neglected.

As emphasized by Rodríguez Enríquez, the greatest weakness of cash transfer programs like the BFP is the consolidation of the sexual division of labour. Benefits are given to mothers because they are expected to be responsible for managing resources and for meeting the conditions of the benefits targeting their children. In addition, Silvana Mariano and Cássia Maria Carloto raise the question of whether meeting the conditions for the program serve as a further drain on women's time and make it more difficult to reconcile family responsibilities with the search for paid work. Despite expanding childcare and early childhood education in recent decades, demand still far outstrips existing provisions. Without investments in public childcare and education, the BFP cannot effectively transform opportunities available to mothers living in poverty. As is evident in the interviews I conducted with Brazilian women, the absence of structural supports is a central contributing factor to the prevalence of informal work conducted in the household and of women's economic precariousness.

A Micro Approach to the Problems of Poverty and Social Protection

The interviews were conducted in December 2016 on the outskirts of Juiz de Fora, a city with approximately five hundred thousand inhabitants and located in the southeastern region of the country. The researched neighbourhood has a reasonable infrastructure, including a health unit, public schools, and a recreational centre for children and youth. In a country of great regional inequalities, it is notable that these interviewees, living in one of Brazil's most economically developed regions, are closer to overcoming their deprivation and to social mobility through the schooling of their children. As a result, their experiences do not necessarily reflect the situation of the main targeted audience of the program: those living in rural areas and in the poorest regions of the country.

I interviewed eight women for this study; all mothers were between the ages of twenty-three and fifty-one, with two to four children each. They are all black and brown women, living in the suburban area of

Juiz de Fora, which has relatively stable access to school and public health services. Most of the women are current or former beneficiaries of the program. Few interviewees worked full time on a formal contract, but many engaged in informal sector work at home, such as childcare and food production to be sold in the neighbourhood. Those who did not work for pay generally took care of their small children, under three years of age. Interviewees were generally married (formal or cohabitating) women, but many had a first child unmarried in a first union, followed by separation and remarriage. Their current husbands typically performed low-paid urban activities, such as bricklayer, carpenter, pool cleaner, and urban sanitation servant.

In general, the women interviewed reported a routine of much domestic work, with an unequal division of the care of home and children. One interviewee, a thirty-six years old woman with two children, sixteen and six years old, described a seemingly endless domestic work routine: "with exception of the eight hours from work [she has formal work in a marketplace], it is constant, he [her husband] contributes about three hours of domestic work, the daughter, who now works and studies, contributes nothing at home."[3] Another interviewee, a thirty-five-year-old woman with two children, who makes snacks and sells them in the neighbourhood, responded as follows when asked about who does the housework: "To tell you the truth only myself; it is me who cleans up the house. I do everything, take care of the child ... It's a lot of time." Her husband, a bricklayer, leaves home at 5:30 a.m. and returns at 7:00 p.m., which is why she says, "I do not demand so much from him; he works hard and arrives tired."

The domestic and care workload among the interviewees is heavy. Beyond caring for their own children, some of them also do domestic work in middle- and upper-class households and some care for other children in the neighbourhood on top of preparing and selling food in the informal economy. As Evelyn Nakano Glenn argues in the United States, despite changes over time, gender, class, and race remain central organizing principles of care work. This perspective is also valid for Brazil, where the association of mothers, wives, and daughters with racialized and gendered domestic work also functions to coerce women into care work (Glenn).

The separation between men and women deeply structures the

organization of space (Raibaud), and, in fact, husbands were frequently away from the home during interviews, which took place on weekdays. Studies have shown how gender imprints on the organization of bodies and also on space and time, as is evident in inequalities in time spent on paid work, domestic and care work, and leisure time. Inequalities are, therefore, not only social but also spatial; they generate interdictions that demarcate "invisible walls" (Di Meo) not only by gender but also by age. In this way, according to their age and role in the family (mothers, wives, and daughters), women build their own cities from the spaces, places, and territories through which they move.

The geographies of care employed by these women can be observed in such strategies as residing near their relatives, sharing common backyards, and establishing family-based networks of childcare. These networks of care are also spatially located in the neighbourhood: girls are initiated into work as caregivers of children of poor mothers who work, and adult mothers who do not get jobs outside their homes take care of the children of other mothers, alongside caring for their own children. In addition, the women restricted to the space of their homes, due to a lack of work opportunities or public childcare supports, are not really economically inactive, since they make and sell food and other products.

Some interviewees reported the importance of time-saving household appliances, which have become more common in recent decades with the expansion of consumption in Brazil. In addition to the washing machine, interviewees talked about the importance of the wardrobe to keeping clothes organized. The fact that living spaces are often small, with several residents (since some families shelter their adult children and grandchildren), reveals needs that may be taken for granted in middle-class households but are celebrated as victories for those living in poverty.

In the neighbourhood where the research took place, children are admitted to public school for four to five hours a day when they are three or four years old; before this, most children are cared for by their mothers. With such meagre childcare provisions, the collaboration of neighbours and family members is crucial. Interviewees generally did not complain about the length of the school day, even though they depend on complementary care in order to participate in paid work.

One interviewee, for example, recounted that when she is at work her child's grandmother takes the child to school and takes care of her until she returns. Interviewees also indicated that they rely on the help of family members who live nearby—in some cases in a "family backyard." Childcare connects family members, such as grandparents and sisters, but also neighbours and teenagers hired to look after children. For these mothers, childrearing in this community-minded context seems simple in the face of previous family and professional childcare experiences. A forty-six-year-old woman, mother to three children, said, "I had taken care of children before, from the family and also from the next-door neighbour; she was going to work and asked me if I could stay with her son. I was about thirteen at the time. Then I learned to care. He was three months old at the time." This interviewee clarified that nowadays, it costs about R$150 a month to care for a child for the day. Thus, to earn a minimum wage income (R$ 880 in 2016), a woman must take care of five or six children.

The low social protection for mothers is also a frequent experience among interviewees. As a consequence of the predominance of informal work, most have never had maternity leave or only in one pregnancy. A mother of four children says she never had maternity leave:

> "I looked after other children, but I never worked formally. I had four children here at home [with her own children; there were eight under her responsibility]. I do everything. I feed them, I shower them, and at 5:00 p.m., their mothers would pick them up. It was little [money], but it helped me. My husband is a carpenter, but he does not work formally. My money would help. After they [the daughters] began to work, then that improved a little bit.

Despite the increasing economic contribution of women's work to family budgets in Brazil, women's income still can be perceived as "help" only complementary to other income sources, such as the male wage when it exists. This traditional logic is applied to the income received from the BFP (Pires). Some interviewees pointed out that the income is small, but most considered BFP money useful. One interviewee had already received BFP for her first child, and she said that "It helped me because everything that comes is good. I received it

for five years." The same interviewee was later excluded from the BFP: "After I started to work, it [the BFP] was cancelled. I had to reregister. Since then, it has not come anymore, but they did not inform me that it was cancelled. You only realize this when you try to receive it. There are a lot of mothers who rely on this money and when they get there, they do not have the money." The criticism of the practice of cancelling the benefit without notifying the beneficiaries in advance was very frequent and illustrates that although it is considered supplementary, the income provided by the BFP is, nonetheless, important.

Interviewees spoke a lot about the incentives and conditions associated with the program. Receiving a benefit of R$120 for her teenage daughter, one interviewee said that "it helps to keep the child in school, they are more interested in attending. It helps with the expenses that we have with bus tickets, school materials." As for the health and education monitoring requirements, she explained the following: "The health [condition] is left to the health agent. And the education is made by the social worker of the school, she is always looking for us." There are monthly meetings at 7:00 a.m. at the beginning of classes. She clarified that there are parents who attend and others do not; it is possible to justify their absence due to working hours. She noted that the meetings are open to both parents, but the ones who often go are mothers. In general, interviewees reported that the conditions do not impede their routines as mothers; there are some obligations but sporadic ones. As other studies also show, conditions are not perceived as overloading (Bartholo). The interviewees disagree over whether the program caused them extra effort: "The school reported [to administration of BFP the attendance of children]. There is a control in the health unit. It has not changed the routine. I am doing what I was doing before."

Nevertheless, there is a certain passivity among the beneficiaries in their relationship with the institutions. Their vision of the school tends to be optimistic, marked perhaps by a nostalgia: "The school treats us very well, currently I have my daughter and my granddaughter who study there." Opinions about health services vary. One interviewee said, "The neighbourhood is well attended. A health worker is always passing by, asking if we need some medicine. When there is an elderly person who cannot go to the doctor, the doctor comes." However, one interviewee criticized the health service: "Now it's no good anymore.

Frequently there are no doctors. When I had her [the first daughter], it was good." And another one pointed out: "The health agent does not come very much, the one in our area."

Annette Lareau emphasizes that social inequalities affect the interactions of people with social institutions and notes that middle-class parents are more assertive towards health and education authorities—thus fostering a sense of rights in their children—whereas lower-class parents convey to their children their sense of powerlessness in the face of such authorities. Lareau also identifies different modes of child socialization, such as "orchestrated cultivation"—a term used to refer to the stricter control of children's activities in the middle classes compared to natural growth in the lower classes, where informal activities prevail. This diagnosis is only partially valid for the interviewees. In the case of the interviewed mothers, the search for complementary activities for their children was marked by the available options, and, in general, they revealed a concern to protect their children from drugs (a concern that often shapes the social programs aimed at the suburbs in Brazil). A fifty-one-year-old mother of four—whose one daughter attends a private university (through FIES, a government program which provides public funding to students at the university level) and another daughter participates in the Young Apprentice Project—suggested the following: "They [public policies for children and young people] need to improve a lot. We have to have something for the kids to do, to get them off the streets, to avoid this drug thing. It is very difficult for us to raise our children. I like what my daughter does. She leaves school. She has lunch and goes to SENAI [the organization that offers Young Apprentice Project], she passes a week going to the classroom and a week going to the company. I think there should be something else for the children and young people." In search of their dreams, her children routinely cross the city, experiencing more spatial mobility than their mother.

In a study about the BFP in Campinas, another city in the developed southeast, André Pires notes that living in a large centre generates access to services and also affects personal and familial projects, especially educational and professional ones. In a similar way, the impact of the BFP on the conditions in which motherhood and the care of the children are exercised cannot avoid considering the wider social context.

Final Considerations

Maternity cannot be understood outside the power relations through which it is constituted, which includes the state. Through social policies and programs, the state shapes ways of being a mother and disseminates social representations of them, which are equally important in what they do not say, particularly regarding father's responsibilities (Klein). Such discourses simultaneously value and instrumentalize women in their traditional role of care provider. Even if this does not significantly interfere in maternal routines, it reiterates unequal gender divisions.

Although the BFP does not substantially transform the reality of the mothers on the social and spatial periphery of Brazil, it does integrate familial projects of increased wellbeing and social mobility. Mothers are partly disciplined. They do not question the limitations on the educational services offered but are attentive to the possibilities of improving their children's lives, educational opportunities, and professional training—that is, the possibilities of social mobility. At the same time, mother's own mobility remains restricted. Registration for the BFP takes place mostly through a local health unit; only one interviewee registered in the downtown core. A more peripheral citizenship is also observed in the limited access of these mothers to labour rights, which was also evidenced in the quantitative analysis.

As evidenced by survey data, the women who qualify for the BFP are far from the lazy stereotype prevalent in public opinion about the program. From all the work characteristics analyzed, it appears that beneficiaries of the BFP have a higher workload than nonbeneficiaries in similar social conditions. In addition, beneficiary mothers experience more precarious working conditions and fewer social protections related to motherhood.

In these poor working conditions, as shown in the qualitative analysis, the money received by BFP is perceived not as a solution but as a help. However, what matters is not just how many resources are available to the poor to compensate for their deprivation but also the range of services offered to them to create other opportunities for themselves, their families, and their children, including education, health, and job prospects. Where these supports exist, even in a precarious way, it is evident that people are actively engaged in improving their living conditions, and the mother figure is central to this endeavour to build another future for her children. As argued by

Milton Santos, a Black Brazilian geographer who dedicated his life to studying poverty: "Poverty is not only an economic category but also a political category above all else" (18). In the absence of better jobs and care structures, mothers continue to experience precarious work and overwork, leading to a "time poverty," according Araceli Damián, in addition to monetary poverty. In this context, children's urban mobility in search of better educational opportunities is orchestrated with mothers as a strategy of social mobility. The BFP is, thus, a small example of income redistribution offering supplementary money. Combined with the rights of social citizenship (in the form of social rights as well as educational and job training opportunities), the program could also help to broaden the women's and their families' social and geographical horizons.

Endnotes

1. The currency unit is the Brazilian Real. In October of 2003, when the program was launched, one US dollar was equivalent to three reais.

2. PNAD is a national sample survey covering most of the country. It is conducted annually to obtain information about general (IBGE) characteristics of the population concerning education, labour, income, and other factors. Data from the 2006 PNAD are analyzed here because the survey included a supplementary survey on aspects of access to income transfers from social programs.

3. All the interviews were conducted in Portuguese and translated to English by the author.

Works Cited

Bartholo, Letícia. "Bolsa família e autonomia feminina: o que nos dizem os estudos qualitativos." *Research Brief of International Policy Centre for Inclusive Growth*, vol. 57, 2016, www.ipc-undp.org/pub/port/PRB57PT_Bolsa_Familia_e_autonomia_feminina.pdf. Accessed 2 Jan. 2017.

Campello, Tereza, and Marcelo Neri. *Programa Bolsa Família: uma década da inclusão*. Ipea, 2013.

Damián, Araceli. "La pobreza de tiempo: una revisión metodológica." *Estudios demográficos y urbanos*, vol. 52, 2003, pp. 127-162.

Di Meo, Guy. "Éléments de réflexion pour une géographie sociale du genre: le cas des femmes dans la ville." *L'Information geographique*, vol. 76, no. 2, 2012, pp. 72-94.

FGV. *Tempo de permanência na escola. FGV*, 2009, cps.fgv.br/pesquisas/tempo-de-permanencia-na-escola. Accesseed 2 Jan. 2017.

Glenn, Evelyn Nakano. *Forced to Care: Coercion and Caregiving in America*. Harvard University Press, 2010.

IBGE. "Síntese de indicadores sociais: uma análise das condições de vida da população brasileira." *IBGE*, 2016. http://biblioteca.ibge.gov.br/visualizacao/livros/liv98965.pdf. Accessed 2 Jan. 2017.

Itaboraí, Nathalie Reis. *Mudanças nas famílias brasileiras (1976-2012): uma perspectiva de classe e gênero*. Garamond, 2017.

Jaccoud, Luciana. "Programa Bolsa Família: proteção social e combate à pobreza no Brasil." *Revista do serviço público*, vol. 64, no. 3, 2013, pp. 291-307.

Kerstenetzky, Celia Lessa. "Redistribuição e desenvolvimento? A economia política do programa Bolsa Família." *Dados*, vol. 52, no. 1, 2009, pp. 53-83.

Klein, Carin. "A produção da maternidade no Programa Bolsa-Escola." *Estudos feministas*, vol. 13, no. 1, 2005, pp. 31-52.

Lameiras, Maria Andréia Parente and Sandro Sacchet de Carvalho. "Mercado de trabalho". Carta de Conjuntura, n. 36. Brasília: *IPEA*, 2017. www.ipea.gov.br/portal/images/stories/PDFs/conjuntura/170914_cc36_mercado_de_trabalho.pdfAccessed 2 Jan. 2017.

Lareau, Annette. "A desigualdade invisível: o papel da classe social na criação dos filhos em famílias negras e brancas." *Educação em revista*, vol. 46, 2007, pp. 13-82.

Lavinas, Lena. "21st Century Welfare." *New Left Review*, vol. 84, 2013, pp. 5-40.

Lawson, Victoria, et al. "Articulations of Place, Poverty, and Race: Dumping Grounds and Unseen Grounds in the Rural American Northwest." *Annals of the Association of American Geographers*, vol. 100, no. 3, 2010, pp. 655-677.

Mariano, Silvana Aparecida, and Cássia Maria Carloto. "Gênero e combate à pobreza no Programa Bolsa Família." *Faces da desigualdade de gênero e raça no Brasil*, edited by Bonetti, Alinne and Abreu, Maria Aparecida de, IPEA, 2011, pp. 61-78.

Medeiros, Marcelo, and Joana Simões Costa. *Poverty Among Women in Latin America: Feminization or Over-Representation?* Anpec, 2005, www.anpec.org.br/encontro2005/artigos/A05A150.pdf. Accessed 7 Mar. 2019.

Pereira, Mirlei Fachini Vicente. *A pobreza urbana no Brasil: considerações a partir das análises geográficas.* 2008. https://ssl4799.websiteseguro. com/swge5/seg/cd2008/PDF/SA08-20629.PDF. Accessed 2 Jan. 2017.

Pires, André. "Orçamento familiar e gênero: percepções do Programa Bolsa Família." *Cadernos de Pesquisa*, vol. 42, no. 145, 2012, pp. 130-161.

Raibaud, Yves. "Genre et espaces du temps libre." *L'Information geographique*, vol. 76, no. 2, 2012, pp. 40-56.

Rodríguez Enríquez, Corina. *Programas de transferências condicionadas de ingreso e igualdad de gênero: ¿Por donde anda América Latina?* Cepal, 2011.

Santos, Milton. *Pobreza urbana.* 3 ed. Edusp, 2009.

Schwarzman, Simon. "Bolsa família: mitos e realidades." *Interesse nacional,* vol. 2, no. 7, 2009, pp. 20-28.

Tepperman, Jonathan. "La lucha contra la pobreza en Brasil: el éxito sorprendente de Bolsa Família." *Foreign Affairs*, vol. 95, no. 1, 2016, pp. 72-83.

Chapter 15

"*Parce que sans ça tu les oublies, les chansons*"[1] Mothering between Solidarity and Differences through Francophone Places and Networks in Kingston, Ontario

Laurence Simard-Gagnon

Introduction

This chapter explores francophone women's ambivalent experiences of mothering in the francophone geographies of Kingston, Canada, drawing particularly on the example of the French-language drop-in playgroups for preschool age children. Mothering as a francophone woman in Kingston implies navigating complex—and sometimes conflicting—experiences: of physical, emotional, educational and financial needs; of moral imperatives as mothers (McDowell et al.; Christopher; Sweeney and Aldridge); of francophone cultural norms and narratives (Cardinal; Gilbert); and of embodied minorities (Huot et al.; Madibbo). How these experiences are articulated is contingent on each francophone mother's life

trajectory: her circumstances at the moment of her mothering in Kingston, who and where she was in the past and who and where she anticipates she will be in the future (Valentine). This chapter is based on life-story interviews (Gaudet) of thirty-three francophone mothers currently living in Kingston, and to a lesser extent on participatory observations in French-language drop-in playgroups. Language practices, particularly those associated with a minority language, change through life course and are influenced by myriad circumstances such as family composition, places of origin and of residence, and employment (Heller and Lévy; Iqbal). I use an inclusive definition of "francophone," which, for this research, designates someone for whom French was an important language in childhood or youth outside of school settings and who uses French directly or indirectly in raising her children.

Francophone presence in Kingston is attributable to superimposed migration patterns embedded in the history of the city's development (see Gilbert; Donalds and Hall). Kingston today presents the particular context of a mid-size "public service town" (Donalds and Hall). It is dominated by strong institutions—Queen's University, the Canadian army, several carceral-industrial facilities, and the provincial and federal governments—that provide most of the employment and that structure the life of a great part of the population. The Canadian Forces Base employs a number of Francophones, mostly from Québec. Successful struggles for the establishment and development of French language schools (as detailed first-hand in St-Cyr)—alongside the widening of French education offerings in English-language schools (such as French immersion programs) in the last decades—have also attracted a significant number of francophone teachers. Migration— from Québec, elsewhere in Ontario, or abroad—thus characterizes the experiences of Francophones in Kingston, as almost none originate from the city.

At first glance, my research participants seem to form a somewhat homogeneous group. Of the thirty-three interviewed, only four were women of colour,[2] and none declared a physical and/or learning disability or a debilitating illness. Related to the urban economic structure and migration patterns described above, at least one adult in every participant's household came to Kingston for professional employment,[3] so most could be considered middle or upper middle

class. All participants were part of a heterosexual romantic partnership with the father of at least one of their children, or had been in one until separation (in six cases) or the death of their partner (in two other cases). I use life-course analysis as an empirical and research paradigm to problematize this normalized—and normalizing—portrait (Gaudet). Doing this, I reveal the implications of migrating to Kingston and of being a mother in the life trajectories of these women. Gill Valentine has argued that through intersectional analysis of life stories, we can highlight how "who we are" emerges from processes of identification and dis-identification specific to particular spatial contexts (Valentine 18). Following her lead, in this chapter, I argue that motherhood and migration represent closely interwoven pivotal moments that shape francophone mothers' gendered subjectivities. I demonstrate that Kingston francophone geographies, and particularly francophone places such as the French-language drop-in playgroups, feed and reiterate gendered processes of identification and subject construction that tie mothering and minority language transmission to feminized roles of social reproduction.

Motherhood and Migration

Parce que être dans le brouillard pendant des années, je te dis pas.
(Because being stuck in the fog for years, I'm telling you.)

The arrival of a child—and especially of a first born—presents an important transition in both life trajectories and everyday geographies of mothers (Aitken; Luzia). Mothering a baby or a young child implies a drastic departure from the normative model of individuated subjectivity, which is prescribed in democratic liberal societies (Chandler). Although liberal ideals of autonomy and independence are always more-or-less illusory (Watson et al.), the illusions shatter spectacularly when one's subjectivity becomes inextricably entangled with that of a dependent and needful being (Chandler; Baraister).

My use of the term "mothering" instead of "parenting" is not incidental (Jupp and Gallangher). It points to the fact that whereas the overwhelming allotment of care and reproductive work to women is a global phenomenon (Dyck; Lawson), this gendered distribution of labour hits a neuralgic point in heterosexual partnerships at the birth

of a child (Aitken; Luzia; McDowell et al.; Sweeney and Aldridge). Thus, even in relationships where there was a former commitment to a more-or-less equal division of care work and reproductive labour among partners, the birth of a child generally upsets this equilibrium both in day-to-day practices and in wider life trajectories (Aitken; McDowell et al.; Sweeney and Aldridge; Kohlman and Krieg). The birth of a child is often a brusque turning point in a woman's life; her subjectivity becomes deeply etched by the moral imperatives of motherhood and gendered norms (Aitken; McDowell et al.; Luzia). This mothering moment is reinforced at multiple scales. It translates into roles and expectations in new parental partnerships—most often structured on the unchallenged assumption that mothers will shoulder the bulk of the menial, emotional, and mental labour of caring for children (Seeney and Aldridge; Ruddick)—and in social policies and institutions, such as maternity leave programs (see Gaudet).

Migration strongly influenced the articulations of this mothering moment in the lives and subjectivities of the francophone mothers who participated in my research. The reasons for migrating, as well as the circumstances of the migration, differed between participants. One element of particular significance in terms of migration outcomes in each mother's life was whether she came to Kingston to pursue a professional opportunity or to follow her partner.

Fifteen participants moved to Kingston for opportunities of their own, including post-graduate education and/or employment. Seven of the fifteen work in French-language schools or in francophone community and social services, and all fifteen hold high-skilled professional positions. Most women in this group migrated well before they had children and solidified their employment before starting a family. Many of these mothers are part of a bilingual romantic partnership. Most are highly fluent in English and have established networks of people and places in the city that extend beyond francophone spaces. All of them expect their medium-term future to unfold in Kingston.

The other eighteen participants moved to Kingston to follow their partner's employment. This group includes spouses of soldiers and/or military employees who are not themselves part of the Canadian Forces. Many in this group had little knowledge of English before migrating to Kingston. Although most of these women were already

mothers, (or about to be mothers) before, migration generally implied a sharp bifurcation towards more differentiated gender roles and labour—both in terms of reproductive work within their households and in the types of remunerated work they perform (for those who are employed at all). More concretely, moving to Kingston implied increased restriction of their lives around the daily needs of their households and working for the social and economic integration of their partners and children without established networks, landmarks, activities, or projects of their own. *"Passer en dernier"* (to come in last) was a feeling commonly expressed, as illustrated by the words of this mother: *"quand tu déménages à Kingston et que t'as un enfant, tu deviens 'femme de,' 'mère de.'"* (When you move to Kingston and you have a child, you become "wife of," "mother of"). The sharp differences between the experiences of francophone mothers who moved for their own opportunities and those who moved for their partners demonstrate that gendered dynamics of social and economic inclusion and exclusion, interlocked in a sharply skewed division of reproductive labour, are critical in mothers' experiences of migration (Bastia et al.). These dynamics are attributable to the disproportionate importance ascribed to men's as opposed to women's professional occupation within heterosexual migrant families (Chicha and Deraedt).

The age and number of children and the (lack of) availability of daycare and babysitting options for mothers who follow partners exacerbates gendered divisions of labour and space (Chicha and Deraedt). Francophone mothers of preschool age children find very few employment opportunities in Kingston due in part to their lack of English and/or locally recognized credentials but also due to the prohibitive cost of daycare. They often find themselves stuck in a vicious cycle: they cannot afford to pay for daycare without a relatively high paying job that they cannot obtain because of their limited professional opportunities and their care and reproductive work responsibilities. Thus, one mother who came to Kingston following her husband's military posting and who subsequently experienced important deskilling and economic exclusion commented: *"Pas avoir eu mon fils, je serais allée me faire caissière et j'aurais appris l'anglais. Mais je paierai pas la garderie pour aller travailler au Shopper's."* (Had I not had my son, I would have worked as a cashier, and I would have learned English. But I won't pay for daycare to go and work at

Shopper's.) These intersecting obstacles limit mothers' spatial and temporal horizons. They funnel their day-to-day existences to the repetitive rhythms of care, children, bodies, households, "daily 'thinking' about feeding, sleeping, dressing, manners, routines, good stuff, bad stuff, schools, friendships, more stuff, influences, environments, time, responsibility, freedom, control and so on" (Baraister 22). Although for some mothers having this opportunity to centre their activities and responsibilities on their homes and children is welcome, others describe their existence in terms of a Beauvoirian dystopia (in reference to Beauvoir's *Second Sex*). In either case, the steep separation between their home-centred lives and the wider social, cultural, and economic worlds of the city mirrors the geographies of their linguistic practices. The French they speak in their houses, streets, cars, or on the bus, at the park, and in stores effectively cuts them off from the taken-for-granted unveiling of daily life in wider anglophone Kingston. This linguistic geography anchors their lives firmly upon their French-speaking partners, children, and friends—creating parallel binary spatial divisions between French and English and private and public (an idea approached by Gilbert).

Social and economic changes brought about by migration are long lasting in the life trajectories of francophone mothers who followed their partners, which warrant the terms "turning point" and "bifurcation" (Gaudet). Despite the relative financial ease of the women who participated in my study, their experiences of migration often involve vulnerability, which obstructs imaginings of alternative futures—in terms of educational or career paths or in terms of family changes, including separation from their partners. Although mothering preschool age children may represent a limited period in these women's life span, the economic, social and cultural loss resulting from their intersecting experiences of motherhood and migration have profound effects on the rest of their lives.[4] As one mother recalled:

L'immigration c'est quelque chose qui va te chambouler toute ta vie.... Et une fois j'ai discuté avec mon mari ... il m'a dit "écoute, si on part de ton point de vue à toi, c'est vrai Kingston c'est pas bien.... Moi, franchement, ça me dérange pas.... Si on regarde du point de vue des enfants, tu trouveras pas mieux que le Canada. Que Kingston" ... Et c'est là où j'ai ouvert les yeux et j'ai accepté en fait. J'ai accepté d'être au Canada. D'être toute ma vie.

(Immigration is something that will disrupt your whole life....
Once I discussed this with my husband ... he told me "listen,
from your point of view, Kingston isn't good.... Me, frankly, I
don't really care.... If you look at it from the children's point of
view, you won't find better than Canada. Than Kingston" ... And
that's when I opened my eyes, and accepted. I accepted to be in
Canada. For my whole life.)

For many mothers, this life-changing bifurcation feels like an
irremediable "step back," accompanied by grief for what might have
been.

Francophone Places of Mothering: French-Language Play Groups

> *Ça serait donc beau si on n'avait pas tout le temps à chercher.*
> (It would be so nice if we didn't always have to search.)

The French-language playgroups of the Ontario Ministry of Education's
Early Year Centres (hereafter EYCs) emerge at the crossroad of two
different sets of policies and objectives. As creatures of the Ontario
Ministry of Education, the EYCs reflect governmental efforts to
promote specific values and standards regarding families and young
children. However, the development of French-language programs
within the EYCs resulted from grassroots francophone mobilization to
establish spaces of daily living in French and of French-language
transmission (Thériault).

The understanding of children as critical anchors of linguistic
minority practices and vectors of continuity underlies many of the
struggles for francophone rights and development of francophone
institutions. This is illustrated in Kingston by the importance of the
school-community hub, located in the building of the École *secondaire
catholique Marie-Rivier*—a central place in many francophone
children's geographies. This understanding also translates into moral
imperatives thrust upon families and mothers to ensure continuity and
transmission of minority language and culture (Heller and Lévy; Yax-
Fraser). For mothers, the education and socialization of children in
French imply extra cultural work and day-to-day battles to police
children's (and sometimes partner's) linguistic practices; to switch

back to French when English slippages occur; to monitor the language of television shows; to incessantly look for French services—"*c'est toujours à recommencer*" (it always has to be started all over again)—and to travel inconvenient distances to access them. For participants in my study the cultural minority work of French language transmission also involves concerted efforts to seek francophone spaces.

The French playgroups of the EYCs were one of the first "franco-phoning" places women frequented as mothers of francophone children in Kingston. The aim of the French playgroups is to provide spaces in which mothers can speak and mother together in French. Although they are open to all and English is not forbidden per se, the use of French is strongly encouraged, and I never heard a mother express herself in English in those places. The groups are facilitated by a French-language educator, whose mandate is also to present childhood cultural material in French. For many francophone mothers, it is in the French-language playgroups that they revive francophone elements of their own childhood, such as songs: "*Parce que sans ça tu les oublies, les chansons*" (Because otherwise, you forget them, the songs). Sharing and celebrating these elements as an intentionally francophone group endows what they share with particular meaning and value as cultural markers. In this way, through the French programs of the EYCs, francophone mothers gain tools of cultural and linguistic transmission to the next generation of francophones and, importantly, are entrusted with the task of this transmission.

Creating Mothers at the French Language EYC

On est comme dans les années 50
(We're living as if it were the 50s)

Although the EYCs provide much needed support and networks to new mothers, they promote specific and constraining versions of intensive mothering, which posit that "mothers should be the central caregivers of children and ideal childrearing is time intensive and emotionally engrossing" (Christopher 189). The French-language playgroups of the Kingston EYC are held on weekday mornings, and, thus, by their very format, they can only benefit caregivers who are not otherwise occupied at that time. Furthermore, the norms and types of parenting

skills promoted at the EYC, for example, home-made baby food workshops—are meant to guide women through a new phase of their lives that would (should) be centred on mothering.

Regardless of the choice (or lack of choice) individual mothers have vis-à-vis their mothering subjectivity (e.g., staying at home or delegating part of their care work to others), all mothers encounter moral imperatives and social discourses of the intensive motherhood paradigm (Aitken; McDowell et al.; O'Brien; Sweeney and Aldridge). For francophone mothers in Kingston, the added responsibility for minority language transmission, as well as the lack of option in terms of francophone spaces in Kingston, enhances the importance of the EYC French-language programs in their mothering practices, and thus the influence of the intensive motherhood paradigm in their lives (Cardinal; Heller and Lévy; Yax-Fraser).

Several of the employed or otherwise engaged francophone mothers of young children devised means for their children to access these "francophoning" places. Some of these mothers have flexible employment schedules and could arrange to be free on the mornings of the French-language playgroups. One mother arranged for her daughter to attend the EYC with her mother-in-law. Thus, among the francophone mothers I interviewed, even those who did not entirely adhere to the centre's intensive mothering paradigm felt the importance of the French-language playgroups in facilitating their cultural work of minority language transmission sufficiently to juggle logistics and, at least for the time of the programs, to somewhat adapt their mothering subjectivity to more constraining gender scripts.

Conclusion—Ambivalent Geographies

> Ma vie est vraiment pas ce que je pensais qu'elle serait
> (My life is not at all what I thought it would be)

This chapter highlights the central and interrelated effects of motherhood and migration to Kingston on francophone women's lives and subjectivities, and illustrates how these processes are reiterated through francophone places of mothering—namely the French-language programs of the EYCs. This group portrait points to ambivalence in the geographies of Francophone mothers in Kingston.

All of these mothers, as Francophones, need at some point or another to "*faire avec*" (cope with) the lack of French language services, the somewhat rigid model and format of the EYCs, and/or the limited social and economic opportunities available as a French speaking mother, among other things. For most mothers, the important changes in their lives and the closing of options associated with migrating and mothering, combined with the particular limitations and prospects in Kingston's francophone geographies, led to bifurcations in their life trajectories that were neither planned nor necessarily chosen.

In that sense, this chapter points to the critical importance of recognizing the interrelated effects of migration and motherhood in the experiences of mothers in a cultural and/or linguistic minority context. It highlights how circumstances of migration, and specific imperatives of minority cultural work, can heighten the potency of gendered scripts in shaping these mothers' horizons of possibilities.

Endnotes

1. "Because otherwise, you forget them, the songs." Translation from French to English of quotes from participants has been done by the author.
2. By this I mean women whom I understood as differing from the hegemonic white and Christian/non-religious norm.
3. Kingston is the site of several federal prisons, and families of inmates have migrated to Kingston to be near them. There may be francophone families among this population, and these families may experience considerably different socioeconomic realities than the mothers included in this study. This potential Francophone population did not emerge during the course of my fieldwork
4. On normative temporal expectation of raising healthy and normatively functioning children and the expectation that once they reach school age mothers' reproductive labour decreases, see Kittay.

Works Cited

Aitken, Stuart. *Family Fantasies and Community Space*. Rutgers University Press, 1998.

Baraister, Lisa. *Maternal Encounters: The Ethics of Interruption*. Routledge, 2009.

Bastia, Tanja, et al. "Guest Editorial - Geographies of Migration, Geographies of Justice? Feminism, Intersectionality, and Rights." *Environment and Planning A,* vol. 43, 2011, pp. 1492-1498.

Beauvoir, Simone de. *Le deuxième sexe II: L'expérience vécue*. Gallimard, 1986.

Cardinal, Linda. "L'identité En Débat: Repères et Perspectives Pour L'étude Du Canada Français." *International Journal of Canadian Studies / Revue Internationale D'études Canadiennes*, vol. 45-46, 2012, pp. 55-68.

Chandler, Mielle. "Emancipated Subjectivities and the Subjugation of Mothering Practices." *Maternal Theory: Essential Readings*, edited by Andrea O'Reilly, Demeter Press, 2007, pp. 529-541.

Chicha, Marie Thérèse, and Eva Deraedt. "Genre, Migration et Déqualification: Des Trajectoires Contrastées : Étude de Cas de Travailleuses Migrantes À Genève." *Cahiers Des Migrations Internationales*, vol. 97, International Labour Office, 2009.

Christopher, Karen. "African Americans' and Latinas' Mothering Scripts: An Intersectional Analysis." *Notions of Family: Intersectional Perspectives*, edited by Marla H Kohlman et al. Emerald Group Publishing Limited, 2013, pp. 187-208.

Donalds, Betsy, and Heather Hall. "The Social Dynamics of Economic Performance in the Public-Sector City: Kingston, Ontario." *Growing Urban Economies - Innovation, Creativity and Governance in Canadian City-Regions*, edited by David A. Wolfe and Meric S. Gertler, University of Toronto Press, 2016, pp. 311-334.

Duffy, Mignon. "Reproducing Labor Inequalities: Challenges for Feminists Conceptualizing Care at the Intersections of Gender, Race, and Class." *Gender and Society*, vol. 19, no. 1, 2005, pp. 66-82.

Dyck, Isabel. "Feminist Geography, the 'Everyday', and Local-Global Relations: Hidden Spaces of Place-Making." *The Canadian Geographer/Le Géographe Canadien,* vol. 49, no. 3, 2005, pp. 233-243.

Gaudet, Stéphanie. "Comprendre Les Parcours de Vie : Une Lecture Au Carrefour Du Singulier et Du Social." *Repenser La Famille et Ses*

Transitions : Repenser Les Politiques Publiques, edited by Stéphanie Gaudet et al., Société et Population, Les Presses de l'Université Laval, 2013, pp. 15-50.

Gilbert, Anne. *Espaces Franco-Ontariens—Essai*. Les Éditions du Nordir, 1999.

Heller, Monica, and Laurette Lévy. "Les Contradictions Des Mariages Linguistiquement Mixtes: Stratégies Des Femmes Franco-Ontariennes." *Langage et Société*, vol. 67, 1994, pp. 53–88.

Huot, Suzanne, et al. "Negotiating Belonging Following Migration: Exploring the Relationship between Place and Identity in Francophone Minority Communities." *The Canadian Geographer / Le Géographe Canadien*, vol. 58, no. 3, 2014, pp. 329-340.

Iqbal, Isabeau. "Mother Tongue and Motherhood: Implications for French Language Maintenance in Canada." *The Canadian Modern Language Review/La Revue Canadienne Des Langues Vivantes*, vol. 61, no. 3, 2005, pp. 305-323.

Jupp, Eleanor, and Aisling Gallangher. "Introduction—New Geographies of Parenting, Policy and Place." *Children's Geographies*, vol. 11, no. 2, 2013, pp. 155-159.

Kittay, Eva Feder. "'Not My Way, Sesha, Your Way, Slowly': 'Maternal Thinking' in the Raising of a Child with Profound Intellectual Disabilities." *Mother Troubles: Rethinking Contemporary Maternal Dilemmas*, edited by Julia Hanigsberg and Sara Ruddick, Beacon Press, 1999, pp. 3-27.

Kohlman, Marla H, and Dana B. Krieg. "Introduction: Intersectional Dynamics of Gender, Family, and Work." *Notions of Family: Intersectional Perspectives*, edited by Marla H Kohlman et al., Emerald Group Publishing Limited, 2013, pp. ix–xxv.

Lawson, Victoria. "Presidential Address: Geographies of Care and Responsibility." *Annals of the Association of American Geographers*, vol. 97, no. 1, 2007, pp. 1-11.

Luzia, Karina. "Travelling in Your Backyard: The Unfamiliar Places of Parenting." *Social and Cultural Geography*, vol. 11, no. 4, 2010, pp. 360-375.

Madibbo, Amal Ibrahim. *Minority within a Minority: Black Francophone Immigrants and the Dynamics of Power and Resistance*. Routledge, 2006.

McDowell, Linda, et al. "Women's Paid Work and Moral Economies of Care." *Social and Cultural Geography*, vol. 6, no. 2, 2005, pp. 219-235.

O'Brien, Maeve. "Mothers' Emotional Care Work in Education and Its Moral Imperative." *Gender and Education*, vol. 19, no. 2, 2007, pp. 159-177.

Ruddick, Sara. *Maternal Thinking: Toward a Politics of Peace*. Beacon Press, 1995.

St-Cyr, Marie-Noel. "From Cohabitation to Autonomy: The Emergence of a Franco-Ontarian Catholic Secondary School in Eastern Ontario." Master of Education. Queen's University, Kingston, Ontario, 1992.

Sweeney, Kathryn A, and Delores P. Aldridge. "Blocked Opportunities and Gendered Power: Inability to Attain Preferred Gender Roles." *Notions of Family: Intersectional Perspectives*, edited by Marla H. Kohlman et al., Emerald Group Publishing Limited, 2013, pp. 29-47.

Thériault, Joseph Yvon. "Compétude Institutionnelle: Du Concept À L'action." *Mémoire(s), identité(s), marginalité(s) dans le monde occidental contemporain – Cahiers du MIMMOC*, vol. 11, 2014, https://journals.openedition.org/mimmoc/1556. Accessed 7 Mar. 2019.

Valentine, Gill. "Theorizing and Researching Intersectionality: A Challenge for Feminist Geography." *The Professional Geographer*, vol. 59, no. 1, 2007, pp. 10-21.

Watson, Nick, et al. "(Inter)Dependence, Needs and Care: The Potential for Disability and Feminist Theorists to Develop an Emancipatory Model." *Sociology*, vol. 38, no. 2, 2004, pp. 331-350.

Yax-Fraser, Maria Josefa. "We Compromise on a Daily Basis: The Choices and Processes of Cross-Cultural Mothering." *Journal of the Motherhood Initiative for Research and Community Involvement (MIRCI)*, vol. 2, no. 2, 2011, pp. 252-266.

Chapter 16

LGBT Families and "Motherless" Children: Tracking Heteronormative Resistances in Canada, Australia, and Ireland

Catherine Nash, Andrew Gorman-Murray,
and Kath Browne

Introduction

This chapter examines the production of a certain figure of the mother—and especially the discourses of motherlessness, motherless families, and motherless generations—put forth by organizations and individuals working in opposition to the implementation of LGBT (lesbian, gay, bisexual, trans) equalities legislation in Australia and Ireland, and to a lesser extent in the Canadian context. Legal and social changes are often reflected in local debates surrounding the enactment of legislation enabling same-sex marriage (SSM), parenting, and adoption. With equality rights for LGBT people in place in all three countries, battles regarding SSM and parenting have taken a different shape in contemporary debates. A key set of oppositional discourses propagated by anti-SSM organizations defends the correctness of the normative heterosexual nuclear family form and heterosexual marriage, and aggressively reasserts conventional gendered parenting

roles and biological imperatives associated with mothering and fathering—what we term "heteroactivism"—to capture the notion of a type of activism seeking to restore normative heterosexualities (Browne et al., "LGBT Families"; Browne and Nash, "Heteroactivism").

In particular, heteroactivists in Australia and Ireland often argue that SSM and parenting propagate social acceptance of motherless families and genderless parenting regarded as problematically enshrining a "motherless generation" In the Canadian context, more importance is placed on appropriate gender roles in families (and cisgendered expectations more generally), as oppositional groups are increasingly linked transnationally through social media, as well as in-person attendance at national and international conferences, such as the World Congress of Families. Paying close attention to the ways that these narratives take form and travel is pivotal in understanding the "how" and the "why" of these oppositional discourses (Browne and Nash, "Resisting LGBT Rights"; Browne et al., "LGBT Families"; Nash and Browne).

We position this chapter within our broader research on the geographies of heteroactivism and highlight how trans-scalar resistances draw on arguments grounded in claims about the natural family and the need for its protection in the best interests of society (Browne and Nash "Heteroactivism"; Buss and Herman). In heterosexist claims, the married heterosexual couple is framed as the only proper location for procreating and raising children, thereby ensuring national stability and future prosperity. It is the site where children are protected from gender ideology and gender confusion, which ensures the child's normal development as a cisgendered and heterosexual adult operating within normative female and male roles (Rosky; Stockton). We argue that contemporary heterosexist claims about the creation of a motherless generation surface in Australia and Ireland especially, and to a much lesser extent in Canada. We do not understand this as a comparative approach but as a study in how resistive discourses have particular histories and geographies and touch down in places in ways that reflect both transnational and local circumstances. How and why this has emerged is developed by examining the historically specific and local understandings of motherhood while echoing transnational inflections of the motherless generation to suggest SSM denies children their right to a mother.

We begin with a brief discussion of the Canadian context, due to its early legalization of SSM, to provide a platform for analyzing later events in Australia and Ireland. Canada legally recognized SSM in 2005. Ireland amended its constitution enabling SSM after a national referendum in 2015. Similarly, the Australian parliament legalized SSM on 9 December 2017, following a national postal survey on marriage equality. In both the Irish and Australian debates, oppositional groups mobilized distinctive yet intersecting claims about the destabilizing possibilities of the creation of a motherless generation as one of the many problems they see as arising from the institutionalization of SSM.

Canada

In the debates leading up to the 2005 parliamentary vote on SSM, opposition arguments focused largely on the rights, needs, and welfare of the child, which is assumed to be best met within the supposedly stable confines of the heterosexual, procreative unit—the basic unit of society and the best location for modelling proper gendered and sexual roles (Browne and Nash, "Resisting LGBT rights"). In 2005, debates referenced motherlessness but in the context of the rights of the child to know and be raised by both biological parents. As we detail, this focus on the rights of the child is distinctive from the contentions about the dangerousness of motherlessness taken up in Australia or Ireland. Advocates often argued the following: "Marriage is a child-centred, not an adult-centred, institution. No one has the right to redefine marriage so as intentionally to impose a fatherless or motherless home on a child as a matter of state policy" (Enshrine Marriage Canada). Heterosexual (married) parents, then, arguably provided the most nurturing environment: "By their sexual difference, they provide their children the full range of human nurturing that comes by being raised by a mother and a father" (Henry). In other words, the arguments focused more closely on the family as a unit rather than emphasizing the supposed problems of being raised in a motherless or fatherless household. In this framing, criticism was not directly or overtly aimed at single or divorced parents (men or women), nor did it touch on the more complicated arguments about biological attachment and parenting in relation to adoption or reproductive technologies.

With SSM in place in Canada for over a decade, contemporary resistance is focused on specific issues, such as parental rights in education and freedom of speech and conscience arising from the implementation of LGBT equalities legislation. Resistive discourses decrying so-called motherless families have become more evident, although the main emphasis remains on the rights of the child to both a biological mother and father. For example, Canadian ethicist Margaret Somerville ("Children's Human Rights") argues against SSM through a logic that conflates children's rights with the experience of living in a procreative family unit held together by heterosexual marriage and enabling access to the biological mother and father. In her view, children raised by a married male same-sex couple would be motherless and would, thus, be denied inherent rights to access their biological mother. Again, this logic is problematically narrow (what of co-parenting arrangements, for instance, or the reality of separated heterosexual parents?), and remains a talking point for oppositional groups in places where SSM is legalized.

A transnational set of oppositional discourses around children's rights, parental rights, and motherlessness is visible across Canada, Australia, and Ireland. Indeed, Somerville ("Life's Essence") sketches and promotes some transnational connections. Glossing over specific domestic nuances, Somerville simply finds parallels that oppositional groups may exploit:

> Are we repeating in a new context and in new ways the terrible errors and grave injustices that occurred with Australia's "stolen generation" of aboriginal children, the United Kingdom's "home children" sent to Canada and other British Commonwealth countries, and the "scoop" of native children from reserves into Canadian residential schools and white adoptive homes, all of which deliberately separated children from their biological families?

As discussed below, the mistreatment of Indigenous peoples, especially Indigenous children, has been deployed in both Canada and Australia by those resisting LGBT equalities as examples of government overreach interfering with the heterosexual family. The mistreatment of Indigenous children in Canada's residential schools surfaced in a 2016 protest against the province of Ontario's proposed

sexual educational curriculum. The new curriculum included, among other points, references to same-sex marriage, gender identity, and LGBT families. Some parents argued this violated their parental rights to determine what their child learns in public schools. Brad Trost, an unsuccessful candidate for the leadership of the federal Conservative Party, likened the forced taking of Indigenous children from their parents to the contemporary experiences of Ontario's parents in their apparent lack of input into the sexual education curriculum. Trost stated: "The most tragic of violation—which I don't think this one rises to that level—but the most tragic violation in Canadian history ... of parental rights was residential schools, so I think the underlying issue is the same" (qtd. in Csanady). The usefulness of any parallels made between the scooping of Indigenous children and parental fears around the content of the sexual education curriculum is tenuous at best. Nevertheless, given the legislative lag between SSM in Australia vis-à-vis other anglophone countries, this is a timely context in which to consider how the rhetoric of motherlessness is playing out in locally specific ways in both Australia and Ireland. The argument here is that in the time between the passage of same-sex marriage in Canada (2005) and its passage in Ireland (2015) and Australia (2017), the motherless argument has been redeployed in ways that reflect not only local circumstances but also the emergence of heteroactivist transnational resistances.

Australia

Opposition to SSM in Australia has largely echoed and extended the arguments made in Canada. Indeed, the transnational diffusion of resistive discourses is evident. Somerville's logic has been combined with domestic voices to oppose SSM as supposedly diminishing children's rights— rights that centre on allowing children to grow up in a procreative, heterosexual, and nuclear family with a biological mother and father. Somerville's work is explicitly deployed by anti-LGBT, heteroactivist groups—such as Australian Marriage Forum (AMF), the Australian Family Association (AFA) and Family First (FF)—in their national campaigns in media outlets. The rights of the child become the foundation for a series of oppositional arguments to SSM and LGBT parenting based on a conservative assumption that marriage and parenting go hand-in-glove.

The rhetoric of the motherless generation emerged in the last few years as a specifically Australian spin on the children's rights discourse in opposition to SSM. The expression is used by a range of oppositional organizations—most commonly the AMF, but also the Australian Christian Lobby (ACL), the Family Council of Queensland, Culture Watch, and even the Catholic Church. The term "motherless generation" is intended to suggest that the right that children miss out on in SSM is the right to access their mother. The motherless argument is, thus, most frequently used with respect to male SSM and the prospect of married male couples having children through surrogacy. Australian Marriage Forum's president, David Van Gend, argues that SSM (and any enabling legislation) is "a coldly calculated decision to abolish a mother from the lives of any future children created within two-man 'marriage'" ("Who Will Apologize") and that "the marriage of two men means a motherless family" ("Same-Sex Marriage").

The notion of the motherless generation has recently evolved in two further directions. The first is a strategic move by organizations such as AMF and the ACL to rebadge SSM as genderless marriage. This is done to imply the diminished importance of gender differences and roles in SSM, and to suggest that this will affect children's proper development as cisgendered and heterosexual. The definition of gender and the function of marriage are directly linked to reproduction and parenting. For instance, in a parliamentary submission, the Catholic Archdiocese of Sydney argued that "same-sex marriage would lead inevitably to the trivialisation of the differences between men and women, of motherhood and fatherhood, and of children's biological identity and relationships."

The AMF ("Our Last Mother's Day") reaches so far as to claim that genderless SSM is an attack on gender equality because it removes women from their natural (and essentialist) role as mothers ("Genderless Marriage") and attempts to derive evidence from the example of Canadian SSM to do so ("Redundant in Ontario"). For oppositional groups, parenting is not gender neutral, and the work of mothering and fathering is naturally divided by gender. A child does not merely have a right to parental care but access to a mother and a father together (ideally their biological parents). The ACL, for instance, has borrowed a moniker from US-based group The Heritage Foundation: "There is no such thing as parenting. There's mothering and there's fathering."

The second strategic move has a decidedly nationalist inflection: direct links are drawn with the highly charged domestic issue of the "stolen generations," a term referring to two historical programs involving the removal of children from their families, which continue to be potent political and emotional forces in Australia (ACL "A New Stolen Generation"; Calligeros). First, "stolen generation" refers to the Aboriginal and Torres Strait Islander children (Indigenous Australians) who were forcibly removed from their biological families under a government policy that operated between 1910 and 1970. This is a highly contentious political issue in Australia; Labor PM Kevin Rudd gave a parliamentary apology in 2007. Second, between 1950 and 1980, a program of forced adoptions saw the children of single mothers given up for adoption against the mothers' will, for which Labor PM Julia Gillard gave a parliamentary apology in 2013. In national cultural discourse, "stolen generations" and the associated parliamentary apologies are entwined, reflecting a public understanding of government culpability for the emotional toll on families and children.

Australian anti-SSM organizations have borrowed this discourse to denote the motherless generation as another stolen generation—a generation of children supposedly removed from proper biological families and cisgendered mothering and fathering (ACL, "Rudd's Change on Marriage Sets up a New Stolen Generation"). For instance, the Australian Catholic Marriage and Family Council ("Marriage and Same-Sex Attraction") argued that "children in same-sex families, whether adopted or conceived through a donor parent, despite all good intentions, could become another stolen generation."

It is this issue of the apology—of political culpability for a moral error—that resurfaces consistently in oppositional groups' invocations of a new "gay stolen generation." The groups argue that SSM will inevitably result in another future national apology to the motherless children of same-sex parents. In 2015, an AMF ("Who Will Apologize") advertisement featured footage of former PM Julia Gillard's apology for forced adoption policies and concluded: "Who will apologise to the Motherless Generation?" In the same year, they attacked Labor opposition leader Bill Shorten's support for SSM legislation: "We are on the brink of a new abusive law that will once again cut children off from their own flesh and blood. A new stolen generation who will, after much suffering, require their own national apology" (AMF, "Bill Shorten").

This political strategy is used as a forewarning to current pro-SSM politicians to defer legislating LGBT rights. Given existing political tensions around stolen generations, the rhetoric of the motherless generation and any stolen generation are inflammatory tactical arguments: they position the rights claims of Indigenous peoples—who have faced opposition from conservative groups in their fight for acknowledgement of stolen generations—against those of LGBT groups. Rights pertaining to marriage, family, and children—especially the figure of the mother—are thus implemented as wedge politics, pitting the experiences of different minority groups against one another.

Ireland

Within recent debates about SSM and LGBT rights in Ireland, certain tropes found in the Canadian and Australian discourses reappear. However, they emerge in Ireland in very specific ways, notably due to the importance of the "mammy" in Irish cultural and political discourse. Ireland's constitution writes the mother into the home as central to the common good of the nation (Browne et al., "Geographies"; Browne et al., "LGBT families"). Article 41.2 states the following:

> The State recognises that by her life within the home, woman gives to the State a support without which the common good cannot be achieved. The State shall, therefore, endeavour to ensure that mothers shall not be obliged by economic necessity to engage in labour to the neglect of their duties in the home. (Constitution of the Irish Free State [Saorstát Eireann] Act)

Significant emphasis was placed on notions of the mother and vulnerable children by oppositional groups in the public debates leading up to the referendum to legalize SSM on 22 May 2015; these notions were grounded in the particularly Irish commitment to mothers and motherhood. Those who were eligible to vote were asked to vote on the question "do you approve of the proposal to amend the constitution contained in the undermentioned bill?" The proposed amendment would alter the constitutional statement on marriage to read "marriage may be contracted in accordance with law by two persons without distinction as to their sex" (Article 41 of the Irish

Constitution). Some 1,949,725 people or 60.52 percent of electorate voted in the referendum, with 1,201,607 people or 62.07 percent voting "Yes," and 734,300 people or 37.93 percent voting "No" (Caollaí and Hilliard).

The No campaign, comprised of mainly socially conservative lay Catholic groups (Ryan), vigorously rooted their opposition in the rights of the child argument and asserted the needs of children for their biological parents, even though these rights had already been dealt with under separate legislation, the Children and Family Relationships Act 2015.[1] The Iona Institute, Mothers and Fathers Matter (MFM), and First Families First all fought for the No campaign on this basis and promoted their position through their own websites as well as through columnists such as John Waters and Breda O'Brien who argued the No position in major national newspapers. Although those who sought a No vote referred to both parents—husband and wife and obvious biological realities—the focus on the role of biological mothers and potential surrogacy by gay men were key grounds on which these debates played out. In opposing the redefinition of marriage, arguments made direct links to the roles of biological parents and to the importance of a specific kind of mother's love. For instance, Breda O'Brien, a weekly columnist at the national newspaper *Irish Times* argued the following:

> This is a referendum about re-defining marriage, and therefore parenting. If the referendum is passed, there will be children born in this country who will never experience a mother's love.... [Research published in 2011 by LGBT Diversity on LGBT Parents in Ireland] says currently LGBT parents often have children from previous relationships, but that in the future, those who responded indicate that LGBT families would be more planned.

> Lesbians were likely to access donor-assisted human repro- duction, whereas gay men were hoping to adopt, foster, or in the case of a "sizeable minority," use surrogacy. So it is not just scaremongering No voters who have linked marriage and parenting. It is the LGBT community itself. As a feminist, what does Mary McAleese [Former President of Ireland, an Elected position similar to Head of State, the Prime Minister or similar] think about surrogacy? And using a woman's womb with the

express purpose of the child never being reared by that woman? What does she think about the rights of children in those circumstances?

Although O'Brien refers to LGBT and lesbian parents in these statements, it is the mother's love that is centralised in this discourse. The feminist argument regarding the rights of women's bodies and control of their reproductive potentials (Nast) is arguably superseded by the rights of the child. This is crucial, as it is not the mothers (and fathers) whose lives are at stake (which links of course to abortion); instead, it is the child who needs to be reared by that woman in whose womb they were grown. The scaremongering is associated with male parents and specifically access to surrogacy as a "deliberate attack on the child's right to a mother" (Mothers and Fathers Matter, "Marriage Referendum").

This focus on surrogacy, as is often the case in these polarized debates, then moved quickly to discussions of making children to order. This discourse deliberately seeks to separate, normalize, and idealize natural, spontaneous making of children through procreative sex, which is centralized as a key feature of male-female (penis-vagina) marriages, as MFM, an organization that was central in the Vote No campaign, argued in a press release: "A YES vote gives two men the right to have a child under Article 41. A Yes vote means that if a married opposite-sex couple are given a legal right to use a surrogate mother (we believe surrogacy is problematic in all cases) that right will have to be given to two married men as well" ("Misleading About Surrogacy").

The motherless generation produced through surrogacy is dependent on a very specific notion of an Irish mother: a mother is the one who carries the baby to term (using her own eggs, although this is implied and rarely mentioned). The child deserves a mother and a father, (and to be raised in a cisgendered and heterosexual marriage), but the emphasis is on the loss of the mother in SSM. Two men should not have a child, although all surrogacy is presented as problematic. The location of biology is so powerful in these arguments that the mother is inseparable from the person who gives birth. The mother can never be a social entity—she is too firmly rooted in the biological.

The debates in Ireland differ from the Australian context. Although the removal of children from heterosexual parents was a factor that

emerged in rhetoric about adoption and reproductive technologies, it was less prevalent in the SSM discussions. The arguments canvassed in Vote No campaigns suggested that the creation of children in these ways only serves parental desires and not children's rights to have a mother and a father.

Conclusion

In examining how the discourses of a motherless generation travel transnationally, our chapter highlights local oppositions to SSM and LGBT rights in Canada, Australia, and Ireland. What is evident is that there are clearly both histories and geographies to these arguments. Instead of glossing over domestic nuances as Somerville ("Life's Essence") does, it is important to examine the local and national cultural framings of what may, on the surface, appear to be transferrable discourses. To be sure, there are rhetorical similarities, since the kernel of these arguments reaches across oppositional groups. Yet at the same time, these discourses do not stay bounded within locales in ways that make comparative approaches suitable; instead, they move between them, implicitly and explicitly reframing their rhetoric in and through the context of transnational flows of knowledge. The geographical location of oppositional groups and their arguments are, thus, key to how these discourses are reproduced in diverse, locally specific ways, which make their anti-LGBT claims in locally meaningful terms. In terms of the geographies of motherhood, our discussion of Canada, Australia, and Ireland demonstrates how heteronormative biological imperatives are used to recreate supposedly natural bonds between a mother and child yet emphasises the place-based fluidity and instability of these relationships.

Endnote

1. The Children and Family Relationship Act provided legal clarity around a variety of families and instigated protections for children in families where parents are not married (see childrensrights.ie). It was opposed by groups, such as MFM, who were set up to oppose it at the bill stage because it displaced the centrality of married opposite sex couple and sought to address discrimination regarding nonmarital families (see mothersandfathersmatter.org).

Works Cited

Australian Catholic Marriage and Family Council. "Marriage and Same-Sex Attraction – Why Cannot 'Two Mothers' or 'Two Fathers' be Equivalent to 'a Mother and a Father'?" *Marriage and Same-Sex Attraction, The Gift of Children, Australian Catholic Marriage and Family Council*, 2 Jun. 2015, www.acmfc.org.au/marriage_and_same_sex_attraction_4/#Q.20. Accessed 15 Nov. 2016.

Australian Christian Lobby. "Rudd's Change on Marriage Sets up a New Stolen Generation." *Signposts, Australian Christian Lobby*, 21 May 2013, signposts02.wordpress.com/2013/05/21/rudds-change-on-marriage-sets-up-a-new-stolen-generation/. Accessed 1 Sept. 2016.

Australian Marriage Forum. "Bill Shorten Calls for a New Stolen Generation." *Australian Marriage Forum*, 31 May 2015, australianmarriage.org/media-release-bill-shorten-calls-for-a-new-stolen-generation/. Accessed 15 Nov. 2016.

Australian Marriage Forum. "Who Will Apologize to the Motherless Generation?" *TV Ad #2: Australian Marriage Forum*, www.youtube.com/watch?v=m_siQWMK3mc. Accessed 10 Jan. 2017.

Australian Marriage Forum. "Is This Our Last Mother's Day?" *Australian Marriage Forum*, 6 May 2016, australianmarriage.org/last-mothers-day/. Accessed 15 Nov. 2016.

Australian Marriage Forum. "Genderless Marriage a Step Backwards for Gender Equality." *Australian Marriage Forum*, 8 Mar. 2016, australianmarriage.org/genderless-marriage-step-backwards-gender-equality/. Accessed 15 Nov. 2016.

Australian Marriage Forum. "'Mother' and 'Father' are Redundant in Ontario." *Australian Marriage Forum*, 1 Nov. 2016, australianmarriage.org/mother-father-redundant-ontario/. Accessed 15 Nov. 2016.

Browne, Kath, and Catherine J. Nash. "Heteroactivism: Beyond Anti-Gay." *ACME: An International Journal for Critical Geographies*, vol. 16, no. 4, 2017, pp. 643-652, www.acme-journal.org/index.php/acme/article/view/1631. Accessed 15 Feb. 2018.

Browne, Kath, and Catherine J. Nash. "Resisting LGBT Rights Where 'We Have Won': Canada and England." *Journal of Human Rights*, vol. 13, no. 3, 2014, pp. 322-336.

Browne, Kath, et al. "LGBT Families and 'Motherless Children': The Irish Marriage Referendum." *RGS-IBG Annual International Conference*, 30 Aug-2 Sept. 2016, London, UK. Conference Presentation.

Browne, Kath, et al. "Geographies of Heteroactivism: Resisting Sexual Rights in the Reconstitution of Irish Nationhood." *Transactions of the Institute of British Geographers*, vol. 34, no. 4, 2018, pp. 562-539.

Buss, Doris, and Deedee Herman. *Globalizing Family Values: The Christian Right in International Politics*. University of Minnesota Press, 2003.

Calligeros, Marissa. "*Q&A* Debate Flares over Claims Same—Sex Marriage will lead to New 'Stolen Generation.'" *Sydney Morning Herald*, 1 Mar. 2016, www.smh.com.au/federal-politics/political-news/qa-debate-flares-over-claims-samesex-marriage-will-lead-to-new-stolen-generation-20160229-gn6yg8.html. Accessed 15 Nov. 2016.

Caollaí, Éanna, and Mark Hilliard. "Ireland Becomes First Country to Approve Same-Sex Marriage by Popular Vote." *The Irish Times*, 23 May 2015, www.irishtimes.com/news/politics/ireland-becomes-first-country-to-approve-same-sex-marriage-by-popular-vote-1.2223646. Accessed 10 Jan. 2017.

Catholic Archdiocese of Sydney. "Submission to the NSW Legislative Council Standing Committee on Social Issues Inquiry into Same-Sex Marriage Law in NSW." *Parliament of New South Wales*, 1 Mar. 2013, www.parliament.nsw.gov.au/committees/DBAssets/Inquiry Submission/Body/51802/1163%20Catholic%20Archdiocese%20 of%20Sydney.pdf. Accessed 1 Sept. 2016.

Constitution of The Irish Free State (Saorstát Eireann) Act, 1922. *Irish Statute Book*, 25 Oct. 1922, www.irishstatutebook.ie/eli/1922/act/1/ enacted/en/print. Accessed 10 Jan. 2017.

Csanady, Ashley. "Protesters, CPC Leadership Hopeful Compare Ontario's New Sex-Ed Curriculum to Residential Schools." *National Post*, 21 Sept. 2016, nationalpost.com/news/politics/protesters-cpc-leadership-hopeful-compare-ontarios-new-sex-ed-curriculum-to-residential-schools . Accessed 15 Oct. 2108.

Enshrine Marriage Canada. "A Declaration on Marriage." *Enshrine Marriage*, 14 Mar. 2005, enshrinemarriage.ca. Accessed 10 Jan. 2017.

Henry, Fred. "Ask the People, Stephen." *Catholic Register*, 24 Nov. 2006, catholicregister.org/opinion/guest-columnists/item/10256-ask-the-people-stephen. Accessed 10 Jan. 2017.

Mothers and Fathers Matter. "Marriage Referendum No Posters Focus on the Key Areas of Public Debate." *Mothers and Fathers Matter*, mothersandfathersmatter.org/marriage-referendum-no-posters-focus-on-the-key-areas-of-public-debate/. Accessed 10 Jan. 2017.

Nash, Catherine J., and Kath Browne. "Best for Society?: Transnational Opposition to Sexual and Gender Equalities in Canada and Great Britain." *Gender, Place and Culture*, vol. 22, no. 4, 2015, pp. 561-577.

Nast, Heidi. "Queer Patriarchies, Queer Racisms, International." *Antipode*, vol. 34, no. 5, 2002, pp. 874-909.

O'Brien, Breda. "Does Mary McAleese Understand Why People are Voting No?" *The Irish Times*, 18 Apr. 2015, www.irishtimes.com/opinion/breda-o-brien-does-mary-mcaleese-understand-why-people-are-voting-no-1.2179917. Accessed 10 Jan. 2017.

Rosky, Clifford. "Fear of the Queer Child." *Buffalo Law Review*, vol. 61, no. 3, 2013, 607-697.

Ryan, Fergus. "Ireland's Marriage Referendum: A Constitutional Perspective." *DPCE Online, [S.l.]*, vol. 22, no. 2, 2017, www.dpceonline.it/index.php/dpceonline/article/view/168. Accessed 15 Feb. 2018.

Somerville, Margaret. "Life's Essence, Bought and Sold." *The Globe and Mail*, 9 July 2010, www.theglobeandmail.com/opinion/lifes-essence-bought-and-sold/article1386923/. Accessed 15 Nov. 2016.

Somerville, Margaret. "Children's Human Rights to Natural Biological Origins and Family Structure." *International Journal of the Jurisprudence of the Family*, vol. 1, 2011, pp. 35-54.

Stockton, Kate. *The Queer Child: Growing Sideways in the Twentieth Century*. Duke University Press, 2010.

Van Gend, David. "Same-Sex Marriage and the Motherless Generation." *Online Opinion: Australia's E-Journal of Social and Political Debate*, 5 Jun. 2013, www.onlineopinion.com.au/view.asp?article=15091. Accessed 15 Nov. 2016.

Van Gend, David. "Who Will Apologise to the 'Motherless Generation'?" *Conjugality*, 30 Mar. 2015, www.mercatornet.com/conjugality/view/who-will-apologise-to-the-8216motherless-generation8217/15894. Accessed 15 Nov. 2016.

Notes on Contributors

Kath Browne is a professor of geographies of sexualities and genders in the Geography Department, Maynooth University, Ireland. Kath's research focuses on social justice and inequalities, specifically around gender and sexualities. She has worked on lesbian, gay, bisexual, and trans equalities, lesbian geographies, gender transgressions, and women's spaces. Most recently her work has focused on the limits of legislative change, exploring both liveabilities and the research associated with this book, heteroactivisms. She has authored a number of journal publications; co-wrote with Leela Bakshi *Ordinary in Brighton: LGBT, activisms and the City* (Ashgate, 2013) and *Queer Spiritual Spaces* (Ashgate, 2010), and co-edited *The Routledge Companion to Geographies of Sex and Sexualities* (Routledge, 2016) and *Lesbian Geographies* (Routledge, 2015).

Shana Calixte lives on the ancestral, traditional and unceded territory of the Atikameksheng Anishnawbek, in the Robinson Huron Treaty territory and is the manager of Mental Health and Addictions for Public Health, Sudbury, & Districts. She leads a multidisciplinary team to provide upstream mental health promotion programs as well as community initiatives around addictions and opioid use. Her previous roles included the lead for Mental Health and Addictions at the North East Local Health Integration Network, as well as the executive director of the Northern Initiative for Social Action (NISA), a peer-run organization located in Sudbury.

Wanda Campbell teaches women's literature and creative writing at Acadia University in Wolfville, Nova Scotia. She has published a novel *Hat Girl*, five collections of poetry, and *Hidden Rooms: Early Canadian Women Poets*. Her academic and creative work has appeared in journals across Canada.

Nadia Der-Ohannesian holds a PhD in comparative literature from Universidad Nacional de Córdoba, Argentina, since 2014. Her dissertation focused on anglophone Caribbean literature and geographical disciplines. She is an adjunct professor, teaching literature in English at the undergraduate level at the Universidad Nacional de Córdoba, and she also teaches postgraduate courses sporadically. At present, her research interests include gender studies and feminist science fiction and their relationship to space (as currently understood by cultural geography). She is a former postdoctoral CONICET (Consejo Nacional de Investigaciones Científicas y Técnicas, Argentina) fellow (2015-2018). She is also a mother.

Danielle Drozdzewski is a senior lecturer in the Department of Human Geography at Stockholm University, Sweden. Her research focuses on cultural memories and the interlinkages of these with identity and place. Her research has looked at the outcomes of these memory encounters for national identities, especially within the context of multicultural societies and in postwar landscapes. She has explored the relationship of identity and place in the context of academic parenting and has an ongoing research focus on the mixing of care work and wage work.

Karen Falconer Al-Hindi is professor of geography at the University of Nebraska at Omaha, where she directs the Women's & Gender Studies Program. She has published research in scholarly journals, including *Society & Space, Social and Cultural Geography,* and *Geography Compass.* She lives with her husband and sons in Omaha.

Carolyn Fraker is a PhD candidate in sociology at the University of Minnesota. Her dissertation research explores a federally funded doula program that provides free birth support to low-income women; it focuses on how the doulas balance birth justice with the neoliberal demands of city government. She currently resides in New York City with her husband and two children.

Andrew Gorman-Murray is a professor of geography and leader of the Urban Research Program at Western Sydney University. His expertise is in gender, sexuality, and space. His research interests include sexual minorities' experiences of belonging and exclusion in everyday spaces, including homes, neighbourhoods, suburbs, and

country towns. His work analyzes the intersections between queer politics, everyday experience, and urban and regional geographies. His books include *Material Geographies of Household Sustainability* with Ruth Lane (2011), *Sexuality, Rurality and Geography* with Barbara Pini and Lia Bryant (2013), *Masculinities and Place* with Peter Hopkins (2014), and *Queering the Interior* with Matt Cook (2018).

Tracy Gregory is a long-time sex work activist and advocate, and the founder of Sex Workers Advisory Network of Sudbury (SWANS). Tracy's work revolves around human rights and safety for sex workers, social inclusion with sex workers, and, most importantly, working with sex worker community to increase their active voices on issues, such as sex workers' human rights, harm reduction, violence against women, gender-based violence, racialized violence, shame, stigma, and discrimination. Sex workers' voices have to be at the centre of any initiative, narrative, or academic exploration of their lives. It is a pleasure to work on this chapter with Dr. Jennifer Johnson.

Nathalie Reis Itaboraí holds a PhD in Sociology (University of the State of Rio de Janeiro) and is an associated researcher at the Centre for the Study of Wealth and Social Stratification (CERES-IESP-UERJ). For almost two decades, she has been researching the sociology of families, and the articulation of gender and class inequalities. She has attended courses about familial diversity, care politics, and gender indicators for the Economic Commission for Latin American and Caribbean and Universitat de Barcelona; she has also participated in several national and international congresses, and has presented her work about social inequalities, families, and public policies, some of which have been published in books and journals. She is mother of three children.

Jennifer L. Johnson is associate professor of women's, gender, and sexuality studies at Thorneloe University federated with Laurentian University in Sudbury, Ontario, Canada. Her research and teaching include feminist geographical approaches to the study of social reproduction and global economies; gender, race and racism; and feminist pedagogies. She is co-editor of *Feminist Issues: Gender, Race, and Class* 6th edition with Nancy Mandell (Pearson Education, 2016).

Krista Johnston is assistant professor of women's and gender studies and Canadian studies at Mount Allison University, located in Mi'kma'ki, along the Bay of Fundy, New Brunswick, Canada. Her teaching and research focus on the roles and responsibilities of non-Indigenous peoples in projects of decolonization, with a focus on gender justice, migrant justice, and urban citizenship.

Natascha Klocker is a human geographer in the School of Geography & Sustainable Communities, University of Wollongong, Australia. Her research focuses on multiple dimensions of inequality, including ethnic- and race-based discrimination, and gender inequality. Regarding the latter, she is particularly interested in exploring how gender has differential impacts on the careers of mothers and fathers.

Jules Arita Koostachin, owner of VisJuelles Productions Inc. is MoshKeKo Cree and a band member of Attawapiskat First Nation in Northern Ontario. She is a PhD candidate with the Institute of Gender, Race, Sexuality and Social Justice at the University of British Columbia. She carries extensive knowledge and experience working in Indigenous community in varying capacities. She is also known as a storyteller and digital media maker who works to honour cultural protocols and build relationship within Indigenous community. Her artistic endeavours are informed by her experience living with her Cree grandparent, as well as her mother, a residential school warrior.

Minako Kuramitsu is an assistant professor in the Department of Geography and Environmental Studies, Ochanomizu University, Tokyo, Japan. Her focus is on human geography, and she has conducted field surveys in the Independent State of Samoa since 1999. She has published extensively on gender and development in Samoa.

Catherine J. Nash is a professor in the Department of Geography and Tourism Studies at Brock University, Canada. Her research focus is on sexuality, gender, and urban places. Her current research interests include changing urban sexual and gendered landscapes in Toronto; a focus on digital technologies and sexuality in everyday life; new LGBT mobilities; and a consideration of international resistances to LGBT equalities in Canada, Great Britain, and Australia. Her books include *Queer Methods and Methodologies* (2010) with K. Browne and *An Introduction to Human Geography* (Canadian Edition) (2015) with E. Fouberg, A. Murphy, and H. de Blij.

Laurel O'Gorman holds a PhD in the Interdisciplinary Northern and Rural Health Program from Laurentian University. Her current research focus is on how rurality, poverty, and gender intersect with health discourses in the context of childhood obesity and on unpaid domestic and reproductive labour as work. Laurel teaches in sociology, labour studies, and women's, gender and sexuality studies programs at Laurentian University and Thorneloe University in Ontario, Canada.

Elizabeth Philps is an artist and academic whose current work explores autobiographical performance and Live Art walking practices. GPS Embroidery is an ongoing project, funded by the Arts Council. Her work has been published in The Live Art Development Agency's *Study Room Guide On The Maternal* (2017), *Embodied Cartographies* at Bath Fringe (2017), and Triarchy Press's *Ways to Wander* (2015). Elizabeth is an editor for the *Journal of Mother Studies*. With a background in contemporary theatre, Elizabeth is subject leader of the BA in Drama and Performance at BIPA, Bristol, UK, and is completing a PhD at Exeter University. www.lizziephilps.com

Emma Sharp is a geographer whose research focuses on food politics, care, diversity, and alternative economies. She has worked in government, consultancy, and the 3rd sector internationally on environmental, education and humanitarian issues. She is a founding member of the NZ Women and Gender Geographies Research Network (2013 -) and associated Pūawai writing collective. She has two preschool children.

Laurence Simard-Gagnon is a PhD candidate at the Department of Geography at Queen's University, Kingston, Ontario. Her research focuses on lived experiences, space, place, and mothering practices of women in context of differences and/or minorities. More generally, she is interested in mothering/motherwork, subjectivity, intersectionality, care and ethics of care, cultural work, neoliberalism, and mental health. She is also a member of several feminist collectives involved in online publishing as well as in political organizing for gendered justice and against violence against women.

Deepest appreciation to
Demeter's monthly Donors

DEMETER

Daughters
Muna Saleh
Summer Cunningham
Rebecca Bromwich
Tatjana Takseva
Kerri Kearney
Debbie Byrd
Laurie Kruk
Fionna Green
Tanya Cassidy
Vicki Noble
Bridget Boland

Sisters
Kirsten Goa
Amber Kinser
Nicole Willey
Regina Edwards